FROM WAR TO PEACE
IN 1945 GERMANY

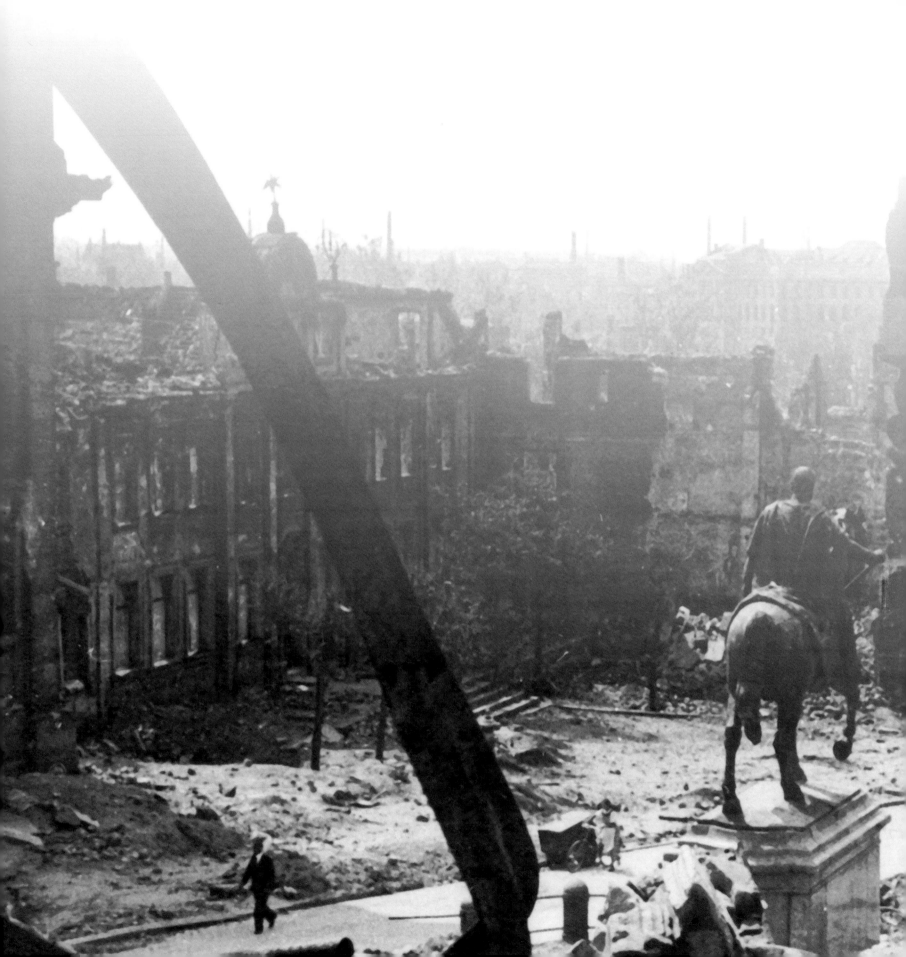

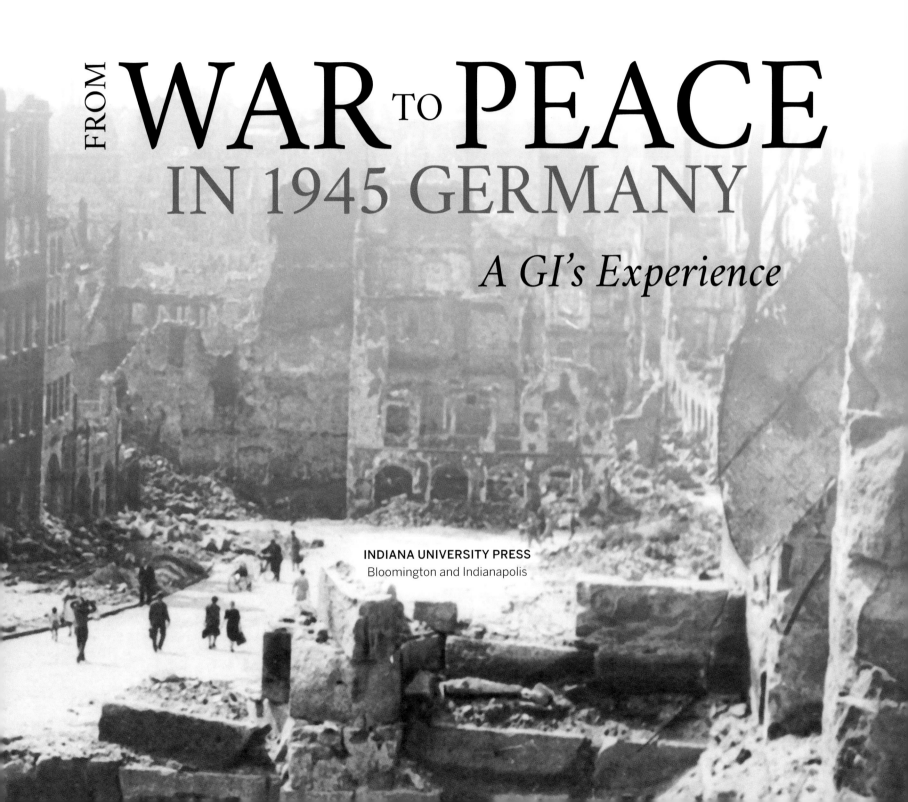

MALCOLM L. FLEMING

Foreword by JAMES H. MADISON

Afterword by BRADLEY D. COOK

FROM WAR TO PEACE
IN 1945 GERMANY

A GI's Experience

INDIANA UNIVERSITY PRESS
Bloomington and Indianapolis

This book is a publication of

INDIANA UNIVERSITY PRESS
Office of Scholarly Publishing
Herman B Wells Library 350
1320 East 10th Street
Bloomington, Indiana 47405 USA

iupress.indiana.edu

The paper used in this publication meets the minimum requirements of the American National Standard for Information Sciences—Permanence of Paper for Printed Library Materials, ANSI Z39.48–1992.

Manufactured in Korea

Library of Congress Cataloging-in-Publication Data

Names: Fleming, Malcolm L., author.
Title: From war to peace in 1945 Germany : a GI's experience / Malcolm L.
 Fleming ; foreword by James H. Madison.
Description: Bloomington : Indiana University Press, [2016]
Identifiers: LCCN 2015023881| ISBN 9780253019561 (cloth : alkaline paper) |
 ISBN 9780253019615 (e-book)
Subjects: LCSH: Fleming, Malcolm L. | World War, 1939-1945–Photography. |
 World War, 1939-1945–Campaigns–Germany. | World War, 1939-1945–Personal
 narratives, American. | United States. Army–Biography. | War
 photographers–United States–Biography. | Cinematographers–United
 States–Biography. | War photography–United States. | Military
 cinematography–United States. | Reconstruction (1939-1951)–Germany. |
 Germany–Social conditions–1945-1955.
Classification: LCC D810.P4 F54 2016 | DDC 940.53/140943–dc23 LC record available
 at http://lccn.loc.gov/2015023881

1 2 3 4 5 21 20 19 18 17 16

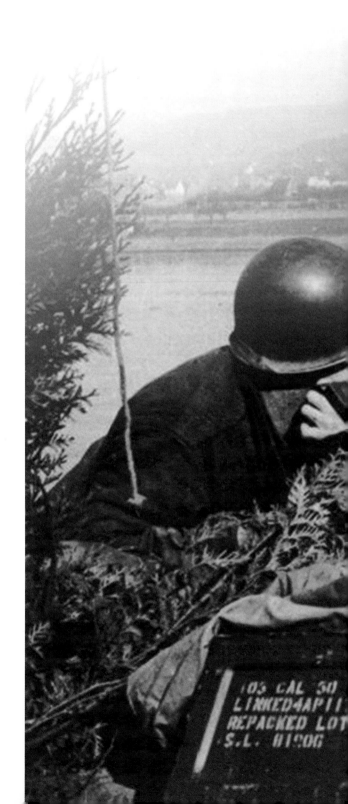

I would like to dedicate this book to all veterans of World War II, most of whose stories are left untold but are no less worthy.

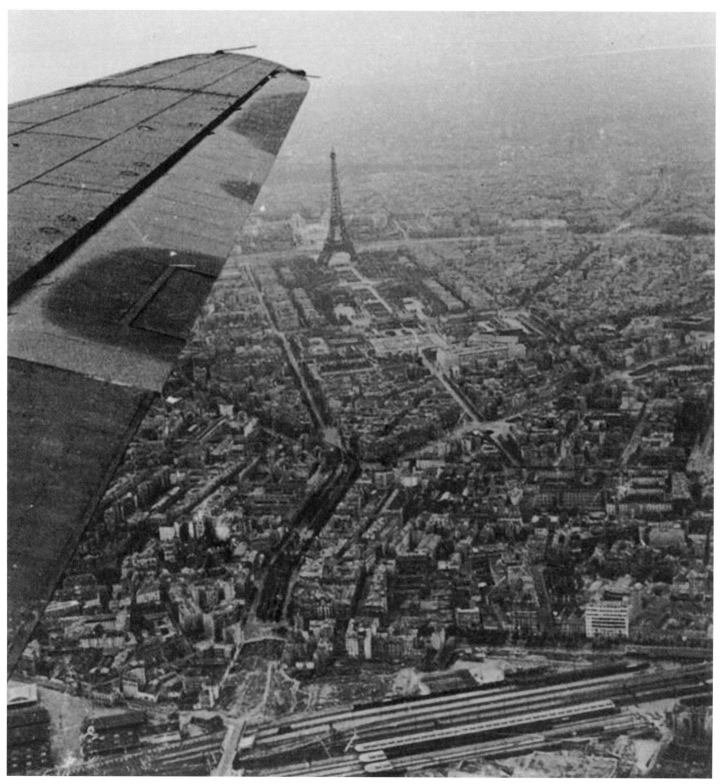

Wings over Paris.

CONTENTS

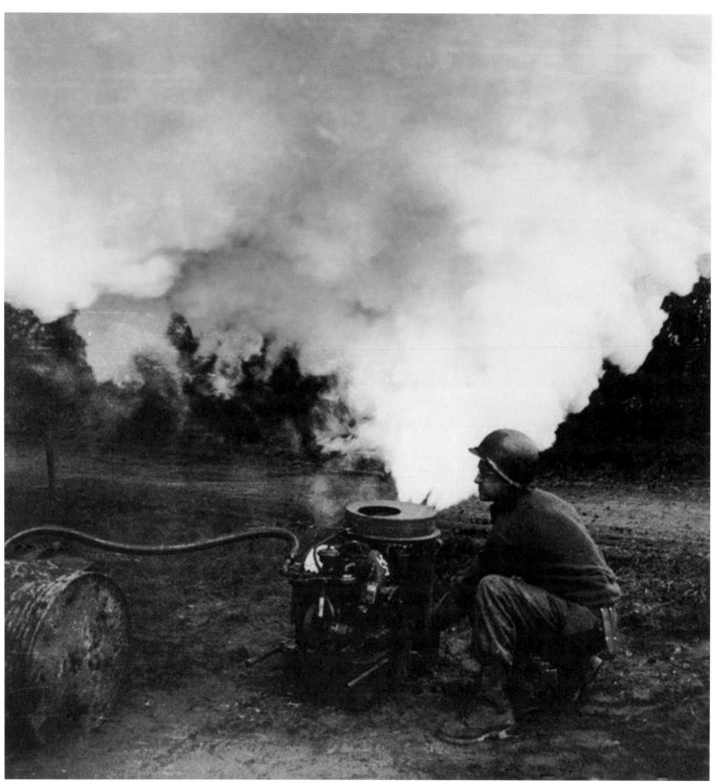

Smoke generator.

FOREWORD

JAMES H. MADISON

*T*he US Army in World War II had a reputation for SNAFUs—"situation normal, all fouled up" (many GIs, of course, used a different "f" word). In Malcolm Fleming's case the army made a smart choice when it took this supply clerk who had worked with a camera as a kid and trained him to be a combat photographer. Off he went to Europe with his Eymo camera to make moving pictures and a small Vollenda for still images. The result is this magnificent photo diary composed of Mac Fleming's selection of images he made and kept, along with his field notes.

Photography changed our view of war. Matthew Brady's Civil War images introduced Americans to the battlefield. World War II cameras sent thousands of war pictures to home-front Americans, though only after censors carefully selected the best to build morale and urge sacrifice. Even through the fog of propaganda, it was possible during World War II to visualize combat in ways unimagined in earlier wars. Tens of thousands of still and motion picture images remain today as powerful shapers of our understanding of this war. In the flag raising on Iwo Jima's Mount Suribachi, the D-Day view of the German-occupied Normandy beaches, and the sailor's victory kiss in Times Square, twenty-first-century Americans "see" a war fading in living memory.[1]

Combat cameramen like Mac Fleming necessarily worked in dangerous situations, often near the very front of the front line. Some became casualties as they risked their lives to record the realities of battle. Their job of finding a good angle for a shot sometimes required standing up rather than ducking down. In one telling detail Fleming notes that when moving for the night into an abandoned German house he and other cameramen "drew the top floor, affording the finest view but least security."

Fleming begins his report in Germany in March 1945, at the Remagen Bridge. American forces captured the bridge before the retreating Germans could destroy it, and so enabled a first crossing of the Rhine River. Over the Rhine Fleming drives his jeep ("peep," he calls it) far into Germany and eventually to the Elbe River, where he records the linkup with Soviet troops in late April 1945. It is a grand celebration, with many toasts between American and Red Army troops. At the Elbe meeting place a friend takes a photo of Fleming standing with a diminutive Russian soldier, a female sniper, one of many such soldiers noted for their expert marksmanship. Soon after, the Germans surrender and the understanding grows that the Soviet allies had fought a different war and intended a different occupation of the Nazi homeland.

Like many other GIs, Fleming remains in Germany to record life at the beginning of the occupation. He points his camera at the physical and human cost of war, notably the steady stream of displaced persons, the thousands and thousands of prisoners and slave laborers the Nazis have

forced from France, Poland, and Czechoslovakia, and of course the surviving Jews. On the rural roads and the grand autobahn, they walk toward home, away from a defeated and hated Germany, and away from the Soviet occupiers they know to be harsher than the Americans or the British. Poignantly, Fleming notes, "Children everywhere."

Fleming's interest in German civilians causes him to photograph women and children working in the fields, walking the streets and roads, clearing away the rubble of destruction. Like most Americans he tries to imagine their level of enthusiasm for the dreams of the Third Reich. "Mixed emotions were mine," he laconically writes. At the place of the Gardelegen massacre, one of the war's many atrocities, Fleming sees Nazi deeds at their worst.

He observes the tangled relationships between GIs and German civilians. The American military authorities had issued reams of rules to govern both sides. GIs obeyed some, but not all, especially the prohibition on "fraternizing" with German women.

There is respite from war in a leave to Paris, the city of light that was spared most of the war's physical ruin. Here Fleming goes like a moth to brightness to make beautiful shots of the Eiffel Tower, of a loving couple on a park bench, of GIs enjoying French wine—all antidotes to a nasty war.

And finally the journey home. Fleming joins the massive exodus of GIs, most of them bone-weary of war, most of them a bit surly. They wait and wait, even as Fleming acknowledges the massive scale of transport to European seaports and across the stormy Atlantic, brightened slightly by the hometown touch of Red Cross doughnuts and coffee. GIs like Mac are impatient to resume relationships and lives so utterly interrupted. Few can imagine yet that there just might be an American Dream waiting after the worst war in human history.

For Mac Fleming, the future would include a long career as a professor at Indiana University, a continuing enthusiasm for photography, and the memory of the war he witnessed, photographed, and preserved for us.

1. Good starting points are Peter Maslowski, *Armed with Cameras: The American Military Photographers of World War II* (New York: Free Press, 1993); George H. Roeder Jr., *The Censored War: American Visual Experience during World War Two* (New Haven, CT: Yale University Press, 1992); Ray E. Boomhower, *"One Shot": The World War II Photography of John A. Bushemi* (Indianapolis: Indiana Historical Society Press, 2004).

ACKNOWLEDGMENTS

I acknowledge my debt to the 165th Signal Photo Company, to its leaders, Lt. Sykes and Lt. Rosenmann, and to my fellow soldier/photographers. You helped a naïve rookie become a team member. Somehow we did our duty and made it through together.

I further acknowledge the loving support of my wife of seventy-two years, Ruth Gaily Van Patten Fleming. She was an essential partner in many hiking/photographing adventures. Our children, Steve and Alice, and grandson, Sean, have been helpful supporters as well.

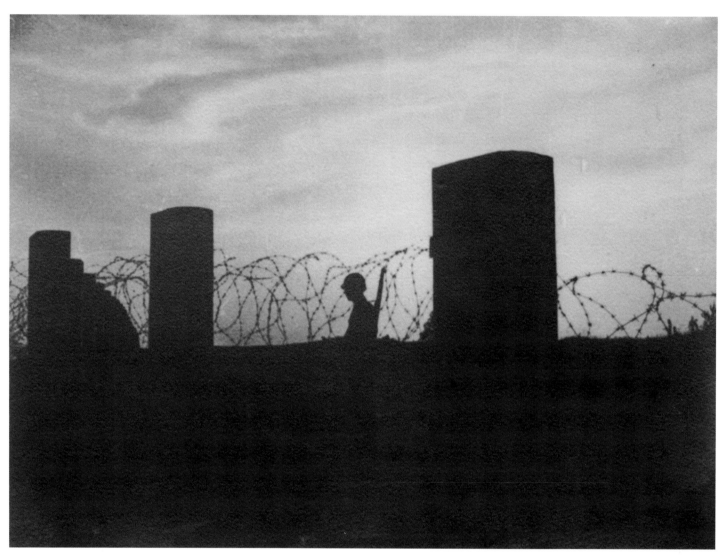

Guard duty.

NOTE FROM THE AUTHOR

All photos herein, except those taken of me, were taken by me, and all were taken in 1944 (New York and Long Island) and 1945 (Europe). Most were taken with my tiny Vollenda camera and were also processed by me. Because these were processed in the field and the negatives had a long, rough ride in my pack, some became scratched. We have removed many of the scratches. Those that remain may provide some authenticity and a reminder of the wartime experience. The other photos are from motion pictures and still photos I took for the army. The army processed them and sent me an occasional test strip. Prints from a few of these are reproduced here.

The army asked us to send accompanying notes for each photograph we took. This practice inspired me to keep my own small field notebook and the captions for the European pictures from 1945 are from this notebook. These comments represent what I saw, heard, and felt at that time; I was twenty-six years old.

Text in italics represents comments added after 1945.

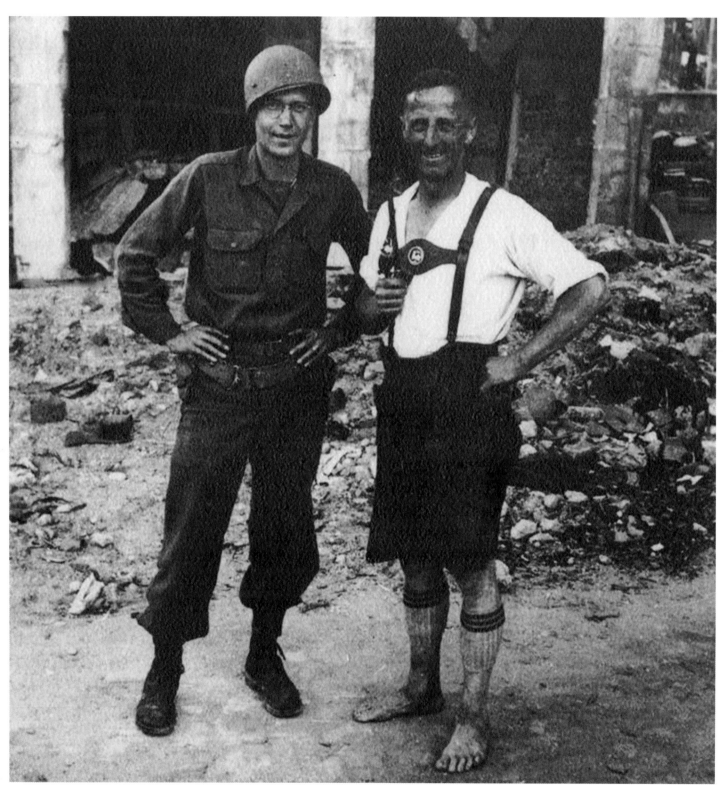

Soldier and civilian.

FROM WAR TO PEACE
IN 1945 GERMANY

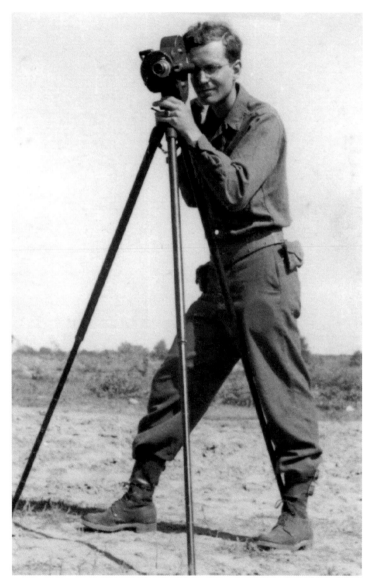

Cinematographer.

INTRODUCTION

I was taking pictures and developing and printing them at an early age. They were not careful portraits but quick grab-shots of whatever interested me. I got in trouble in high school for my candid shots of teachers. In college I had a pocket-sized folding camera well suited to my style: a Kodak Vollenda folding camera, f 3.5 Schneider-Kreuznach lens, compur shutter speeds of 1 to 1/500 second, manual focus, and manual exposure settings.

In the army I was transferred to the Signal Corps Photo Center in New York for training to be a combat photographer in 1944. Our assignments ranged widely in subject matter and photographic difficulty, and were well suited for training army photographers. We were billeted in the American Hotel near Times Square, so my downtown practice photos ranged from action shots of the Rockettes to photos inside the peaceful St. Patrick's Cathedral. A gallery of these New York photos appears in the prelude, "A Photographer in Training." Officers would regularly check and critique our work. Part of the training to use the Speed Graphic 4 x 5 camera was to take pictures while in a foxhole with a small tank (Weasel) rolling overhead. The Speed Graphic 4 x 5 was the standard press camera of the day.

At the Replacement Depot in England a sergeant told me they needed motion picture photographers. He quickly taught me how to load a one-hundred-foot roll of 35 mm motion picture film into a handheld Eymo camera and I became a cinematographer overnight.

The pictures in part 1, "The War," and part 2, "The Peace," were taken in Germany, France, and Belgium in 1945. I arrived at First Army Headquarters in Belgium carrying an Eymo in a case and my tiny Vollenda on my belt in a pouch intended for a first-aid kit. I was hoping that after filming an important story or two each day for the army there'd be an opportunity for a quick snapshot or two.

There was!

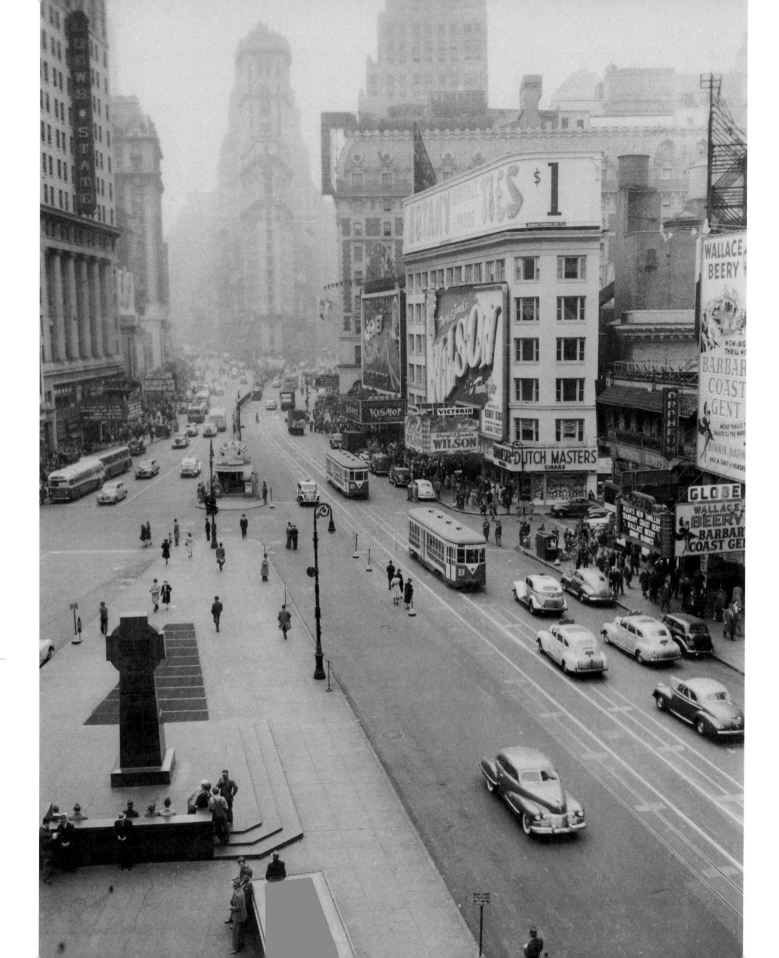

PRELUDE:
A PHOTOGRAPHER
IN TRAINING

*T*hese photos were taken during my time stationed at the Signal Corps Photo Center (SCPC) on Long Island in 1944. This small-town boy from Oregon really enjoyed exploring New York City with a camera.

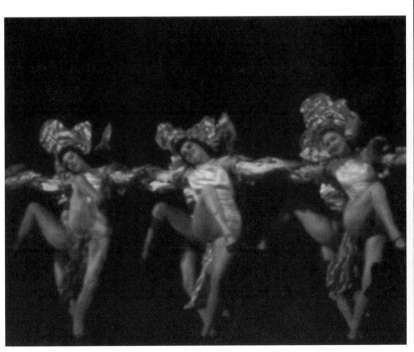

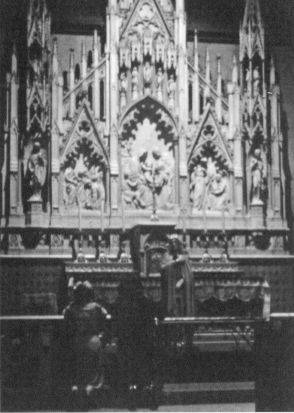

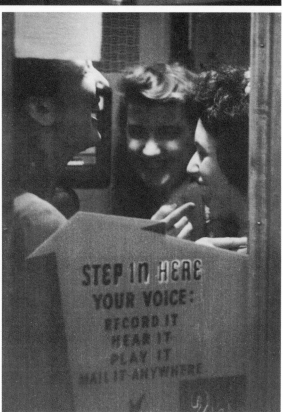

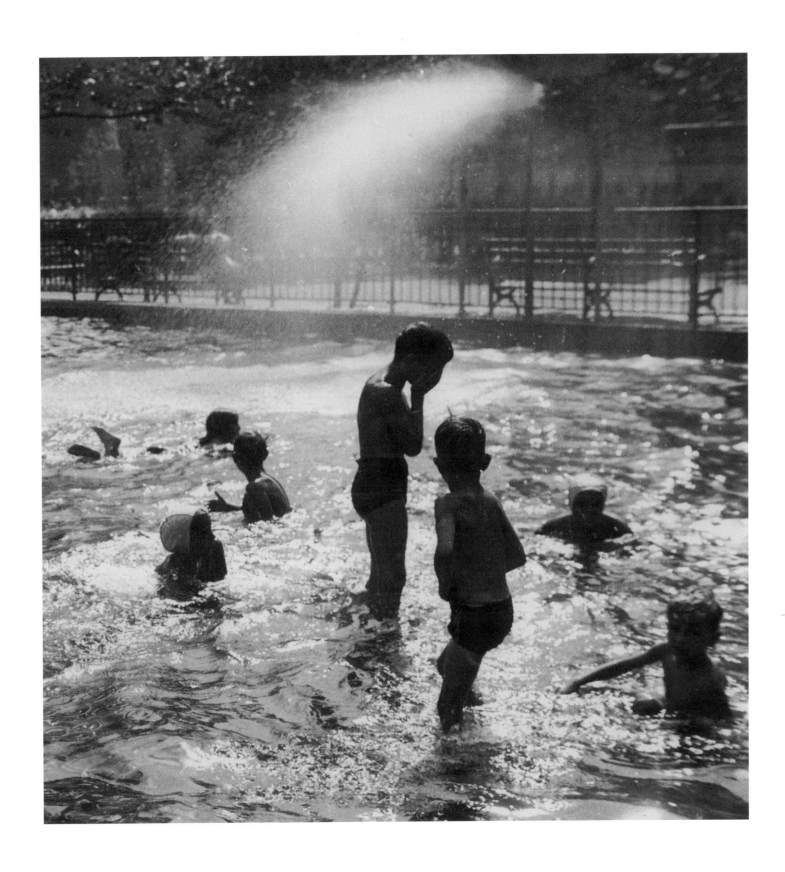

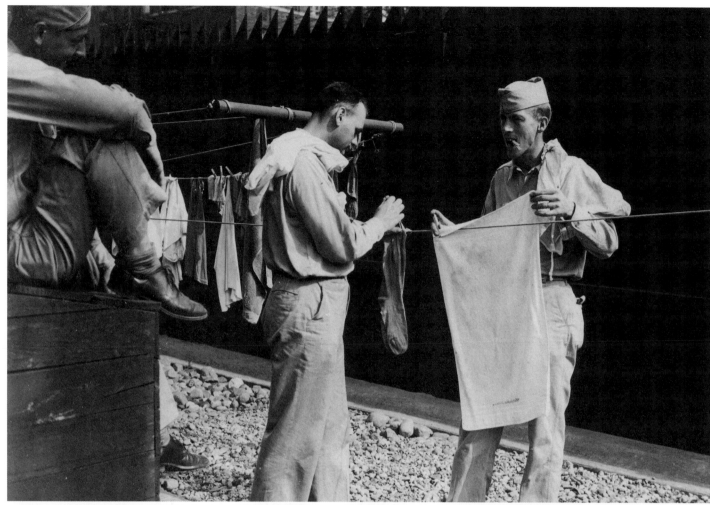

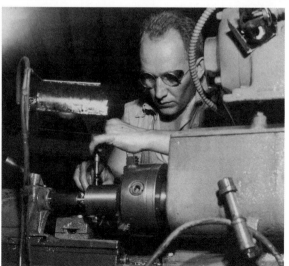

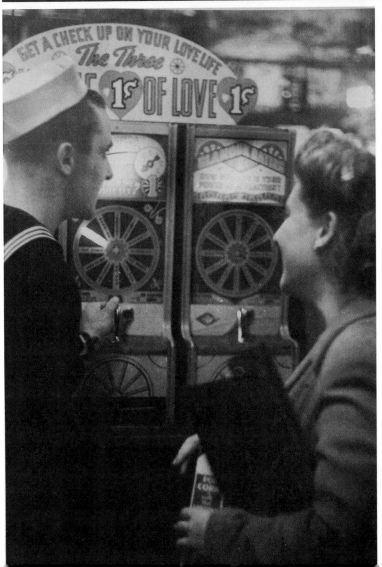

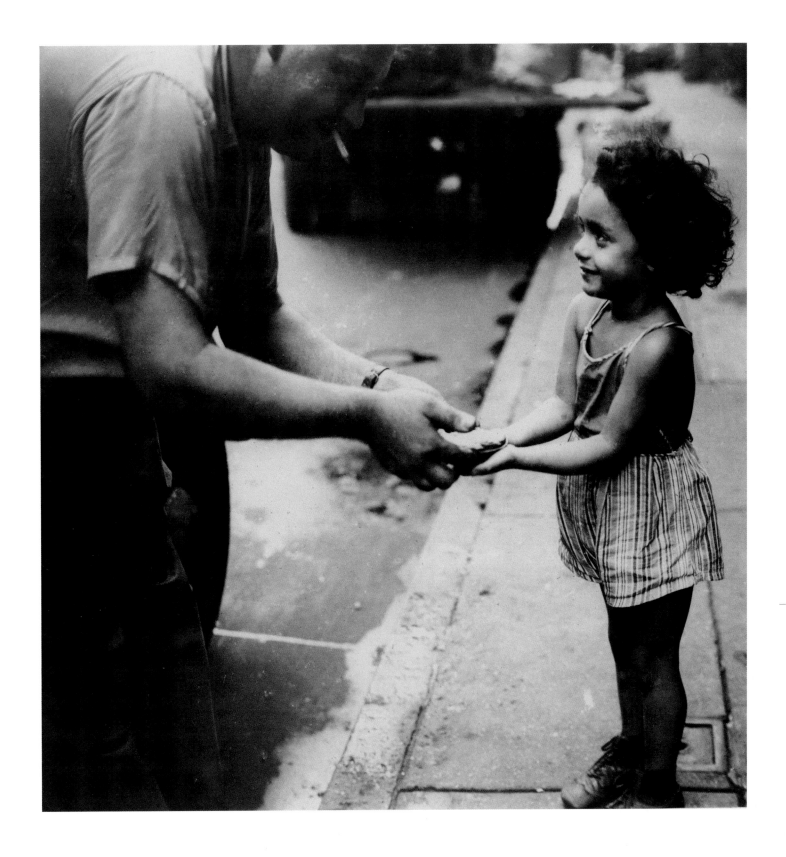

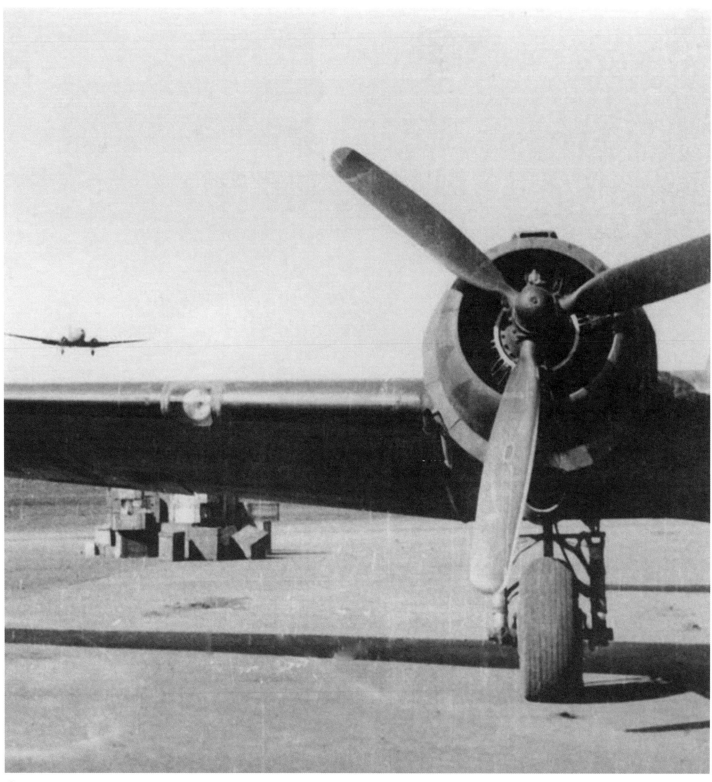

C-47

Part I.

THE WAR:
A CHRONOLOGICAL STORY

1

BATTLE FOR THE REMAGEN BRIDGE ACROSS THE RHINE RIVER

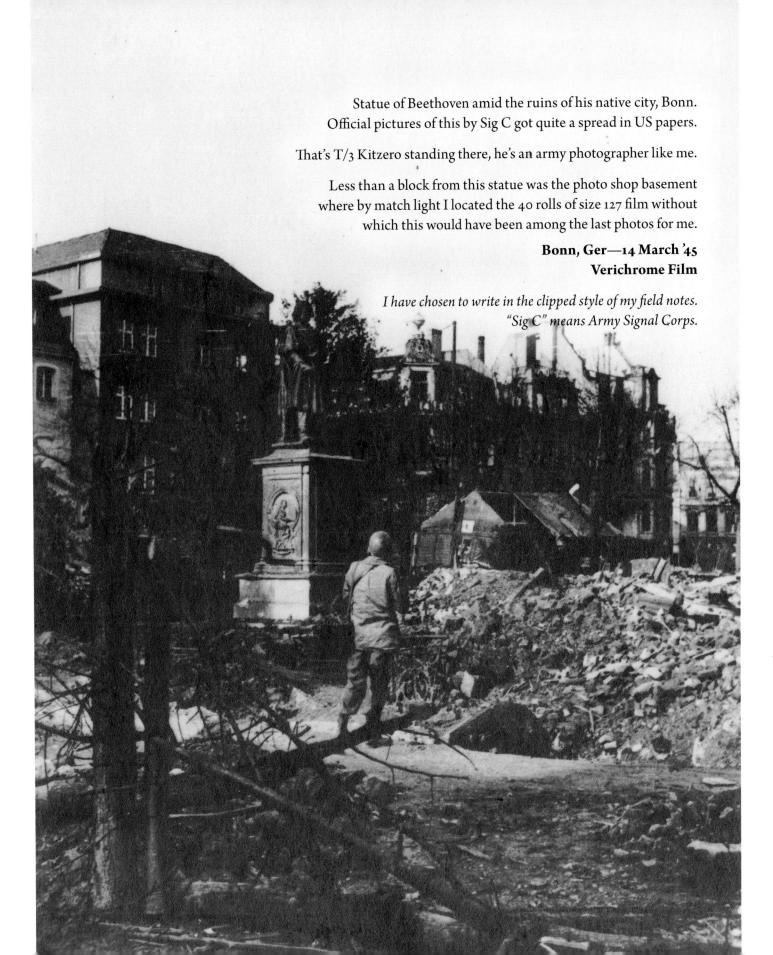

Statue of Beethoven amid the ruins of his native city, Bonn.
Official pictures of this by Sig C got quite a spread in US papers.

That's T/3 Kitzero standing there, he's an army photographer like me.

Less than a block from this statue was the photo shop basement
where by match light I located the 40 rolls of size 127 film without
which this would have been among the last photos for me.

Bonn, Ger—14 March '45
Verichrome Film

I have chosen to write in the clipped style of my field notes.
"Sig C" means Army Signal Corps.

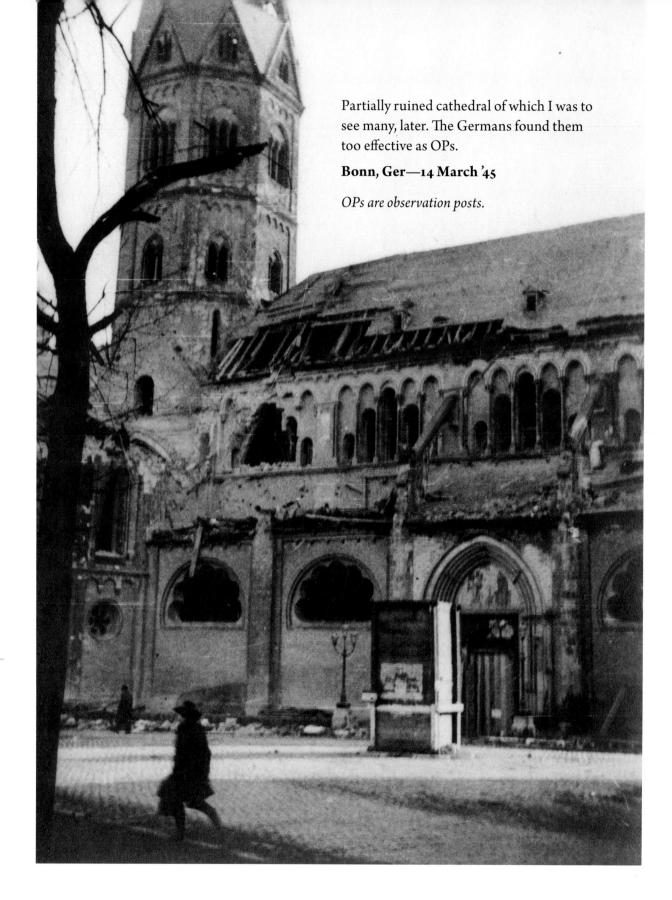

Partially ruined cathedral of which I was to see many, later. The Germans found them too effective as OPs.

Bonn, Ger—14 March '45

OPs are observation posts.

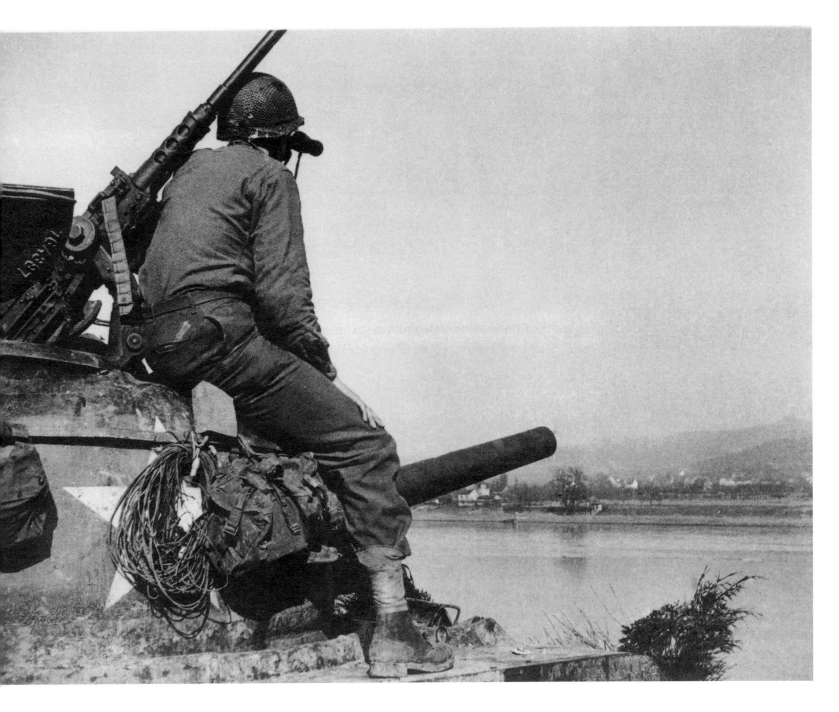

Unusual position for a Sherman Tank, but the tanker was hunting an unusual prey. The army, still jittery about the newly won Remagen Bridge, feared the enemy might destroy it by a one-man submarine or floating mines. So that's what this tanker is looking for. Also searchlights were even used to watch the river by night.

Near Remagen, Ger—16 March '45

Wreckage of a ferry boat on the west bank of the Rhine. Several communication cables dip into the water nearby. Some, if not these, were fired across by signalmen. The strong current and drifting objects kept breaking these lines so they were finally weighted and sunk to the bottom.

Near Remagen, Ger—16 March '45

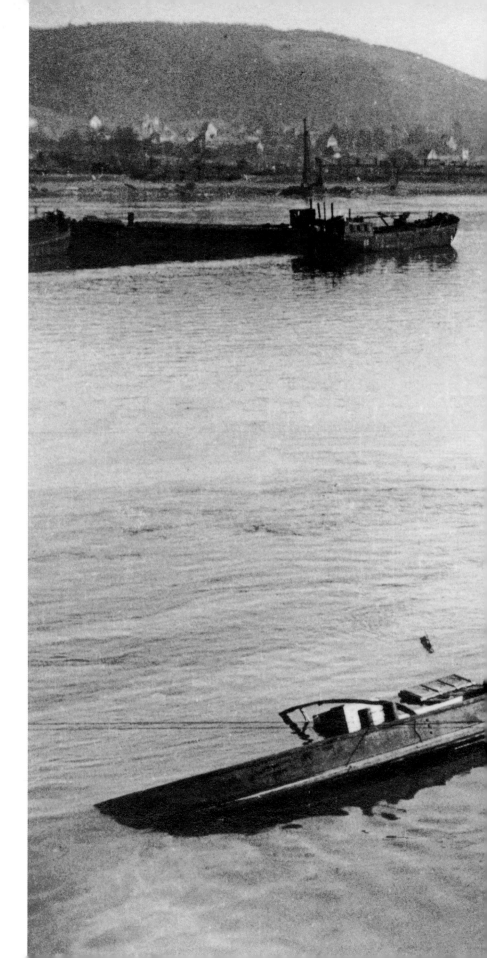

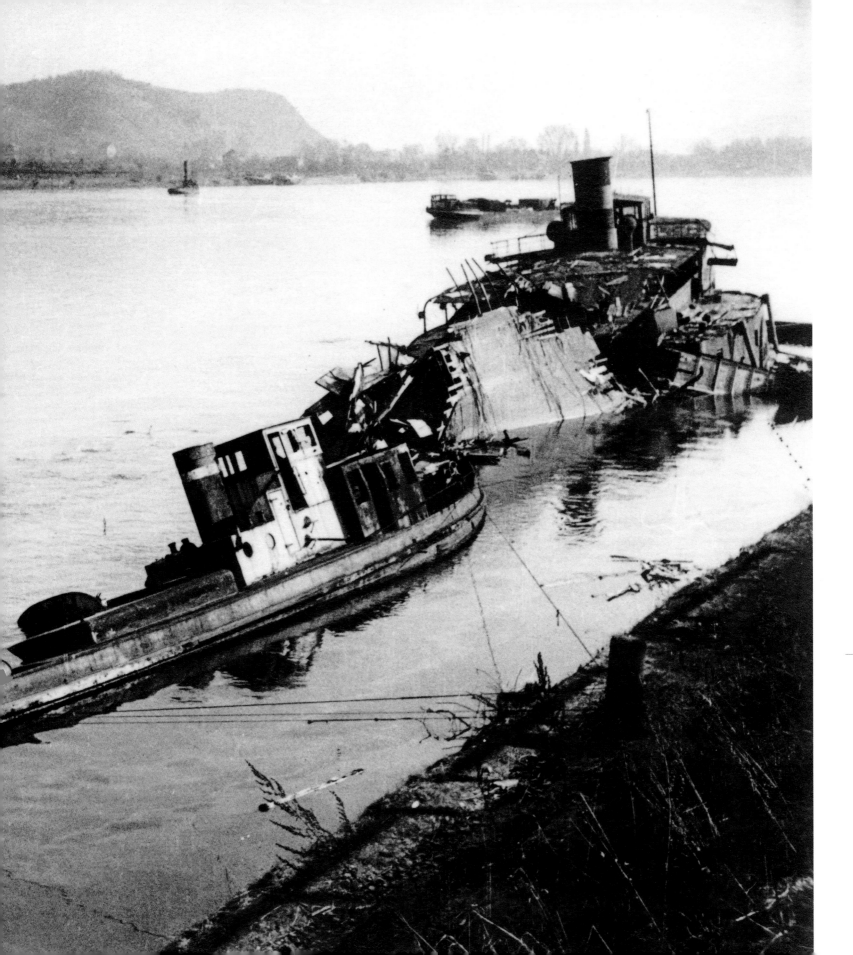

The first CP of 1st Inf after they crossed the Rhine. This mansion had belonged to a certain Hinkel who at first was rumored to be the plane manufacturer. It turned out that he made soap. Anyway, the place was luxuriously furnished so we knew him to be a good Nazi.

We often ate here with Hq Co instead of Signal, especially when we heard they were having chicken or steak. Nice to lean on the back wall & watch the Rhine go by, too.

Unkel, Ger—17 March '45

"CP of the 1st Inf" means Command Post of the First Infantry Division. "Hq Co" means Headquarters Company.

Our Peep takes a ride across the Rhine in an LCVP, courtesy of the US Navy. They said we were the first to cross the Rhine thus with a vehicle. There were other ferry services being improvised too, like the one made of three heavy pontoons fastened together and powered by several outboard motors.

Near Unkel, Ger—17 March '45

"Peep" is an endearing name for an Army Jeep. An LCVP is a Landing Craft, Vehicle, Personnel.

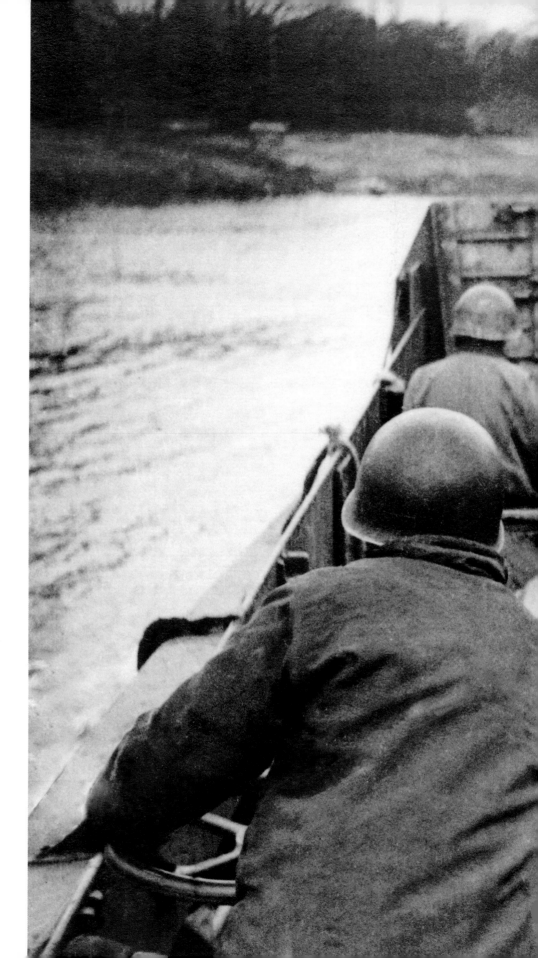

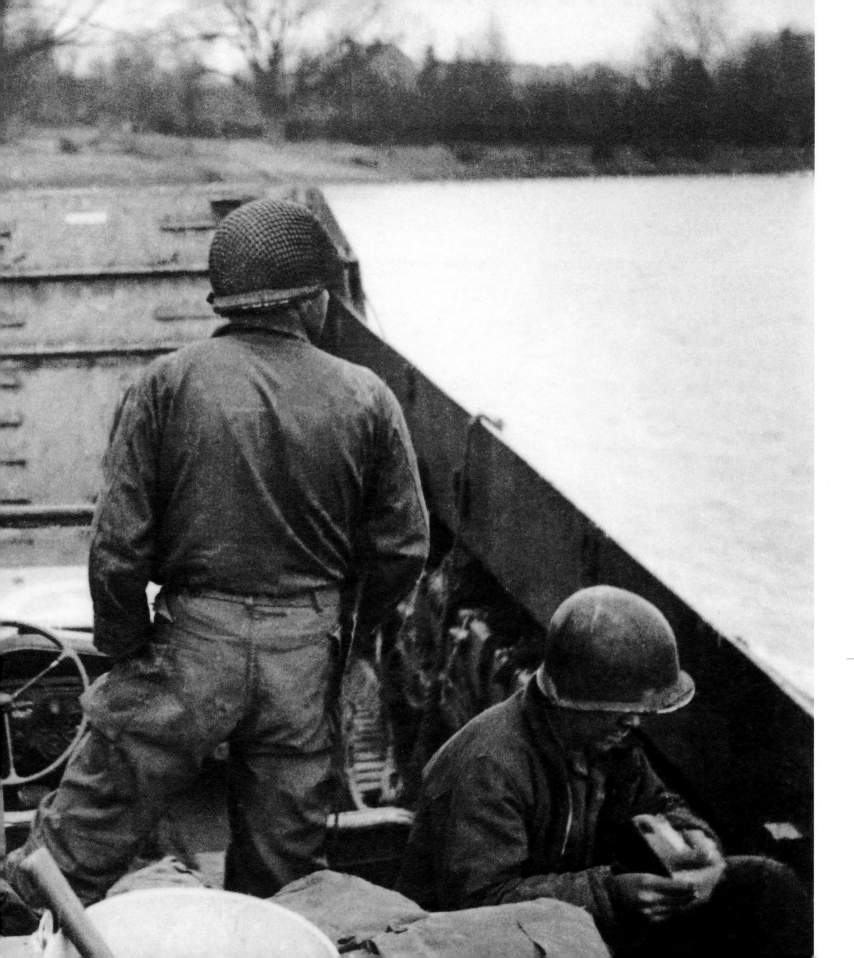

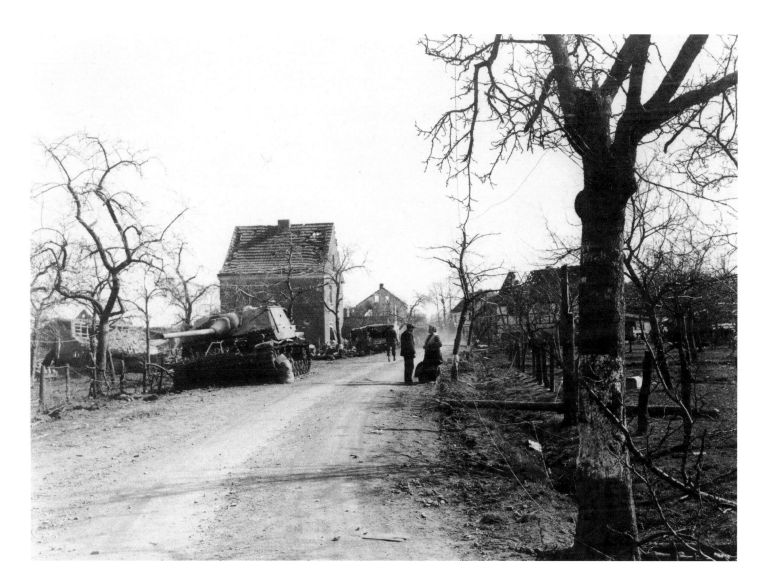

ETO HQ 45 22052 19 Mar
Credit: US Army Signal Corps

Photog-M Fleming 165 Signal Photo Company.

Civilians of Himberg, Germany, walk down the main street carrying their belongings, past a knocked-out German tank. The town fell to troops of the 1st Division, 1st US Army.

Himberg, Germany

I took this one with an Army Speed Graphic Camera. The film was flown to England for processing, like all our army film, motion or still, because of its intelligence value. This print, with the above labeling was returned to tell me how well I was doing: focus, exposure, subject matter, caption, etc. It also clearly credits me and my photo company.

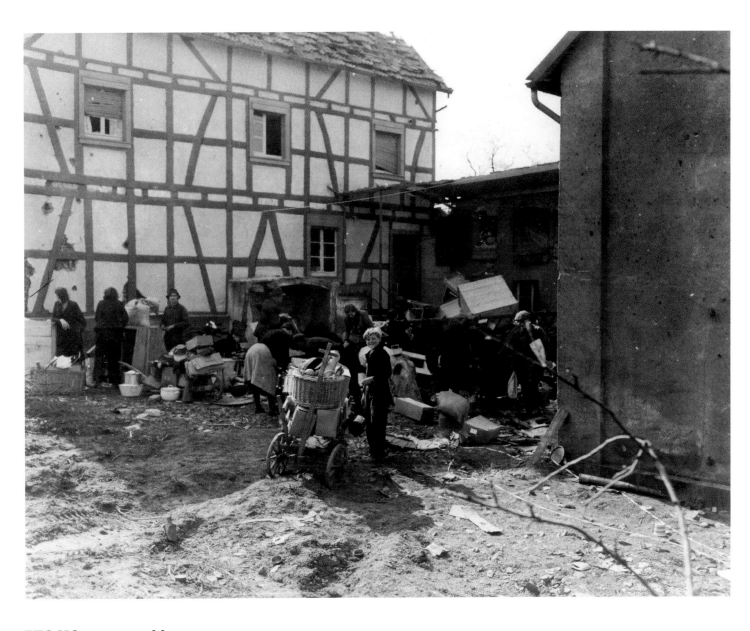

ETO HQ 45 22050 19 Mar
Credit: US Army Signal Corps

Photog-M Fleming 165

Russian and Polish civilians go through all the goods in a German-owned corner store at the edge of Neichen, Germany, in the 1st Division Sector, 1st US Army. The store had been hit by shell fire, and deserted by its owner.

Neichen, Germany

See note for previous photo.

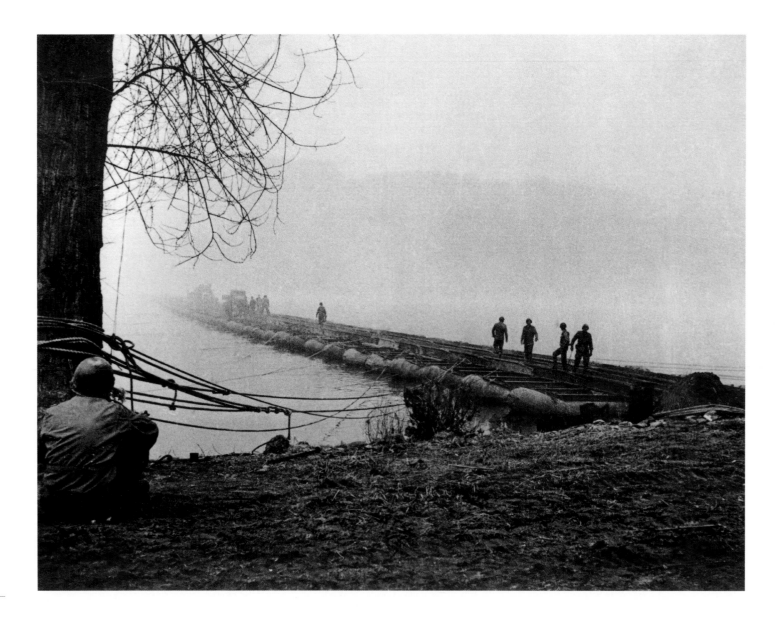

East end of a Treadway Bridge across the Rhine, the third thus far. Being built out simultaneously from both shores the center sections are last to be floated into place. I couldn't complete my movie story of these last links yesterday because the Engineers were afraid that the floating wreckage from the Remagen Bridge, which had just fallen, would puncture the floats. Boats were busy steering big timbers through the open way midstream.

This bridge was built in about twenty hours by the 294th & 297th Eng. Bns. It has a 40-ton load limit, which means that it can handle even a medium tank.

Near Unkel, Germany—19 March '45

"Eng. Bns." means Engineering Battalions.

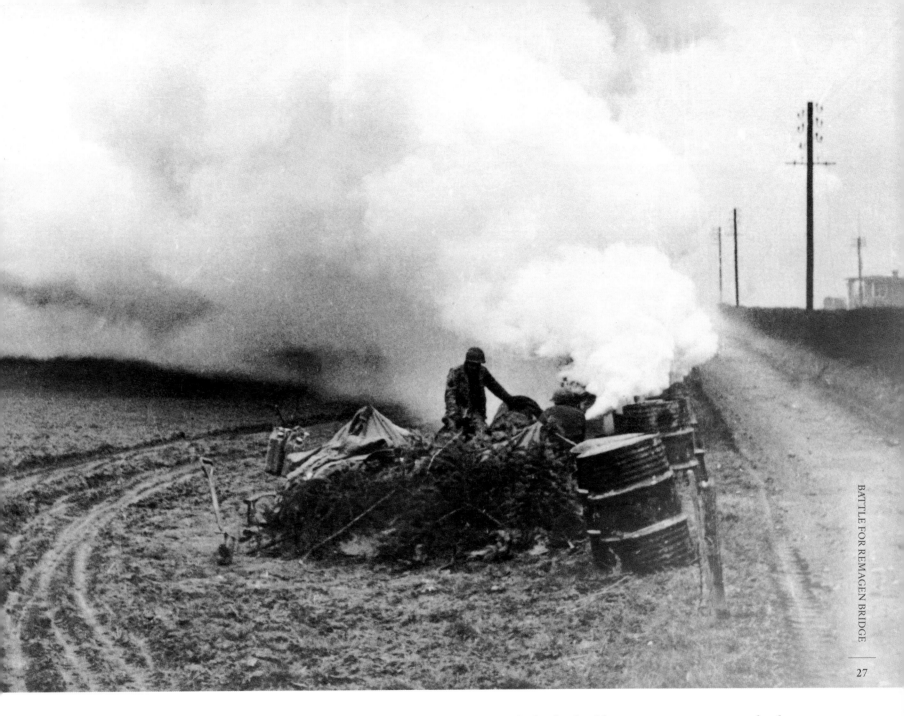

A Mechanical Smoke Generator, M/2. This is one of several covering the bridge-building operations so as to make them invisible to air observation. A changing wind made this difficult from the shores, so a couple of the generators were put on boats which could maneuver easily and keep the smoke properly directed.

This contrivance burns a special oil at 900° F, really a whizz for heating water for a cup of coffee, they say. It generates for about an hour's time on a 50 gal drum of oil. A little water is added to make the smoke heavier so it will hug the ground better.

Near Unkel, Ger—19 March '45

The famous Remagen Bridge several days after it crashed in, killing some of the Engineers working to repair it. We never did cross on it. Pontoon and treadway bridges were handling most all traffic the first day we crossed. That was one week after the original assault was made, and it was so badly shelled as to be considered unsafe even then. Occasional shells were still coming in from behind the hills, for Jerry had observation from high points downstream.

Planes couldn't get near it. Old-timers said they'd never seen such a concentration of anti-aircraft guns since Normandy. Each gun was assigned a small zone of fire over the bridge so that if all fired at once the bridge was completely covered by a canopy. This method was used mainly at night when enemy planes could be heard but not seen. The countless fiery tracers were a sight to see each night.

Near Unkel, Ger—20 March '45

"Jerry" refers to the German army.

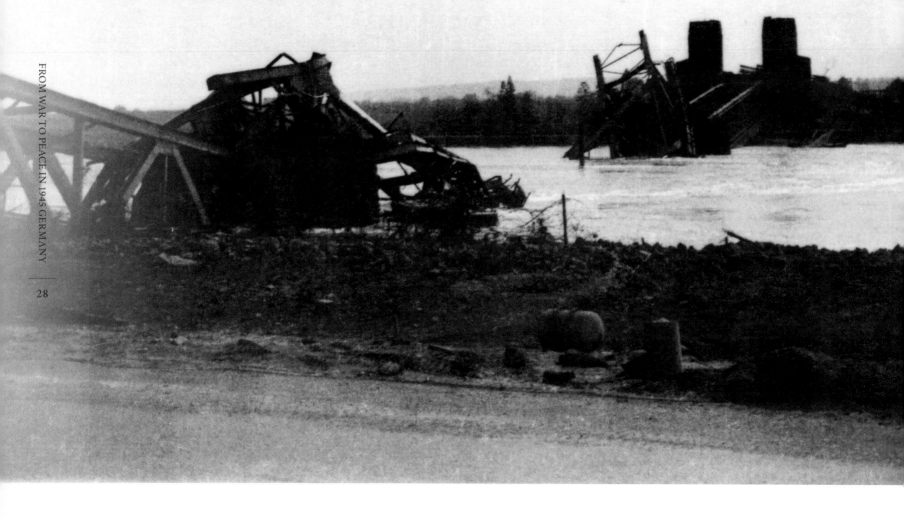

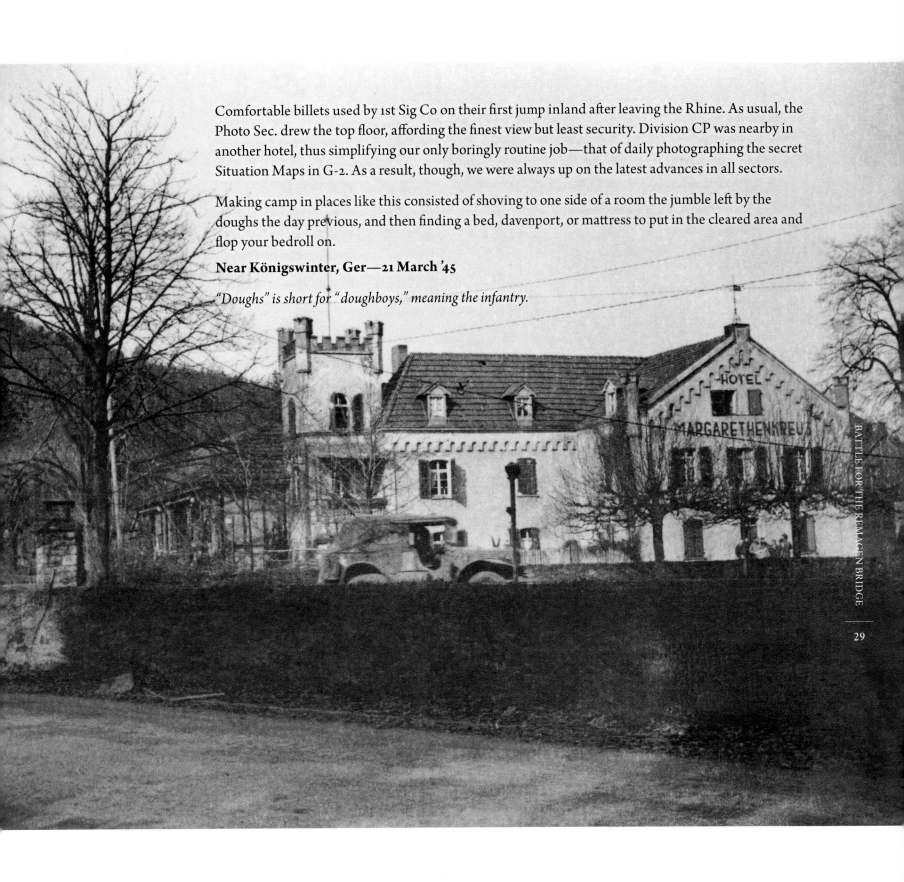

Comfortable billets used by 1st Sig Co on their first jump inland after leaving the Rhine. As usual, the Photo Sec. drew the top floor, affording the finest view but least security. Division CP was nearby in another hotel, thus simplifying our only boringly routine job—that of daily photographing the secret Situation Maps in G-2. As a result, though, we were always up on the latest advances in all sectors.

Making camp in places like this consisted of shoving to one side of a room the jumble left by the doughs the day previous, and then finding a bed, davenport, or mattress to put in the cleared area and flop your bedroll on.

Near Königswinter, Ger—21 March '45

"Doughs" is short for "doughboys," meaning the infantry.

2

FAST EVACUATION OF WOUNDED
—AN EXPERIMENT

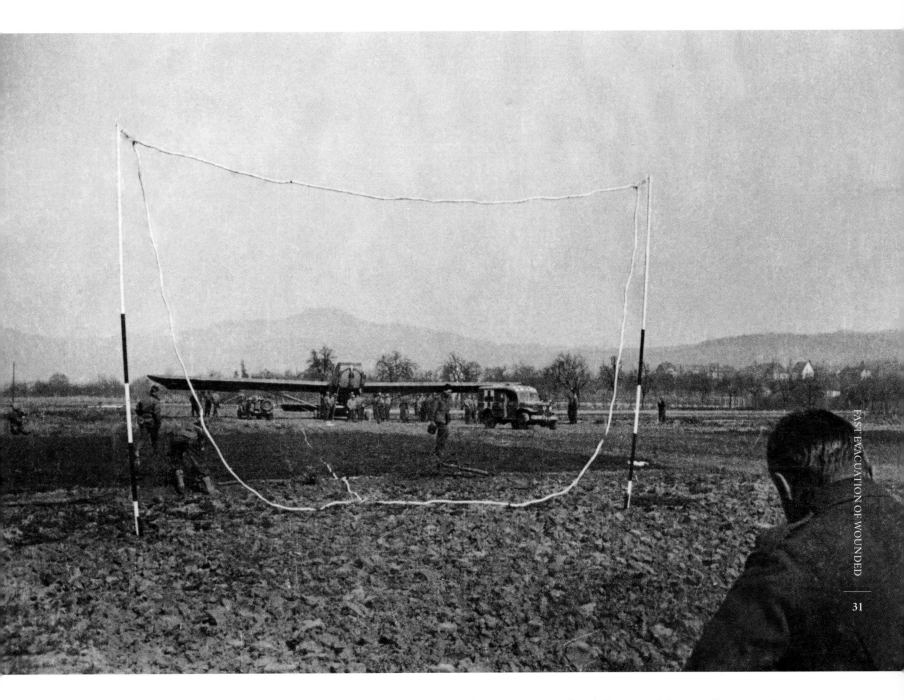

An experiment in the rapid evacuation of wounded men by glider. A C-47 tows the glider in and drops it, later snatching it into the air again by means of the ground pickup loop shown here. This method is particularly fit for use near the front where landing fields large enough for the plane are not available. The glider can land and be picked up from a tiny strip suitable for the little L-4 liaison plane used by the Artillery.

Near Unkel, Ger—22 March '45

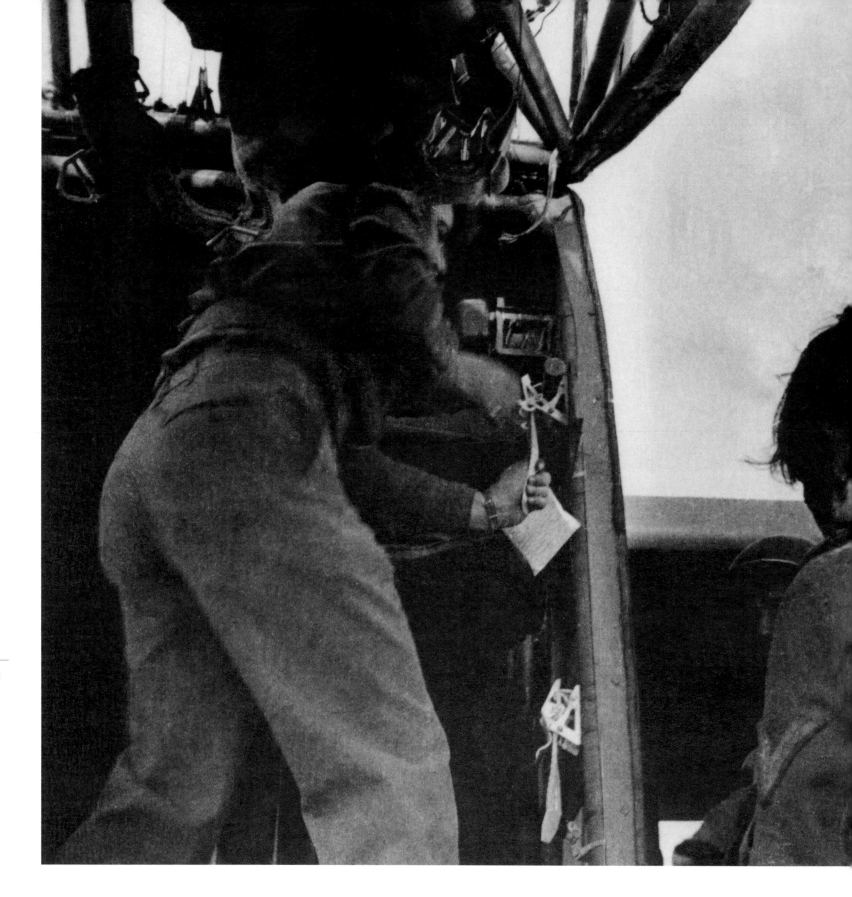

The glider has been adapted to hold twelve stretcher patients and three attendants or walking patients. This glider was built as a cargo glider and used in airborne landing operations. It this time brought in bundles of medical supplies and will take out a full load of wounded.

The walking wounded on the right is a German. Men submitting to use in this experiment were either volunteer GIs or Germans, with or without their consent.

Near Unkel, Ger—22 March '45

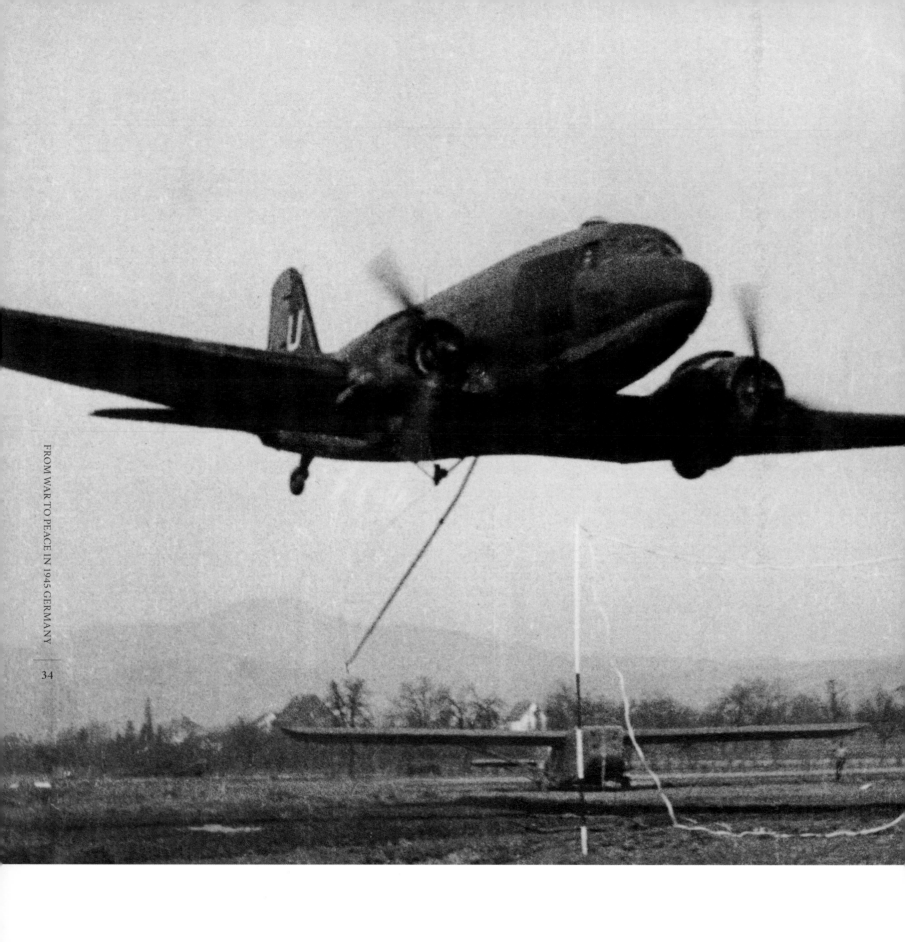

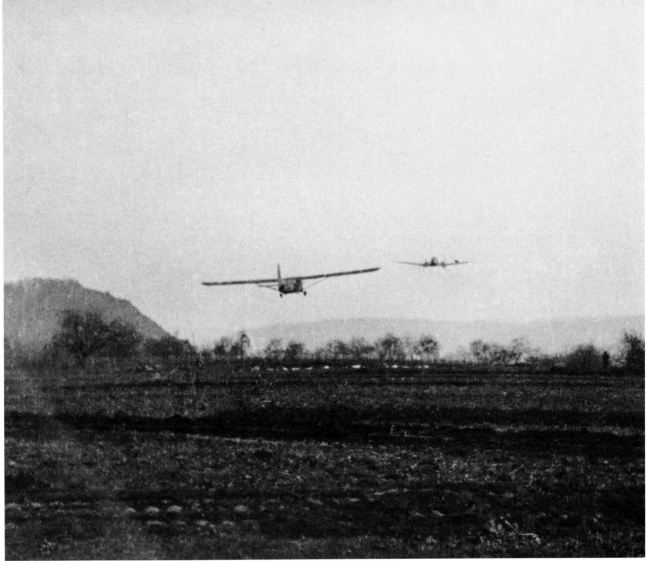

(*Left*) Hold your breath—the C-47 is swooping in to snatch that loop of nylon rope, a tricky job at 130 miles per hour. But he does it and the surprising part is that people in the glider feel only a sensation like that of a car starting with a fast pickup speed. Of course the rope had some elasticity, but the real reason for the non-jerk takeoff is a special cushioning mechanism in the C-47.

Near Unkel, Ger—22 March '45

(*Above*) They're off, C-47 with Cargo Glider in tow. In a few minutes the patients will be arriving at the Evac Hosp.

Near Unkel, Ger—22 March '45

"Evac Hosp." means Evacuation Hospital.

3

CONTINUED FIGHTING

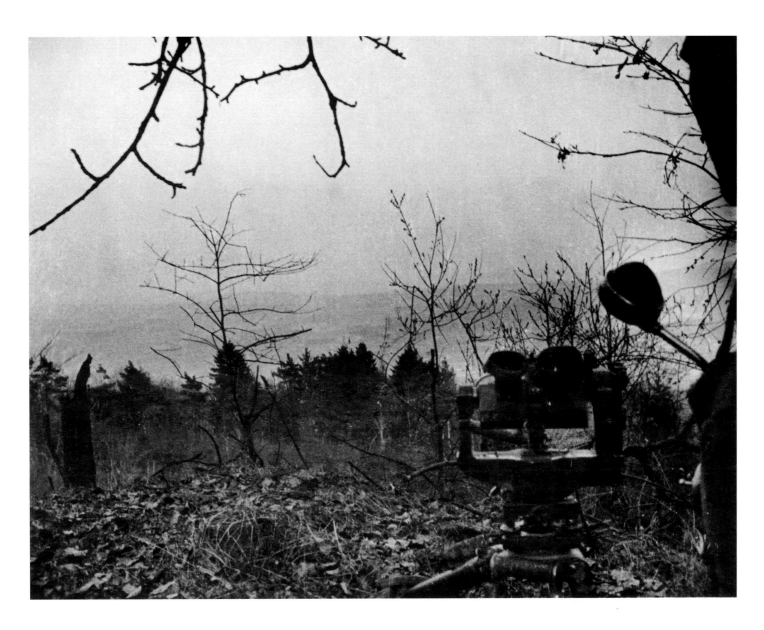

On the hill above Margarethenkreuz was this Forward Observation unit which was helping the Artillery direct its fire on the towns below. Particularly at night they would spot enemy guns by their muzzle blast and phone their locations to our own batteries. Here was my first birds-eye view of war, the so-called front lines being several miles distant. The fellow showed me what towns had been taken and what had not. Big puffs of smoke and dirt would occasionally jump up over the "had nots."

Near Königswinter—21 March '45

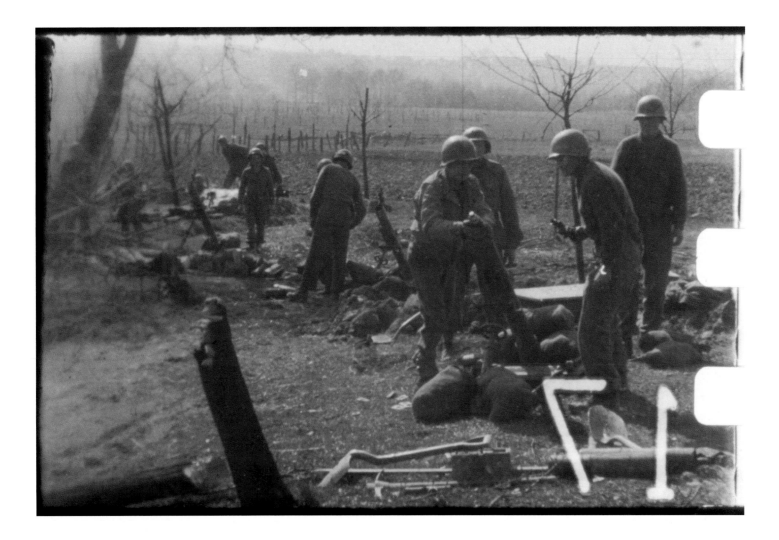

The 86th Chemical Mortar Battalion assigned to 1st Div. for close infantry support, here firing 4.2 in. mortars about 800 yds. from the front lines.

3 mi. from Oberpleis, Ger—23 March '45

Eymo 35 mm

This is a frame of a 35 mm motion picture I filmed with an Army Eymo camera. Each one-hundred-foot roll of 35 mm motion picture film we shot was flown to England for processing. Occasionally we got back a test strip, often with critical comments about how we photographers were doing. This is a frame from such a strip.

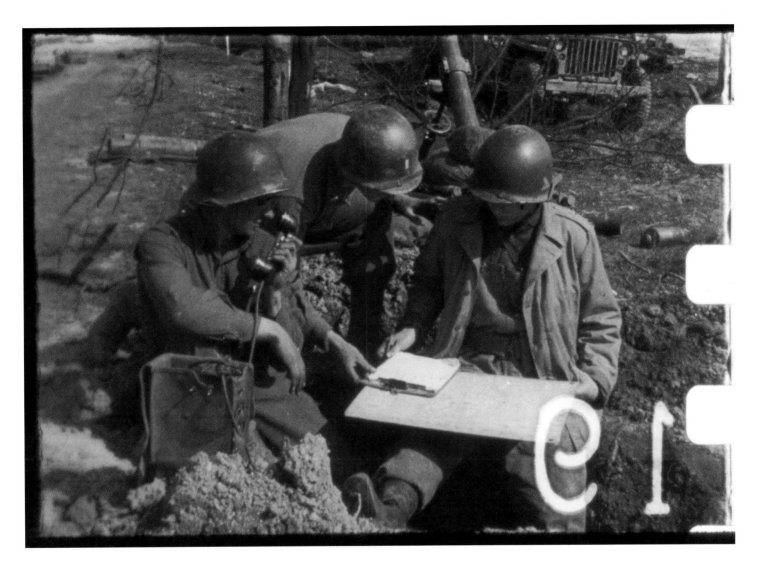

Field Command for the mortar Bn. The 4.2 Chem. Mortar was first introduced in Sicily. It's the only rifle-barreled mortar, giving it pinpoint accuracy.

3 mi. from Oberpleis, Ger—23 March '45

Eymo 35 mm
See preceding note.

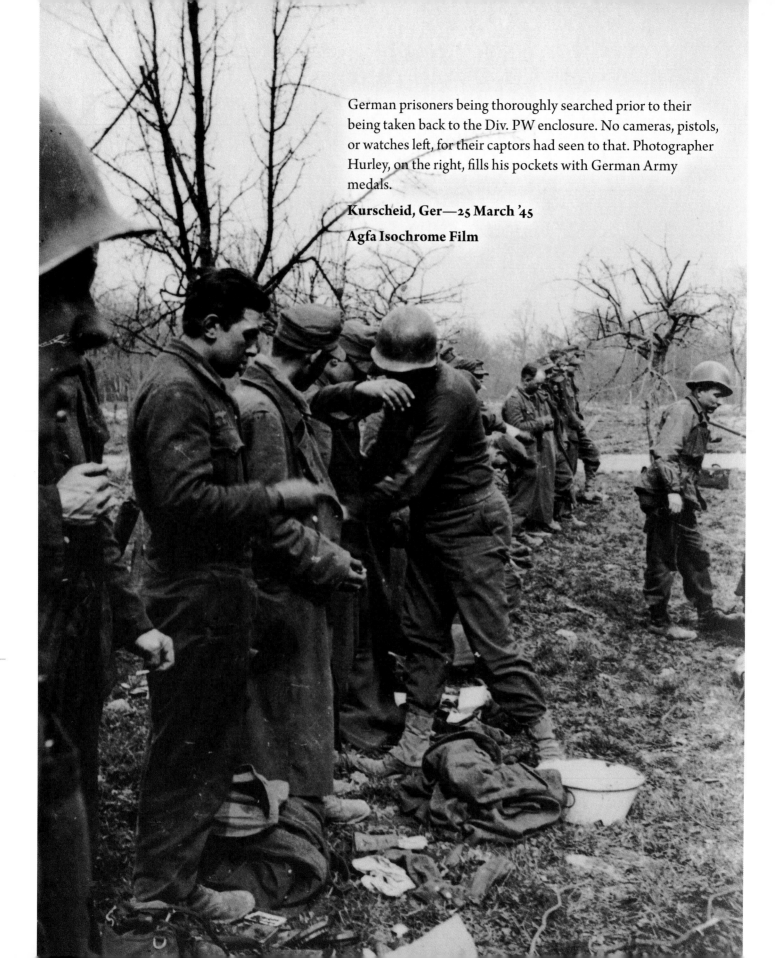

German prisoners being thoroughly searched prior to their being taken back to the Div. PW enclosure. No cameras, pistols, or watches left, for their captors had seen to that. Photographer Hurley, on the right, fills his pockets with German Army medals.

Kurscheid, Ger—25 March '45

Agfa Isochrome Film

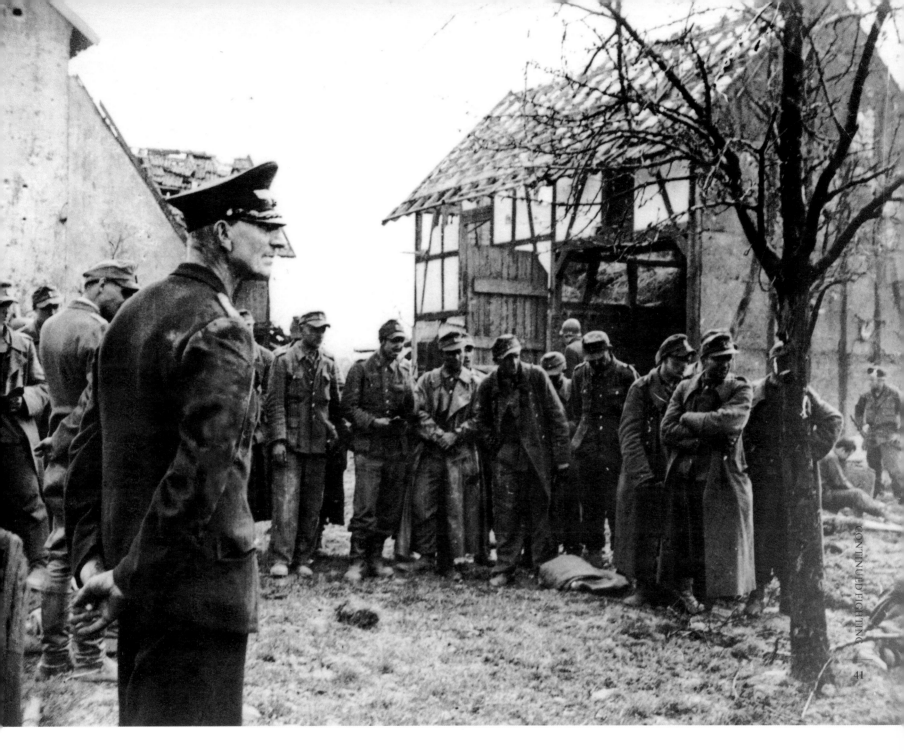

Lineup of PWs, not much concerned or disappointed about their capture. The important looking joker on the left turned out to be only a minor railroad official. That I discovered after I'd carefully maneuvered to feature him in the pic. He's not even in the army, let alone being an officer. What a uniform-loving people.

Kurscheid, Ger—25 March '45

PWs are prisoners of war, and "pic" refers to picture.

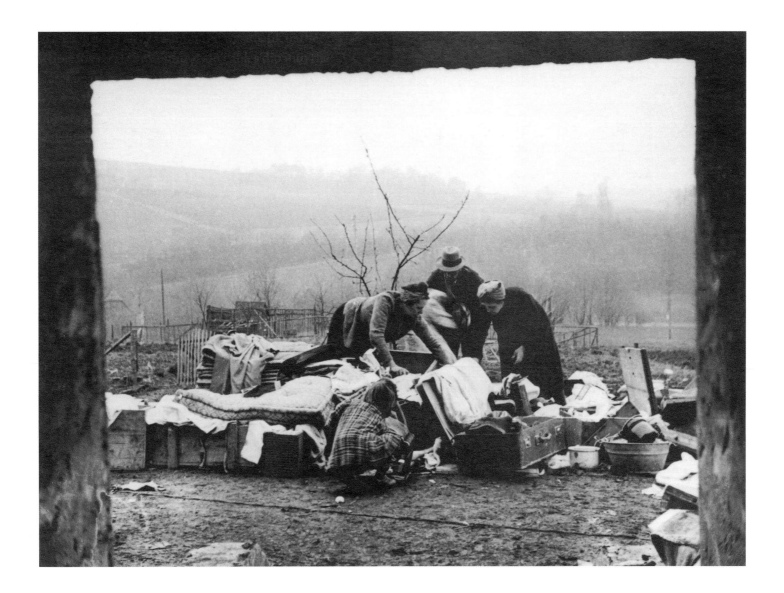

Looking out "our" doorway at the family gathering up their belongings. Their goods got what was probably its third going over at our hands, and one fellow stocked up with marketable items for his Paris trip. Only Nazi Party members could have owned such riches, and they were probably loot from some German-conquered country. Huge silver platters, beautiful table spreads and other finery were left.

In order to sleep one night in that basement we had cleared out everything that had been looted and left by the first comers. Anything locked always got opened one way or another.

I sit behind the camera lounging in an overstuffed chair just watching and wishing I could read the thoughts that were burning in their minds. Mixed emotions were mine.

Obereip, Ger—27 March '45

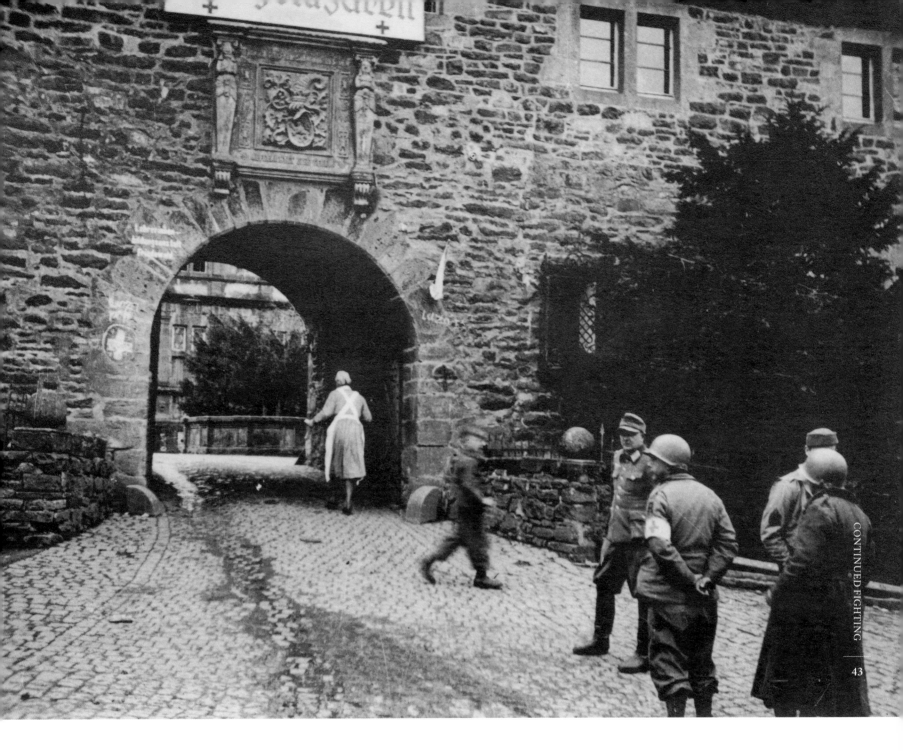

Kriegslazarett or war hospital in an old castle built by the Emperor Ludwig der Bayern in 1324.

This German hospital overrun by US troops a day or so previous will continue to be operated by German medics, doctors & nurses. There are 160 enemy wounded here, all cases that could not be moved. One US Clearing Co. is in charge of supervising this and two other such hospitals.

Friedenwald, Ger—29 March '45

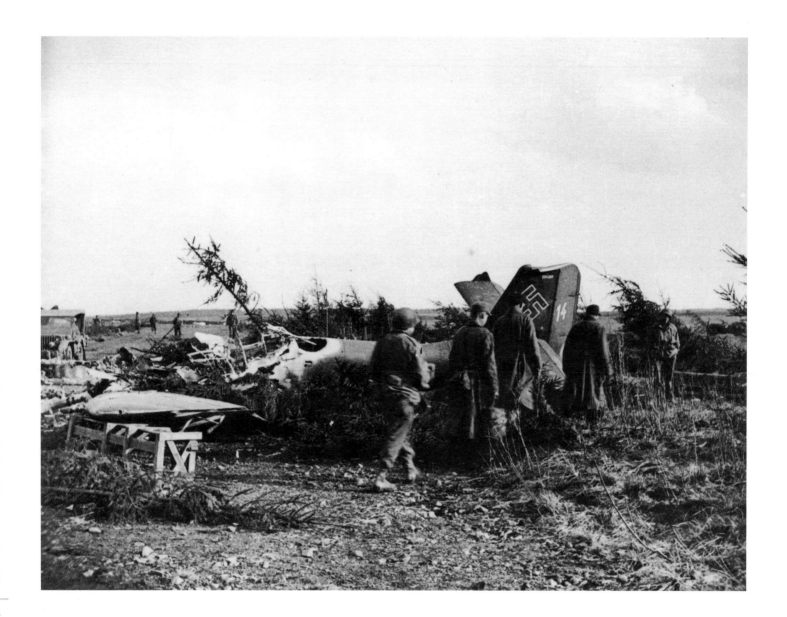

After spending a whole afternoon filming a story on a captured enemy airfield I get a bit of a surprise when this GI proudly brings in three prisoners he'd flushed out from the far edge of the field. Seeing quite a number of US troops around, they'd cooled off a lot. Though left to guard the field, they showed no fight.

Between Newkirch and Burbach, Ger—30 March '45

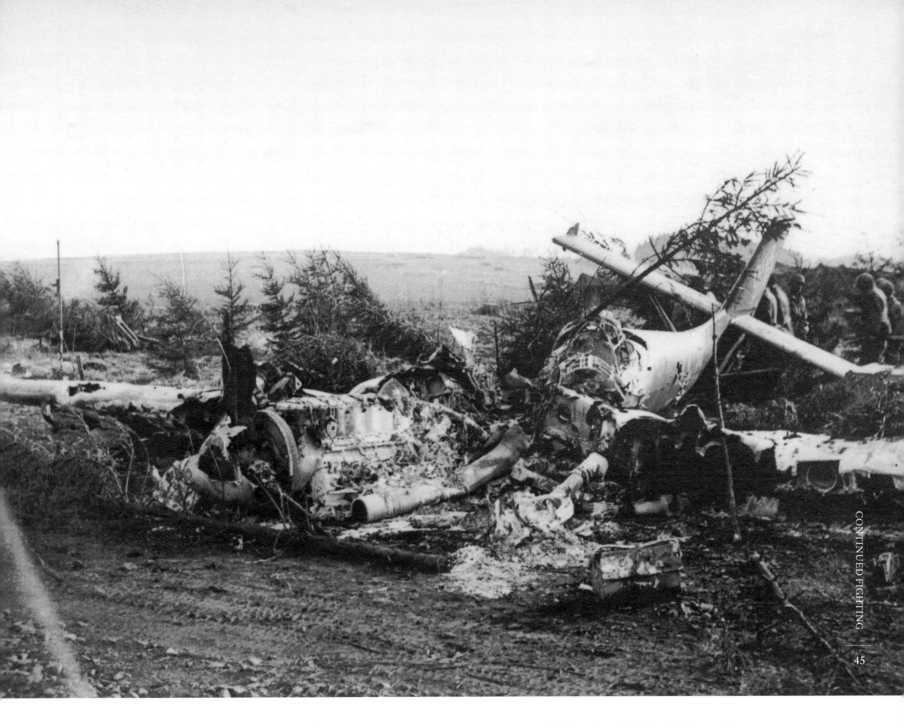

A Stuka Dive Bomber, JU-87, wrecked along with 30 others by the Germans before they left ahead of US columns. Lacking gas to fly the planes out, they had set demolition charges in each. Spare fuel cans and stakes were planted all over the field in an effort to impair use by us. Our artillery later set up on the field and discovered a 500 lb bomb half buried and wired as a booby trap.

Between Newkirch and Burback, Ger—30 March '45

4

ON LEAVE IN PARIS
FOR TRAINING

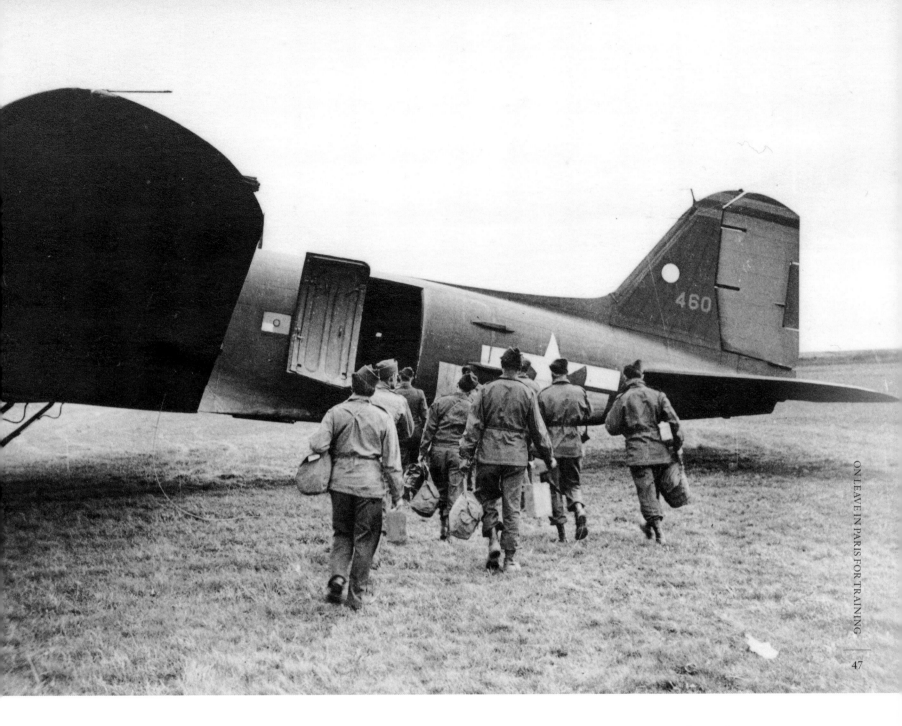

The trusty C-47 that took us safely to Paris for a week of "schooling" by the Army. Two mornings and one afternoon were spent screening some of our own movie footage and getting a critique of it—both technical & how well it told the story (gave coherent information).

However, some of us who carried bags bulging with cartons of cigarettes, dozens of chocolate bars, and beaucoup soap had other priorities.

Euskirchen, Ger—1 April '45

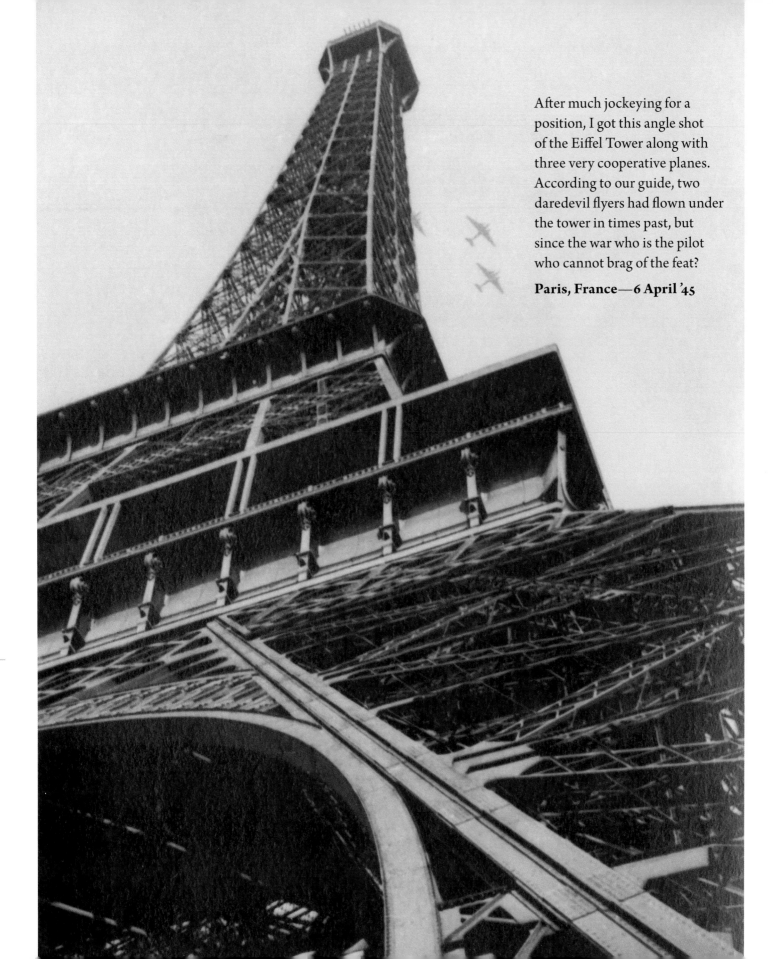

After much jockeying for a position, I got this angle shot of the Eiffel Tower along with three very cooperative planes. According to our guide, two daredevil flyers had flown under the tower in times past, but since the war who is the pilot who cannot brag of the feat?

Paris, France—6 April '45

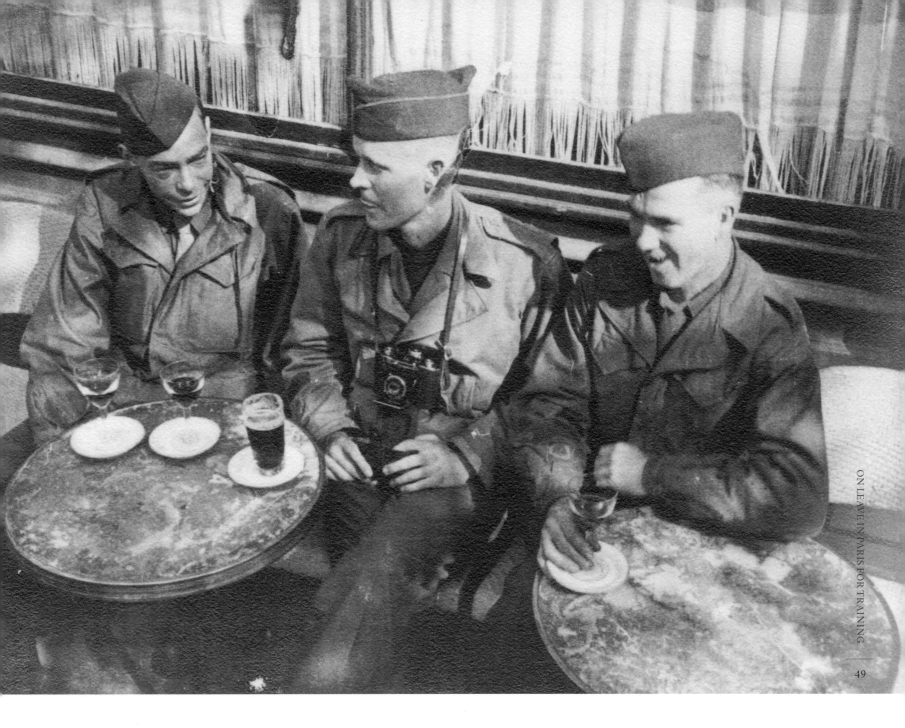

GIs Evans, Rosborough, and Randolph pause from their sight-seeing and snap-shooting for a glass of wine, vin rouge.

Paris, France—6 April '45

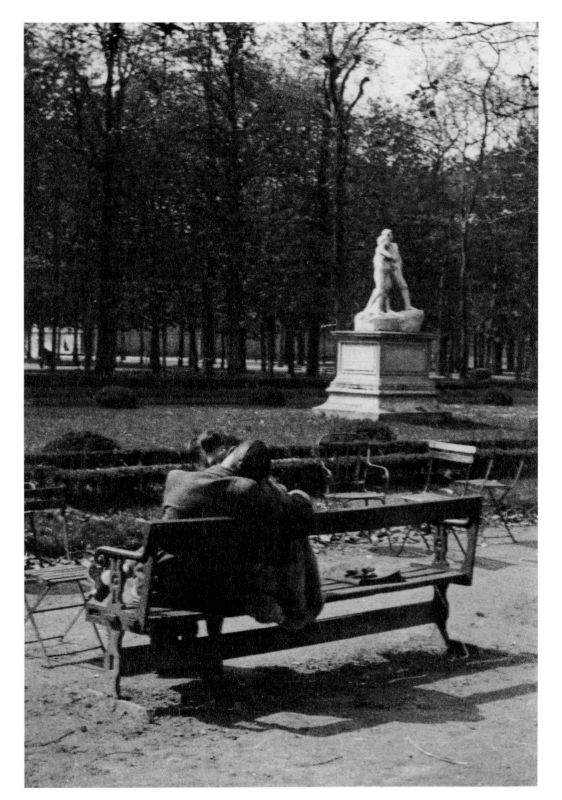

(*This page*) A sculptor's idea of love adds atmosphere to the real thing. Yes, they knew I was taking their picture, afterward. No, they didn't throw anything or seem to care at all. Americans do the darnedest things.

Paris, France—6 April '45

(*Facing*) Randy and I pose for a Warrant O who happened by and offered to help us out. This lifelike statue of Joan of Arc is beautifully done in gilded bronze. The Nazis left her, though other statues of France's great were taken for metal—only the bases remaining now.

Paris, France—6 April '45

"Warrant O" refers to Warrant Officer.

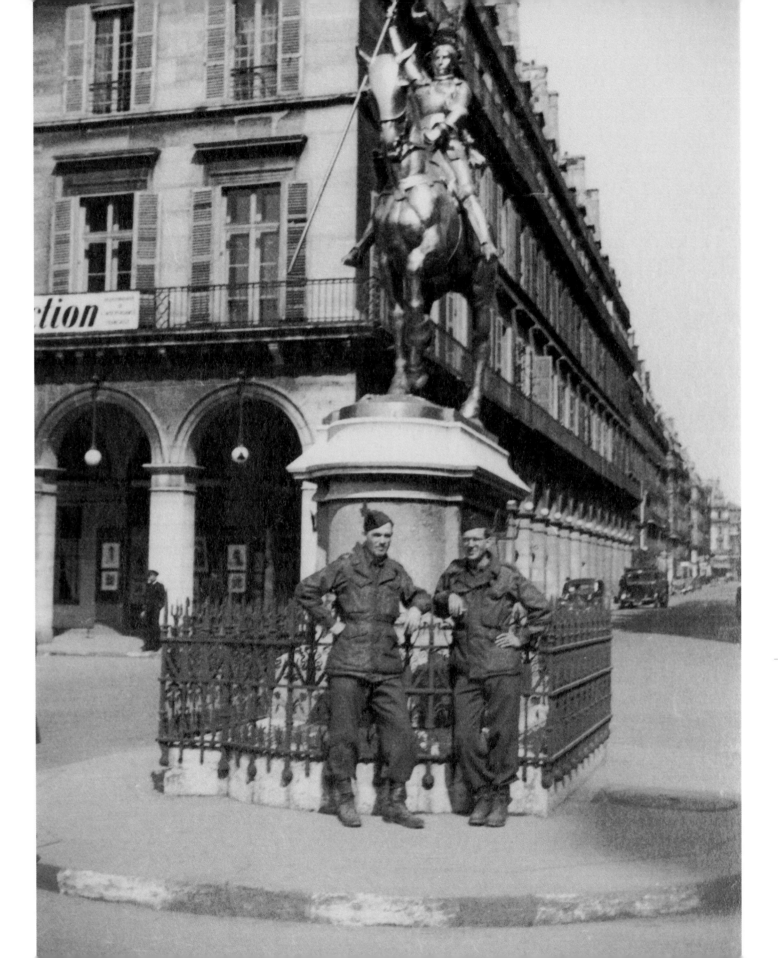

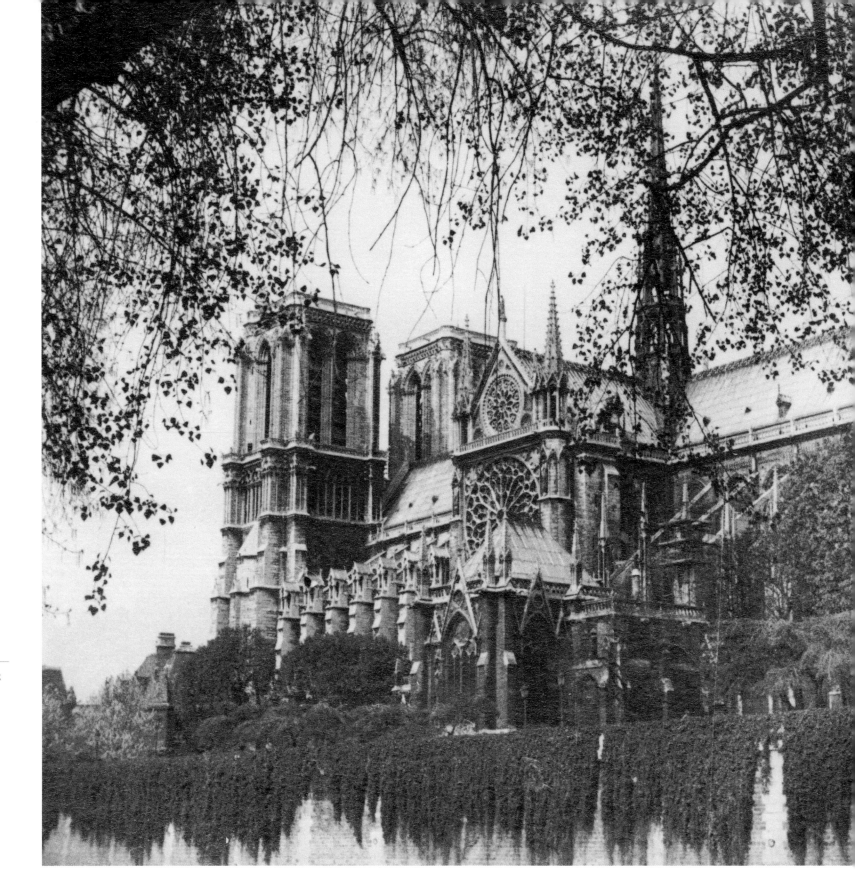

Notre Dame by the Seine River. The Cathedral's famous stained-glass windows were removed and replaced with plain glass as a precaution against bombing.

Paris, France—6 April '45

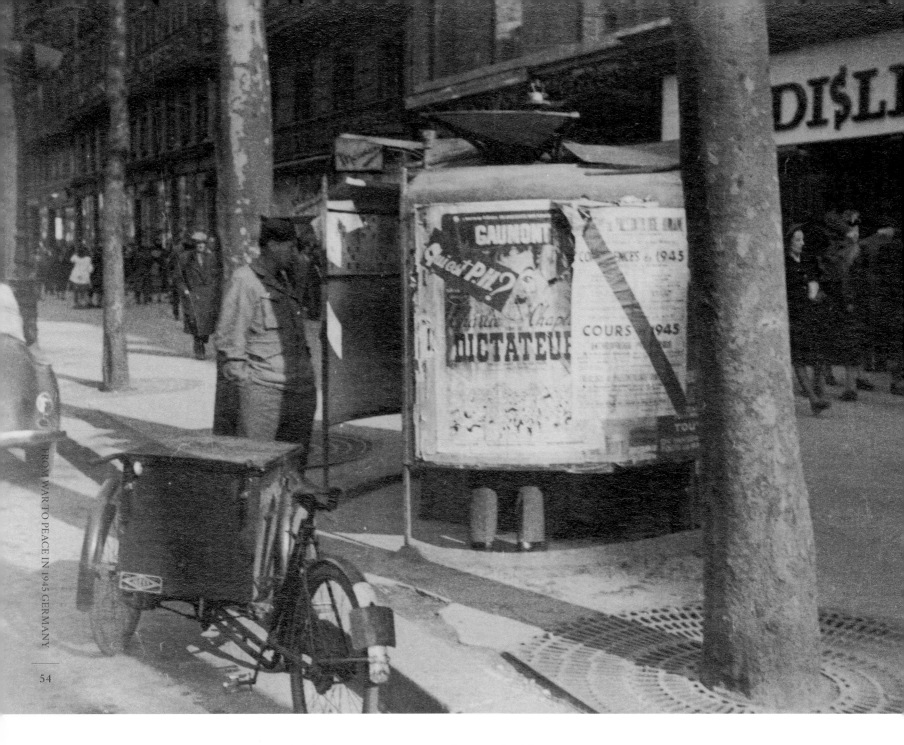

Charlie Chaplin's "Dictateur" is a bit slow getting overseas to the French, I'd say.

GI waits his turn.

Paris, France—7 April '45

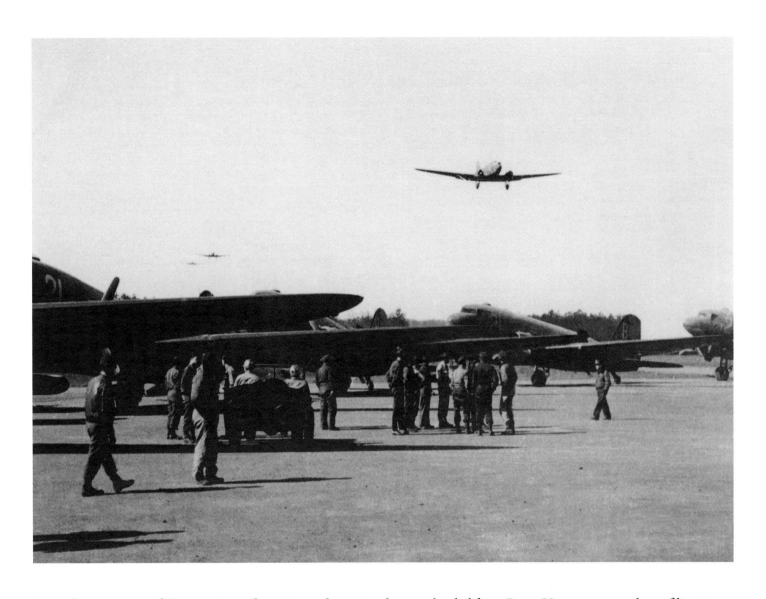

A steady procession of C-47s going and coming at this strip where we landed from Paris. Here you see 3 planes filing in to land while a lineup of several more wait their turn to take off. Another part of the parade was that of the ambulances from the evacuation hospital to the field, unloading the wounded into the planes, and then going back for more.

Near Giessen, Ger—8 April '45

5

ADVANCE THROUGH
THE HARTZ MOUNTAINS

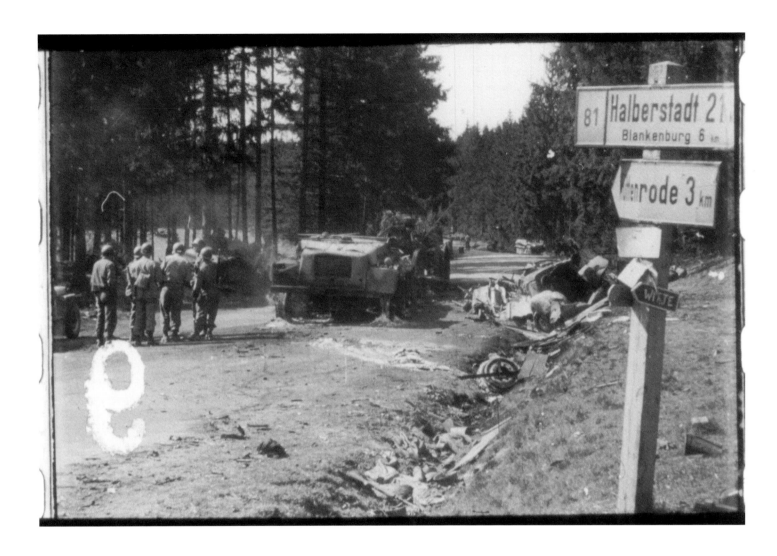

Removing road block of wrecked vehicles, ours & theirs.

Between Dorste & Osterode, Ger—12 April '45

Eymo 35 mm

This is another frame of a 35 mm motion picture I filmed with an Army Eymo camera. It's from a test strip I received back after processing.

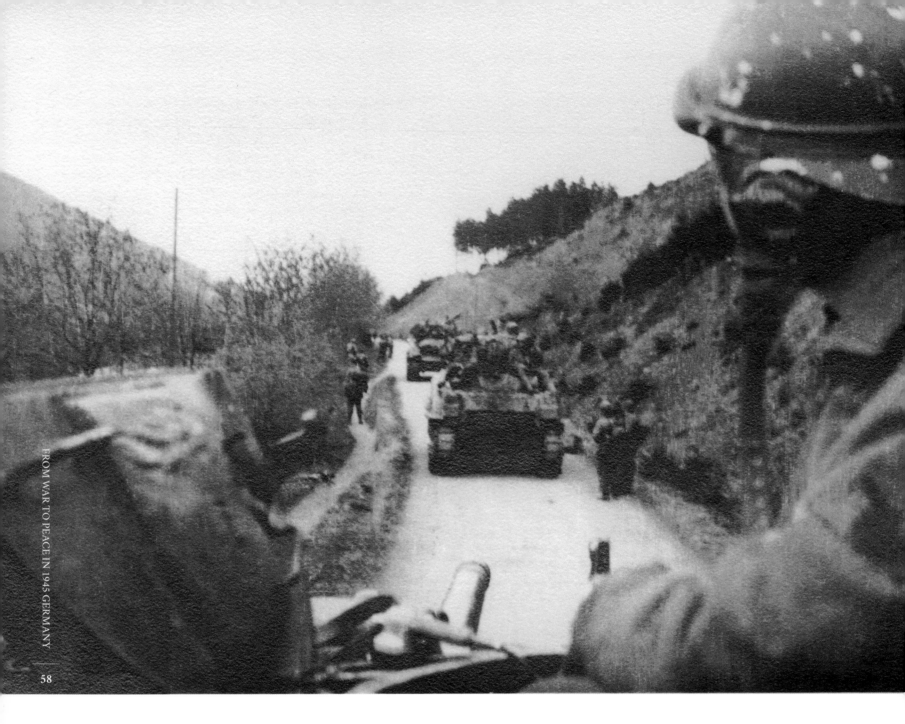

Infantry and Armor move cautiously to clear road running by a lake in the Hartz Mts. Doughs smashing through the brush on either side flushed out several prisoners, and the captain leading the column on foot picked off a German on a motorbike with his pistol. That's about all that happened till about 4 PM they approached a town. As we left them to get our film turned in the heavy weapons section was setting up to cover a platoon going in, tanks being in reserve. Most doughs were busy sleeping in the town next morning when we returned. Infantry were of the 18th Regt of 1st Div. Tankers were of the 745 Tank Bn.

Near Osterode, Ger—14 April '45

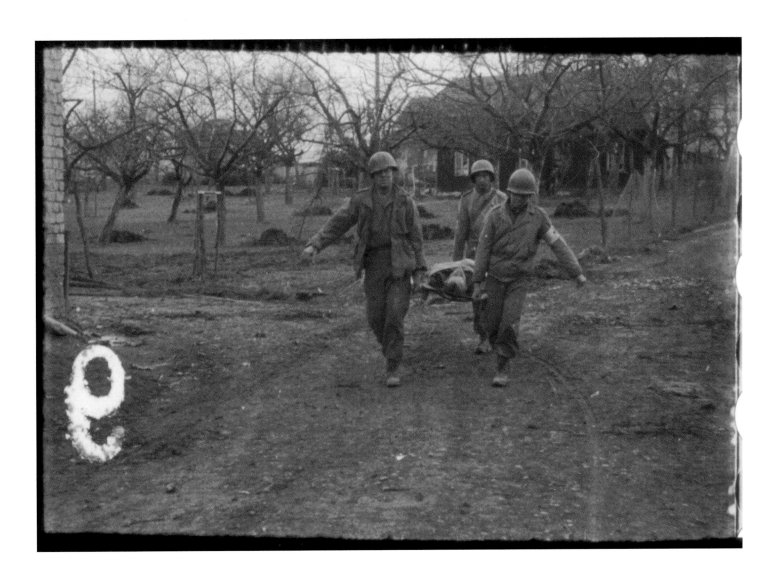

GIs carrying wounded buddy on stretcher.

Near Osterode, Ger—13 April '45

Eymo 25 mm

Another photo from a frame of a 35 mm motion picture.

The familiar wooden wagon, this time moving household belongings. The people's home was either shelled or "requisitioned" for a CP or billet. So they move in with the neighbors.

St. Andreasburg, Ger—17 April '45

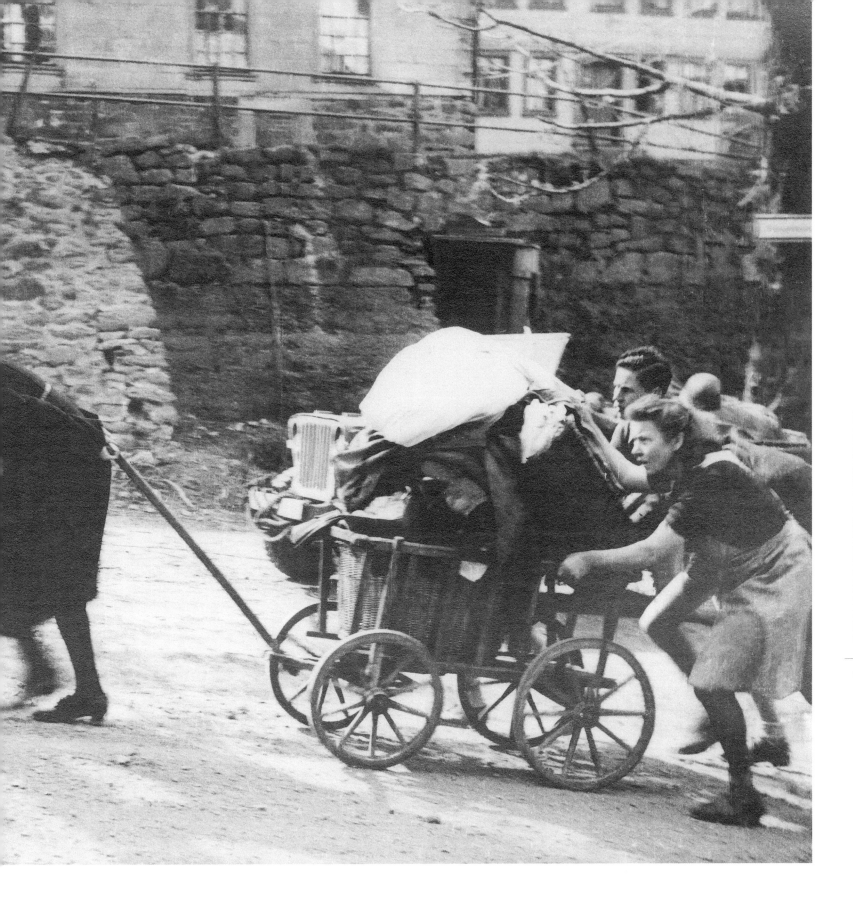

A 155 Long Tom lets one go, startling my camera trigger finger at about the right moment—seems to have startled me all over in fact. Our mess was very unhappily located about a hundred feet up to the left, and meals would always coincide with a fire mission. At each blast a couple more tiles from the kitchen roof would drop off among us as we squatted on our helmets downing the hash. But when we tried to get pics of the muzzle blasts one night no fire missions came through. It had been done a lot before, but we were going to try and get it in color.

St. Andreasburg, Ger—17 April '45

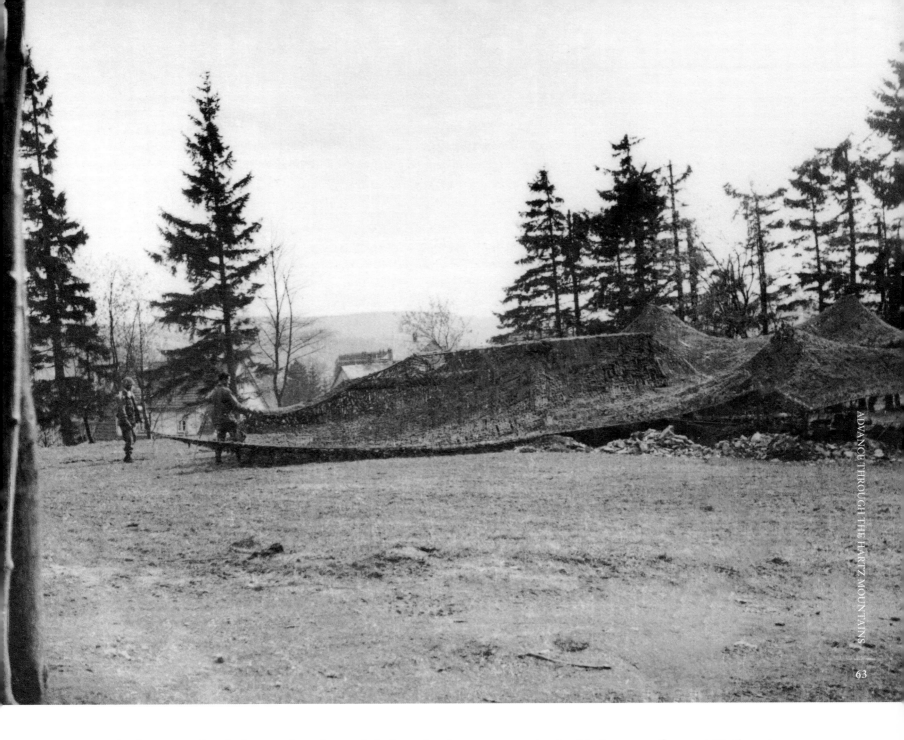

The firing completed, the crew have lowered the barrel and now are covering it with the camouflage net. To the extreme right under the net are foxholes enough for each of the on-duty crew. Those off duty have a dugout farther back, but were sleeping in nearby houses instead.

St. Andreasburg, Ger—17 April '45

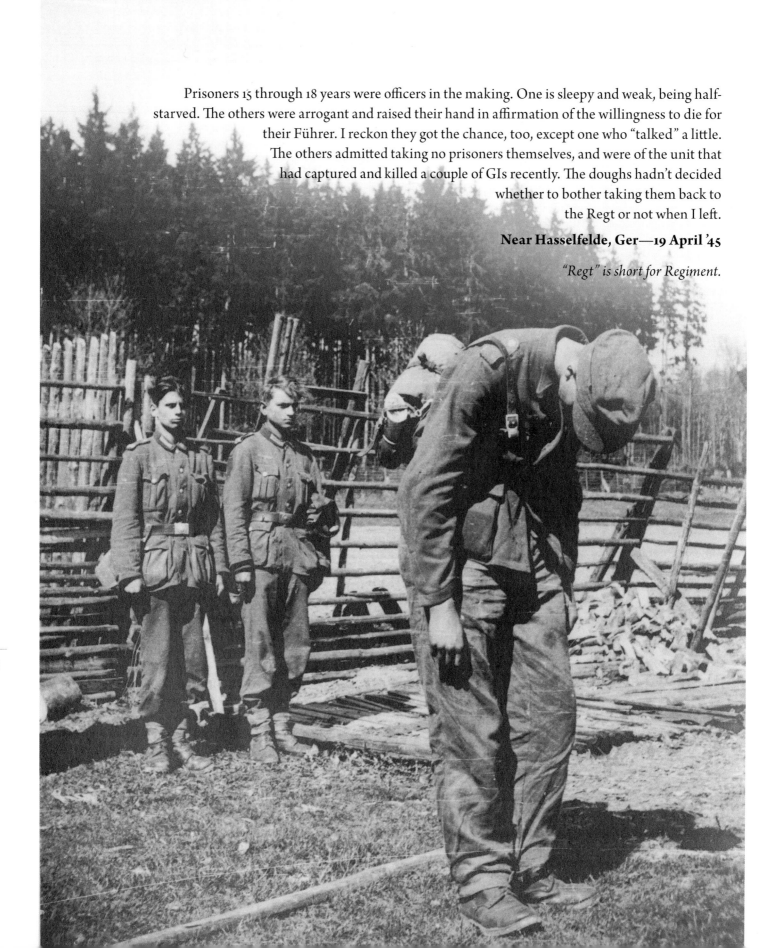

Prisoners 15 through 18 years were officers in the making. One is sleepy and weak, being half-starved. The others were arrogant and raised their hand in affirmation of the willingness to die for their Führer. I reckon they got the chance, too, except one who "talked" a little. The others admitted taking no prisoners themselves, and were of the unit that had captured and killed a couple of GIs recently. The doughs hadn't decided whether to bother taking them back to the Regt or not when I left.

Near Hasselfelde, Ger—19 April '45

"Regt" is short for Regiment.

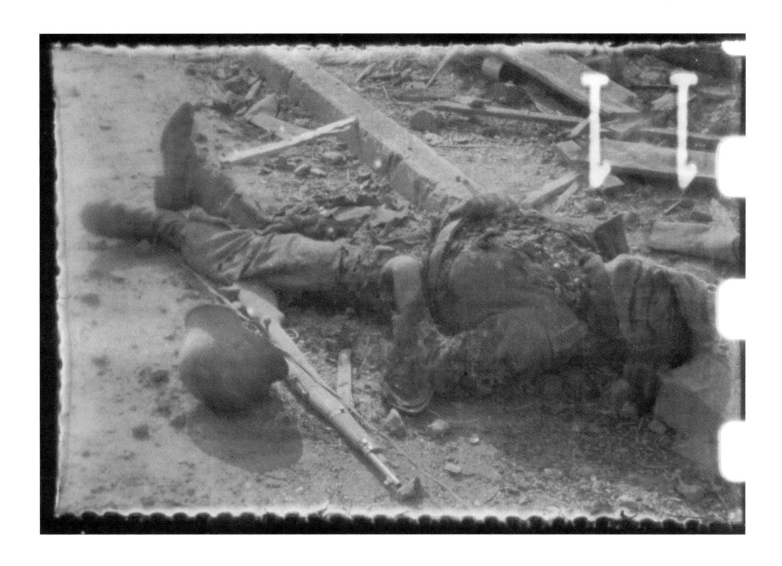

Dead German soldier with his rifle. Not one of those in previous photo.

Near Wienrode, Ger—20 April '45

Eymo 35 mm

Another photo from a frame of a 35 mm motion picture.

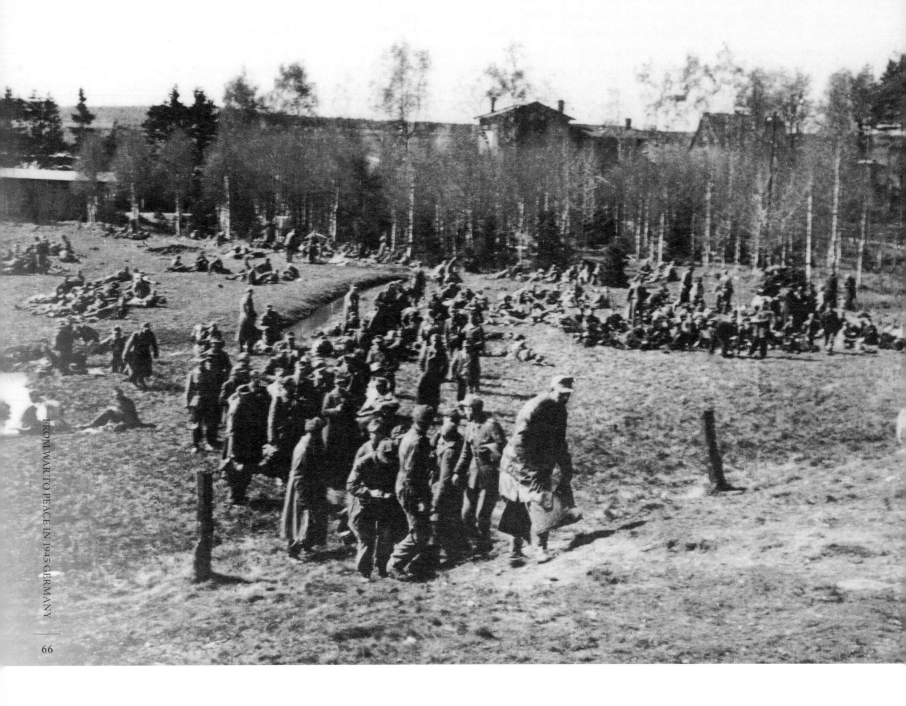

Prisoners of the 18 Regt waiting to be trucked back to the Div PW Enclosure. This was the morning of Hitler's Birthday, and 1st Inf Div was completing its clearing of the Hartz Mts. In the afternoon I shot movies of 2,600 more prisoners taken by the same Regt and guarded by a handful of GIs on horses. When added to the score of the 16th and 26th Regts it made a Division record.

Near Hasselfelde, Ger—20 April '45

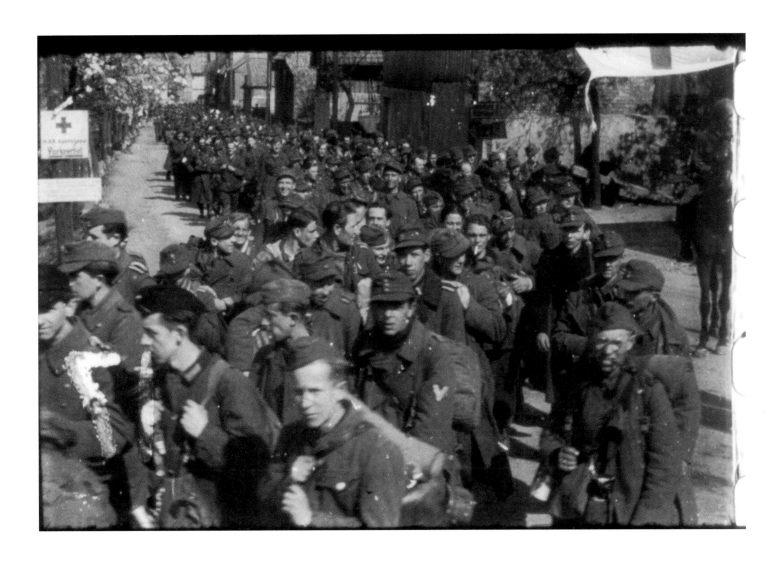

Huge procession of German prisoners.

Near Hasselfelde, Ger—20 April '45

Eymo 35 mm

Another photo from a frame of a 35 mm motion picture.

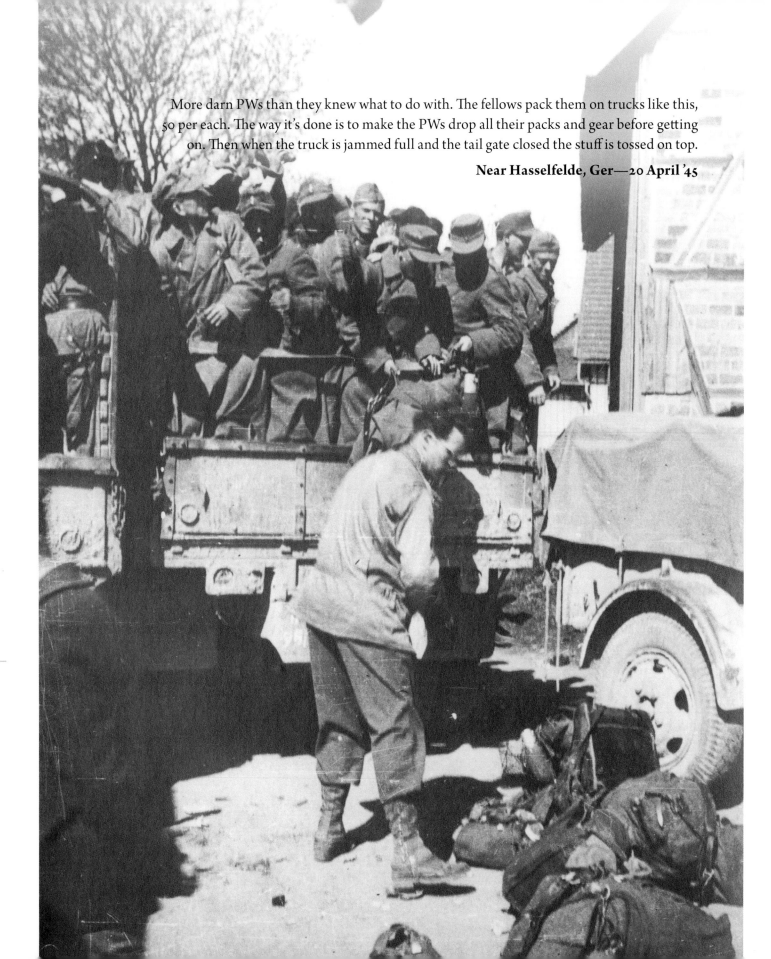

More darn PWs than they knew what to do with. The fellows pack them on trucks like this, 50 per each. The way it's done is to make the PWs drop all their packs and gear before getting on. Then when the truck is jammed full and the tail gate closed the stuff is tossed on top.

Near Hasselfelde, Ger—20 April '45

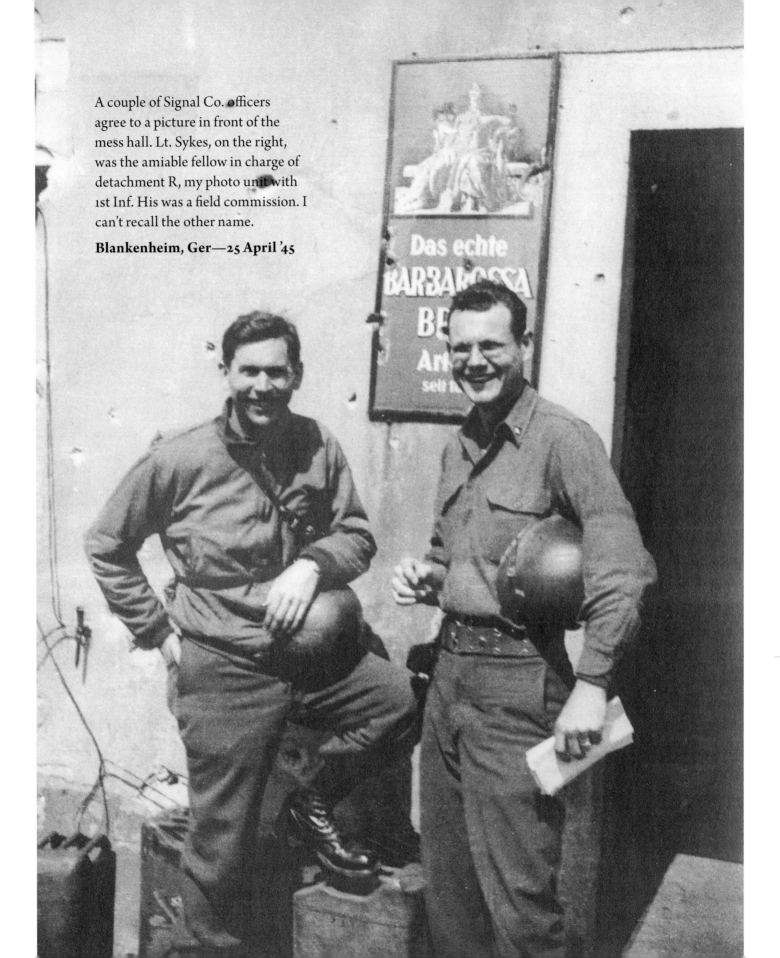

A couple of Signal Co. officers agree to a picture in front of the mess hall. Lt. Sykes, on the right, was the amiable fellow in charge of detachment R, my photo unit with 1st Inf. His was a field commission. I can't recall the other name.

Blankenheim, Ger—25 April '45

6

CIVILIANS DURING THE WAR

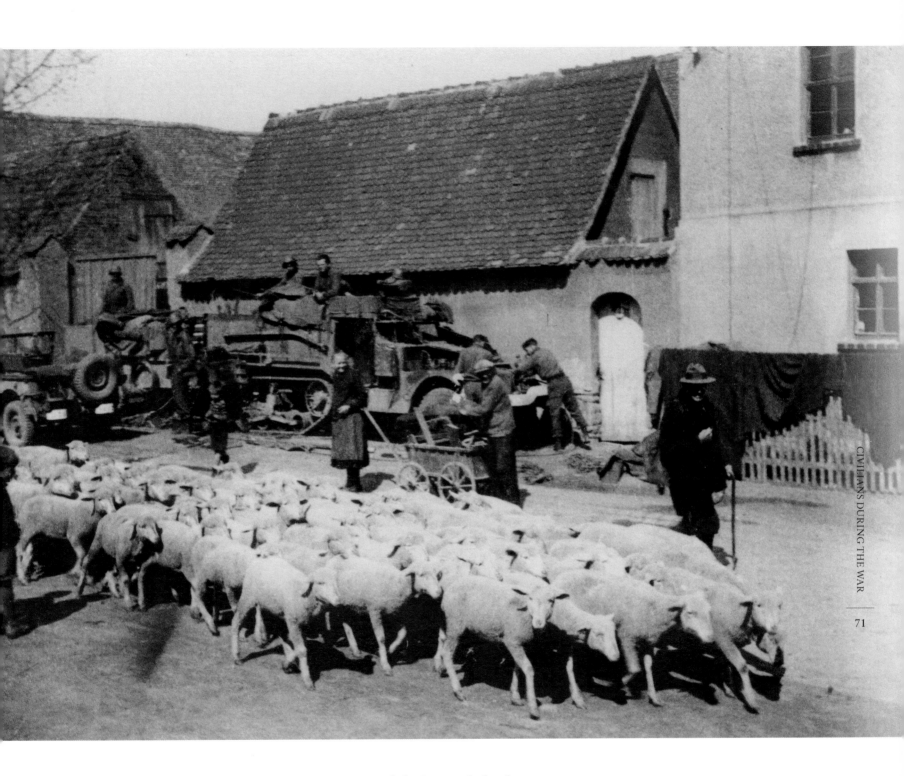

An old shepherd leads his sheep out to pasture while GIs watch the show.

Blankenheim, Ger—25 April '45

T/3 Jack Kitzero had a little after-dinner sport with a German youngster. She and a handful of others were eager to play and got a particular kick out of my helmet and liner. They scrambled for the chance to swing between our arms as we headed back to the billets.

Blankenheim, Ger—25 April '45

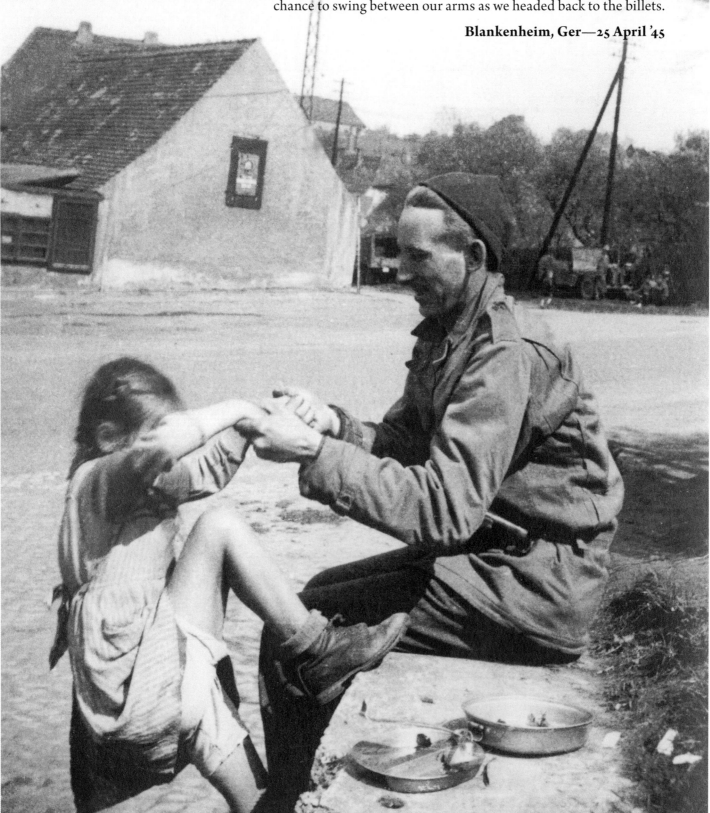

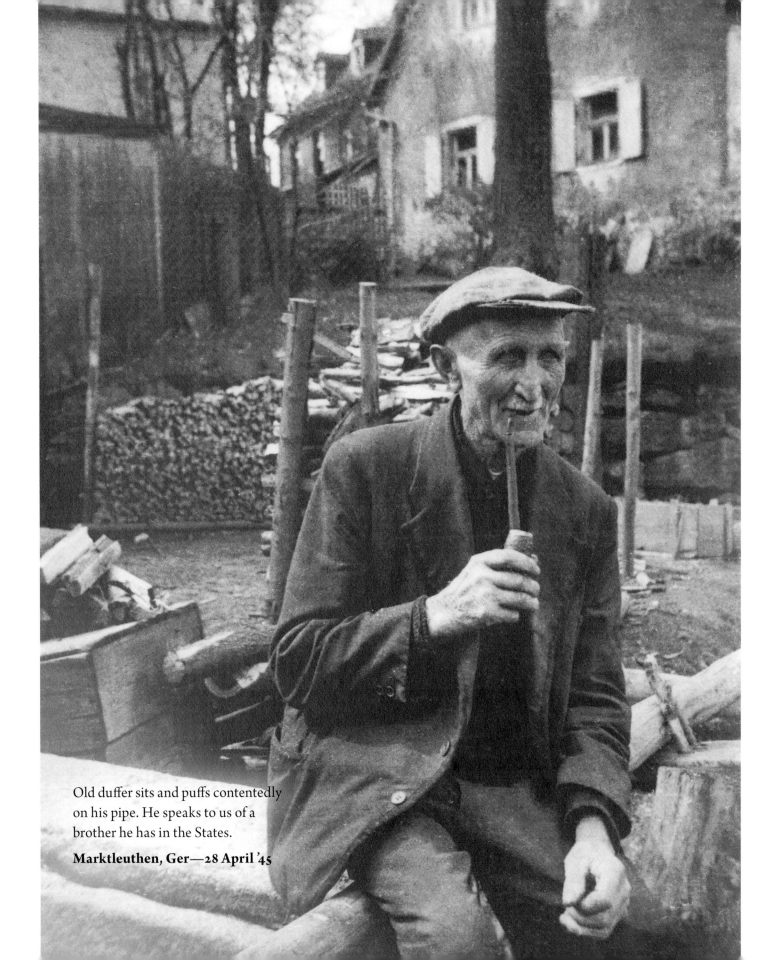

Old duffer sits and puffs contentedly on his pipe. He speaks to us of a brother he has in the States.

Marktleuthen, Ger—28 April '45

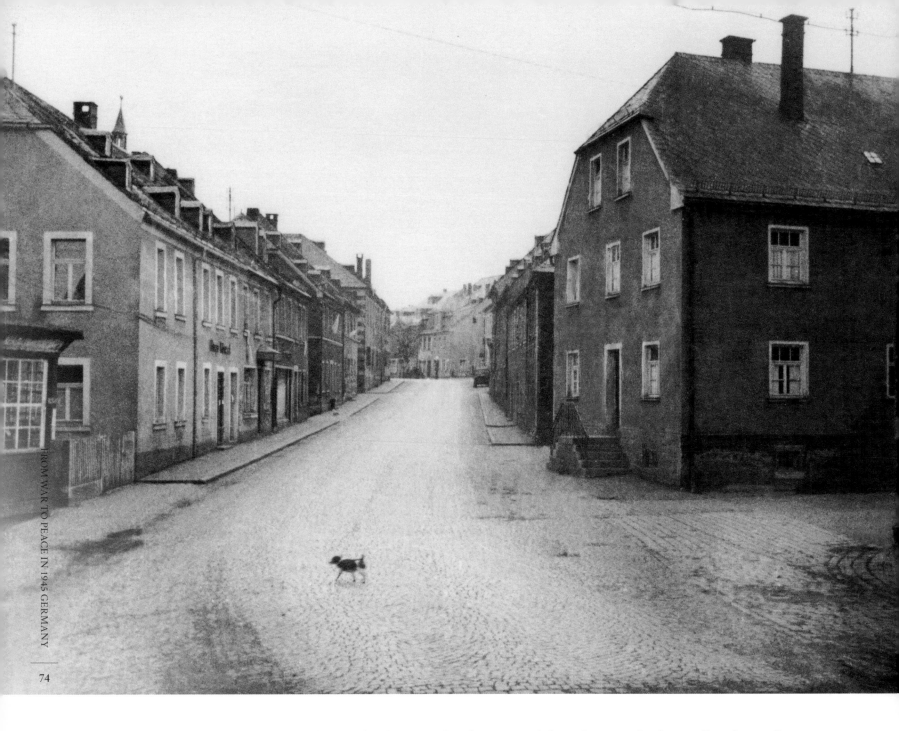

Main street of this city—its only straight stretch. It's 2:30 in the afternoon and the military curfew keeps all civilians off the street. A "Dog's Life" is not so bad in this case.

Marktleuthen, Ger—29 April '45

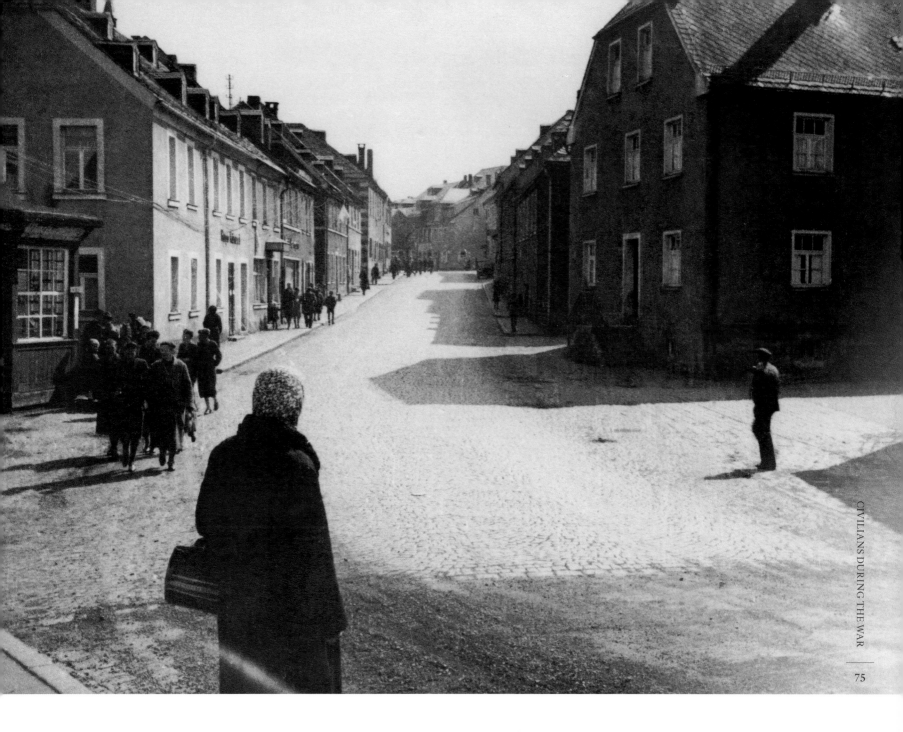

The street has quickly come alive now. Everybody's busy shopping and visiting while their time lasts. Curfew rules allow them onto the streets only from 8 to 9 in the morning and 4 to 5 in the afternoon.

Marktleuthen, Ger—29 April '45

7

RUSSIANS IN EAST GERMANY PART I— LINKUP AT THE ELBE RIVER

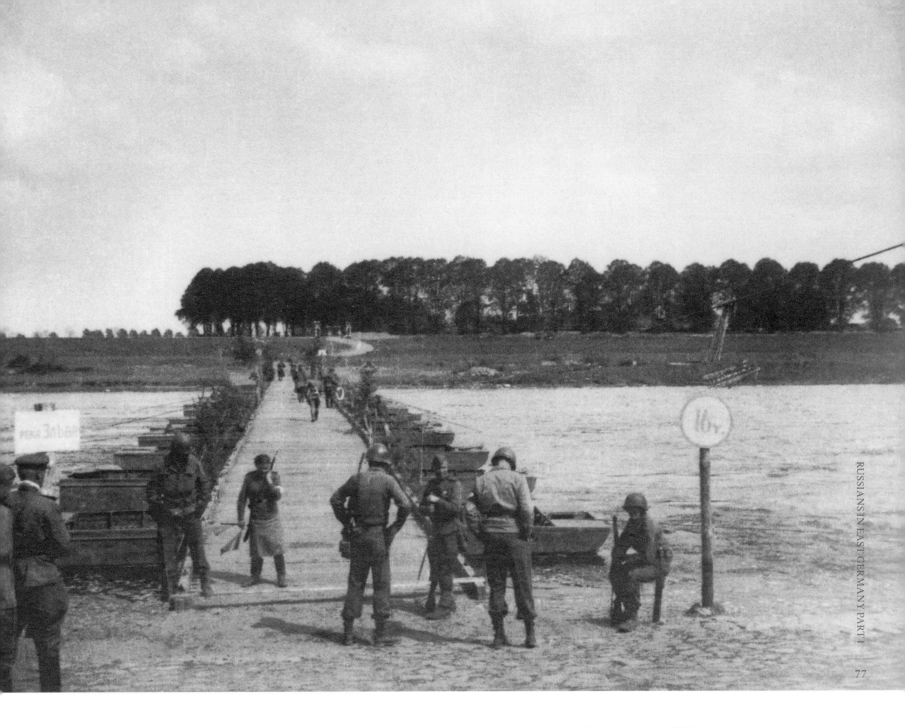

The scene of the historic linkup. A confab and party for the respective army generals, Russian and US, is going on in a building hidden by those trees across the Elbe, but after rushing 150 miles to get there Kitzero and I were not allowed to cross, being too late to go with the other newsmen who were all carefully counted by the Russians as they crossed over and later as they returned. Our "Eisenhower Passes" didn't cut much ice with the Russians. They, incidentally, had uninhibited access to our side.

Torgau, Ger—30 April '45

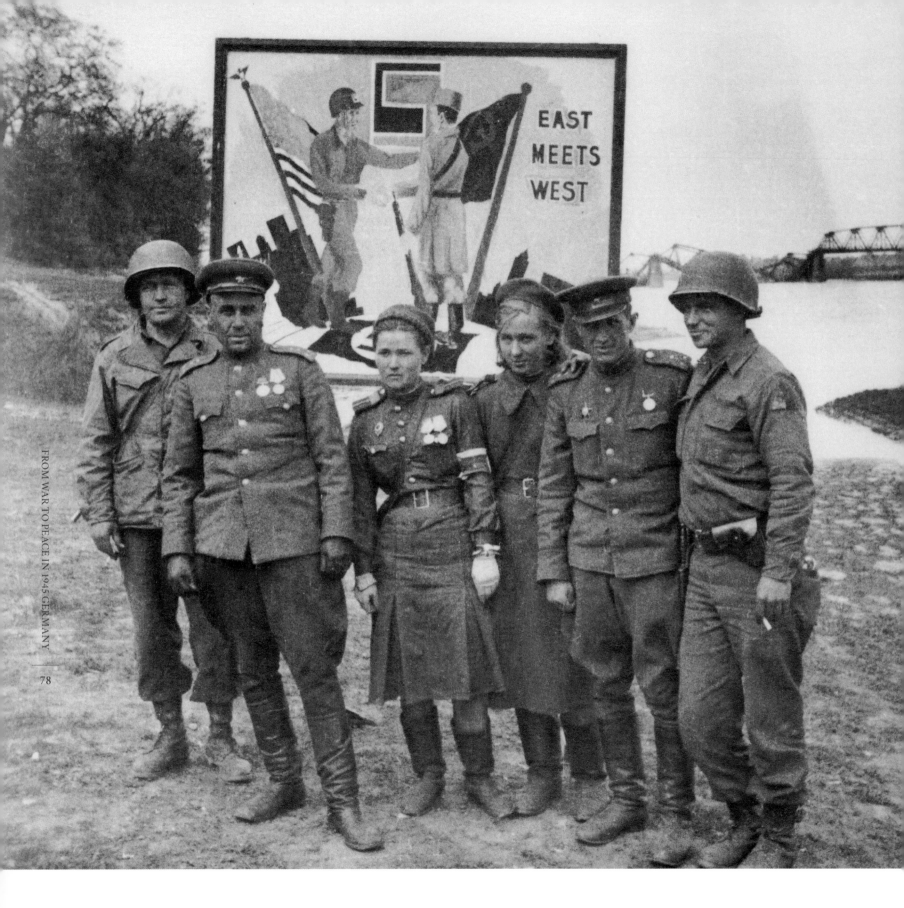

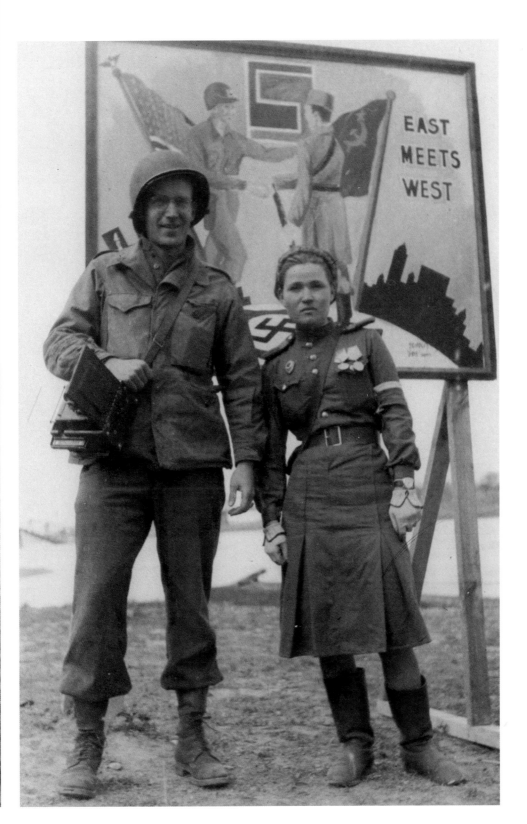

Kitzero took this pic of me. The Girl and the sign were the favorite props of all GI photo fans there. She'd been in the Red Army since Stalingrad, where all her folks were killed or captured. She is a sniper and is said to have liquidated 120 Germans. This was a personal fight to her and to most Red soldiers.

Torgau, Ger—30 April '45

(*Facing*) Four Russian soldiers pose with a couple of GIs in front of the 69th Inf Div's famous sign at the Elbe R. linkup point.

Torgau, Ger—30 April '45

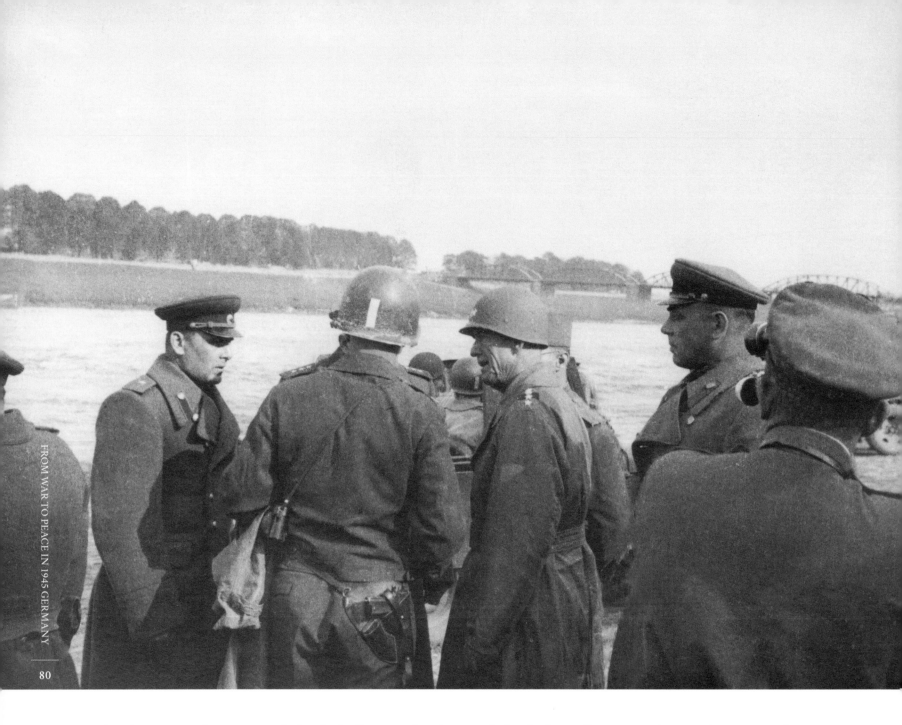

After the party on the Russian side finished, all returned to the US side for the farewells. Gen. Hodges, easily recognized (*in profile center*), represents the US 1st Army, and Gen. Zhadov, don't know which he is, represents the Russian 5th Army. In the usual Russian style every slight excuse called for a toast—usually the straight stuff and to be taken in one breath. The Americans just couldn't keep up.

Torgau, Ger—30 April '45

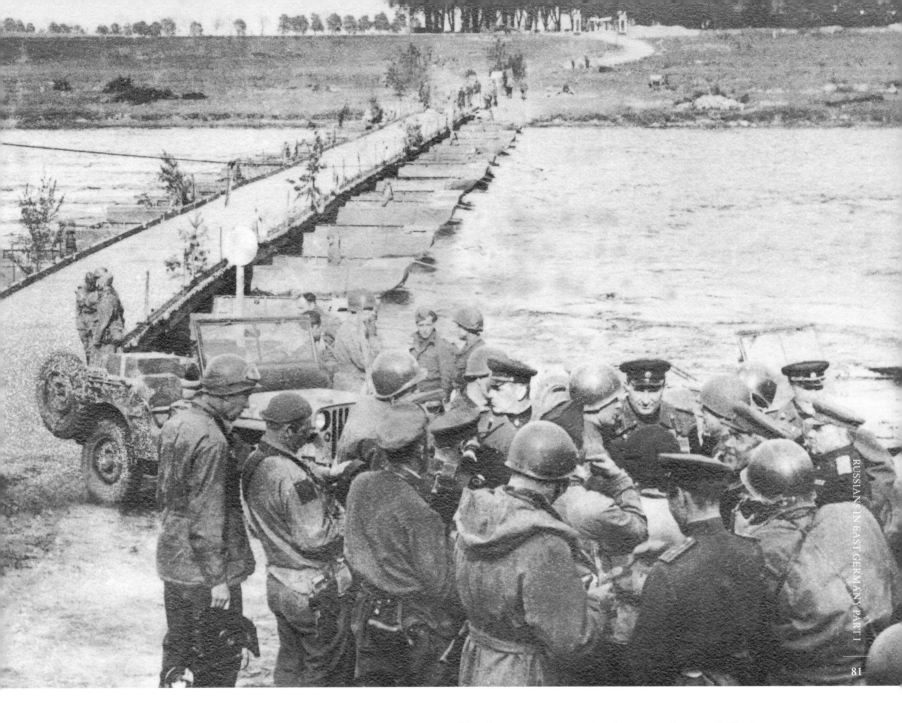

To get this pic I stood on the hood of a Lend-Lease Peep used by the Russian Gen. The driver was having difficulty getting it started, so I casually pulled the choke. That did it and I got in return a bear-hug that I'll never forget.

Torgau, Ger—30 April '45

8

RUSSIANS IN EAST GERMANY PART II— RUSSIANS OCCUPY THE LAND

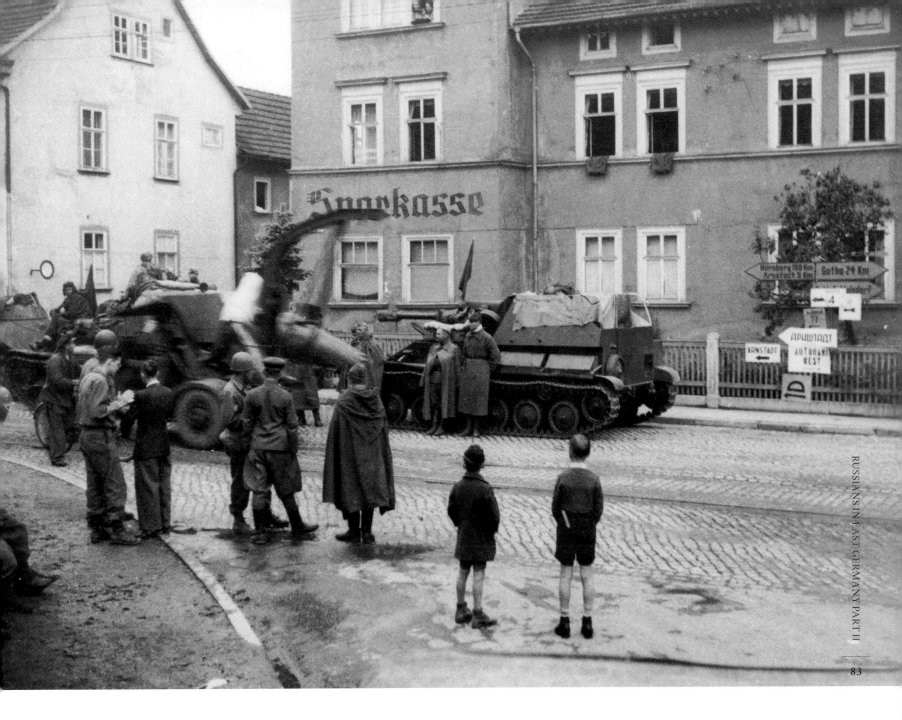

Some of the advance party of Russians stop to exchange a few German words with part of a small group of GIs left behind temporarily as security. The signpost holds German, American, and now Russian signs pointing to Arnstadt.

Ichterhausen, Ger—4 July '45

This Russian occupation took place about two months after the linkup.

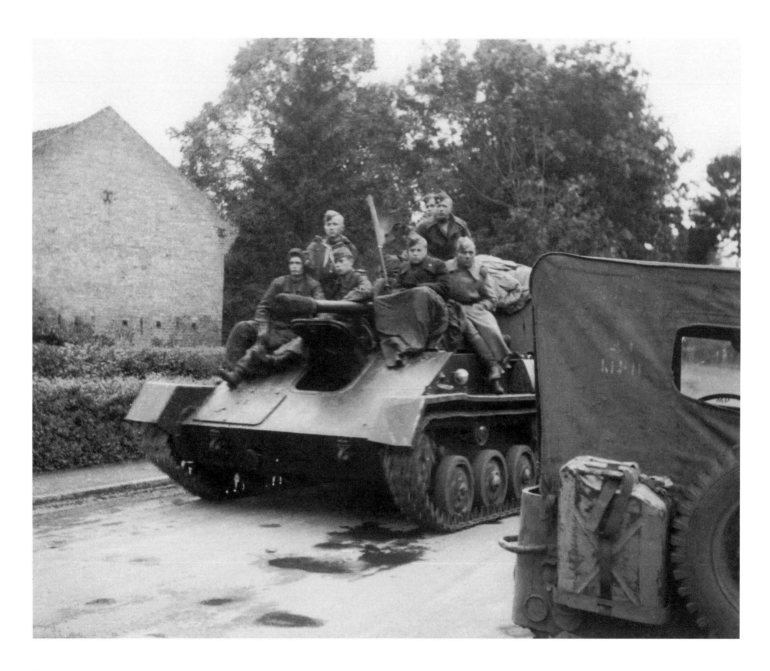

Russian tank rolls by our Peep.

Ichterhausen, Ger—4 July '45

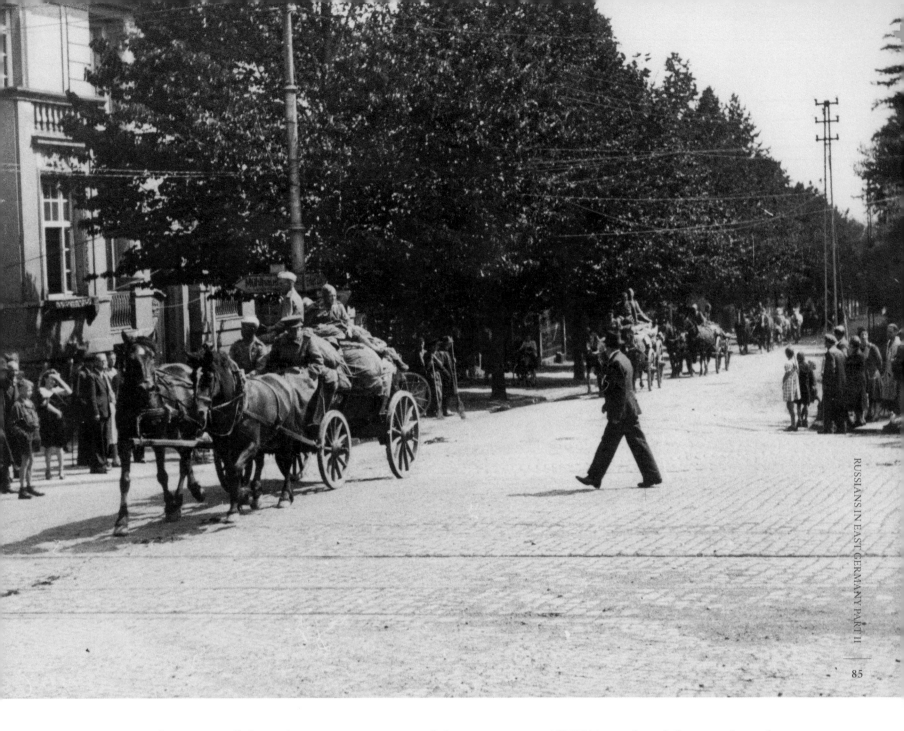

Wagon after wagon rolls by as the Russian occupation of Thuringia goes on. All US Troops have left except three photogs and a few Medics and hospital cases awaiting evacuation by C-47s that are several days overdue.

Gotha, Ger—5 July '45

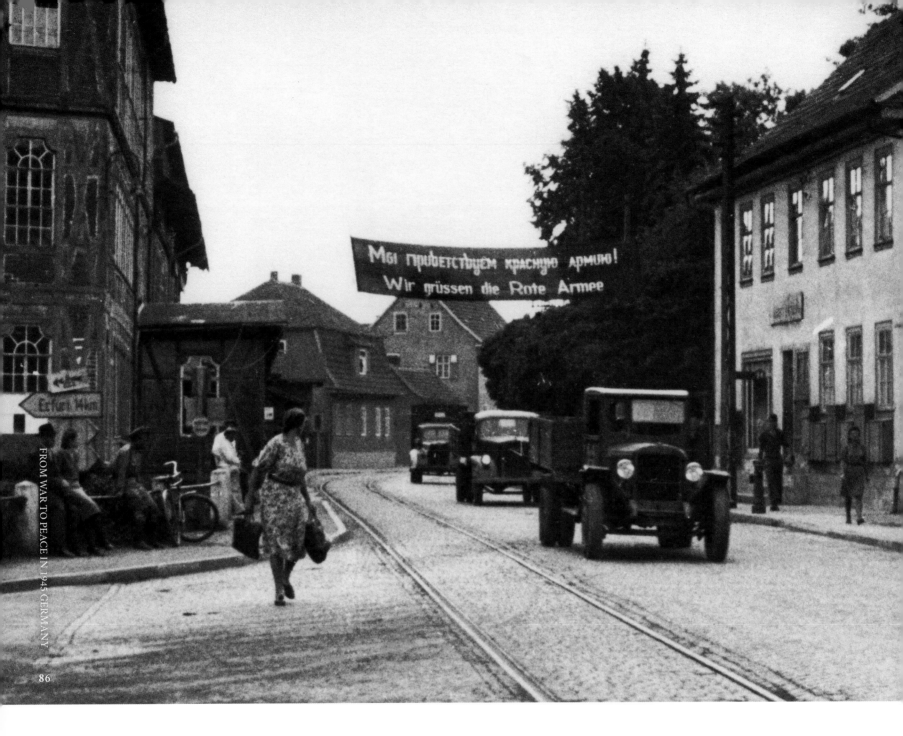

"We Greet the Red Army," the big red banner reads in German and Russian. "We Fear the Red Army" would be more literally true of the German sentiment. Accused of being two-faced, the people absolve themselves of any guilt by saying that the Bergermeister ordered the banner hung. The Little People don't feel they have or want a say in the way things are run.

Ichterhausen, Ger—5 July '45

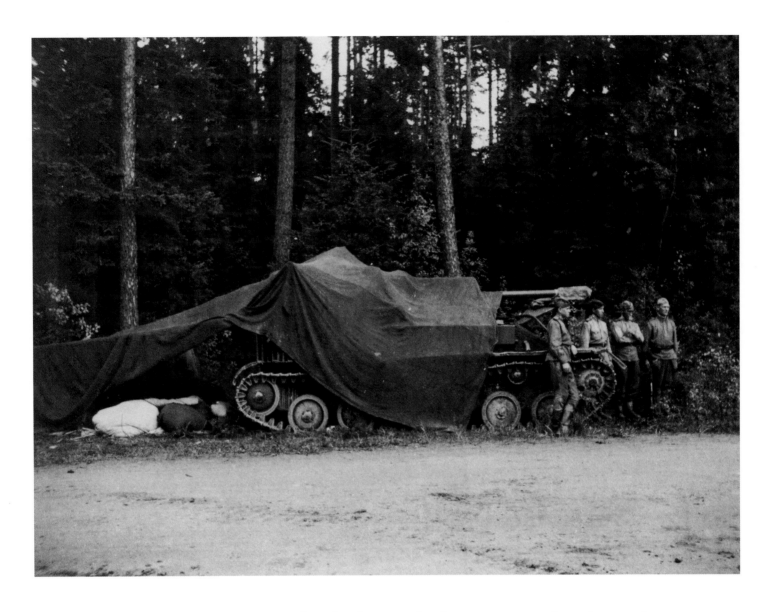

Close look at the Russian tank and crew guarding the Thuringian border. Americans can leave their area but not return without papers proving official business. Germans can't go either way. Several had tried to get us to bring them over the border into US territory in the back of our truck. No dice.

North of Coburg, Ger—5 July '45

9

GARDELEGEN ATROCITY

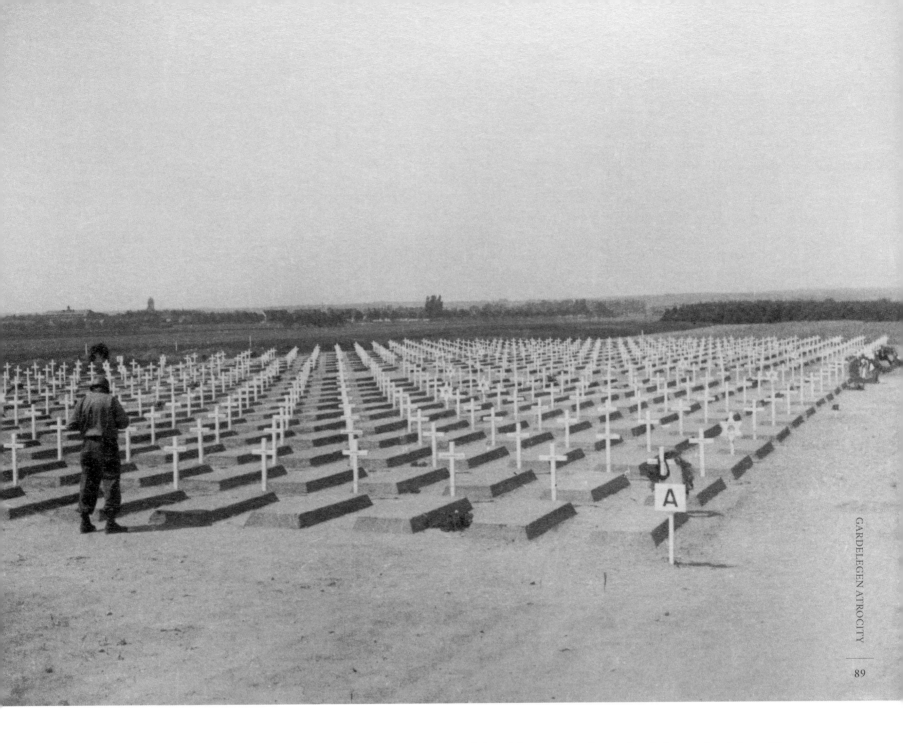

On the day before US Forces took Gardelegen, over a thousand slave laborers were burned and shot to death here. They were herded into a barn, the floor of which was covered with gasoline-soaked straw. A grinning 16 yr. old SS boy struck the match. Victims who tried to smother the flames or escape the barn were shot—machine guns being emplaced around the building. About one in twenty was identified as Jewish.

Near Gardelegen, Ger—20 May '45

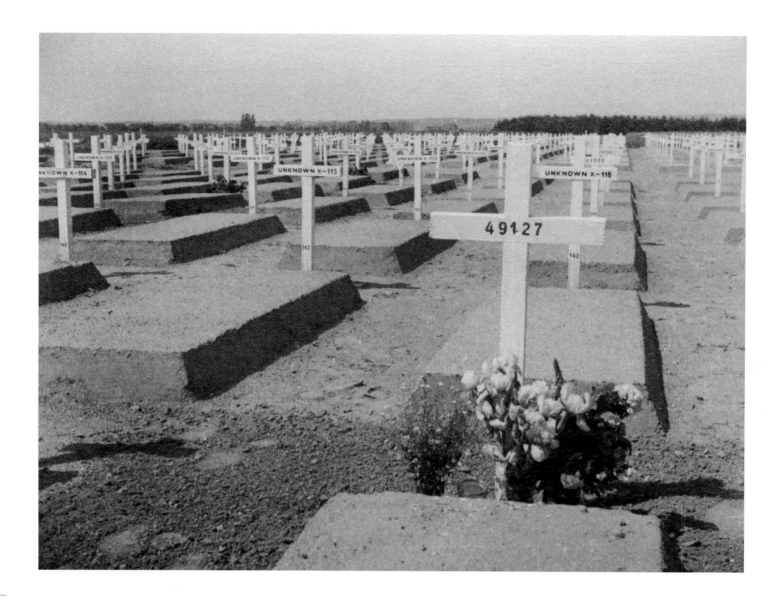

Mayors were brought from all the towns in Gardelegen County, made to view the 300 charred bodies and the makeshift grave for the other 700. All able-bodied males in the city of Gardelegen were forced to exhume the bodies in mass graves and bury all in individual plots with white crosses.

Near Gardelegen, Ger—20 May '45

Sign marking the cemetery entrance. As it implies, each grave has a Gardelegen family charged with keeping it forever beautiful. As we were leaving this area on May 30 the British, who had taken over, saw to it that flowers were placed on each grave.

Near Gardelegen, Ger—20 May '45

GARDELEGEN MILITARY CEMETERY

HERE LIE 1016 ALLIED PRISONERS OF WAR WHO WERE MURDERED BY THEIR CAPTORS.
THEY WERE BURIED BY CITIZENS OF GARDELEGEN, WHO ARE CHARGED WITH RESPONSIBILITY THAT GRAVES ARE FOR-EVER KEPT AS GREEN AS THE MEMORY OF THESE UNFORTUNATES WILL BE KEPT IN THE HEARTS OF FREEDOM-LOVING MEN EVERYWHERE.

ESTABLISHED UNDER SUPERVISION OF 102 D INFANTRY DIVISION. UNITED STATES ARMY. VANDALISM WILL BE PUNISHED BY MAX-IMUM PENALTIES UNDER LAWS OF MILITARY GOVERNMENT.
FRANK A. KEATING
MAJOR GENERAL. U.S.A.
COMMANDING.

GARDELEGEN MILITÄR-FRIEDHOF

HIER LIEGEN 1016 ALLIIERTE KRIEGSGE-FANGENE. DIE VON IHRER WACHE ERMOR-DET WORDEN SIND.
DIE EINWOHNER VON GARDELEGEN HABEN SIE BEGRABEN UND DIE VERPFLICHTUNG ÜBERNOMMEN. DIESE GRÄBER EBENSO FRISCH ZU BEWAHREN. WIE DAS GEDÄCHTNIS DER UNGLÜCKLICHEN IN DEN HERZEN ALLER FREIHEITSLIEBENDEN MENSCHEN BEWAHRT BLEIBEN WIRD.

ERRICHTET UNTER AUFSICHT DER 102 TEN INFANTRIE DIVISION. ARMEE DER VEREINIGTEN STAATEN. JEGLICHE SCHÄNDUNG DIESES FRIEDHOFES WIRD GEMÄSS DEN VERORD-NUNGEN DER MILITÄR-REGIERUNG MIT DEN SCHWERSTEN STRAFEN GEAHNDET WERDEN.
FRANK A. KEATING
GENLT. U.S.A.
KOMMANDEUR.

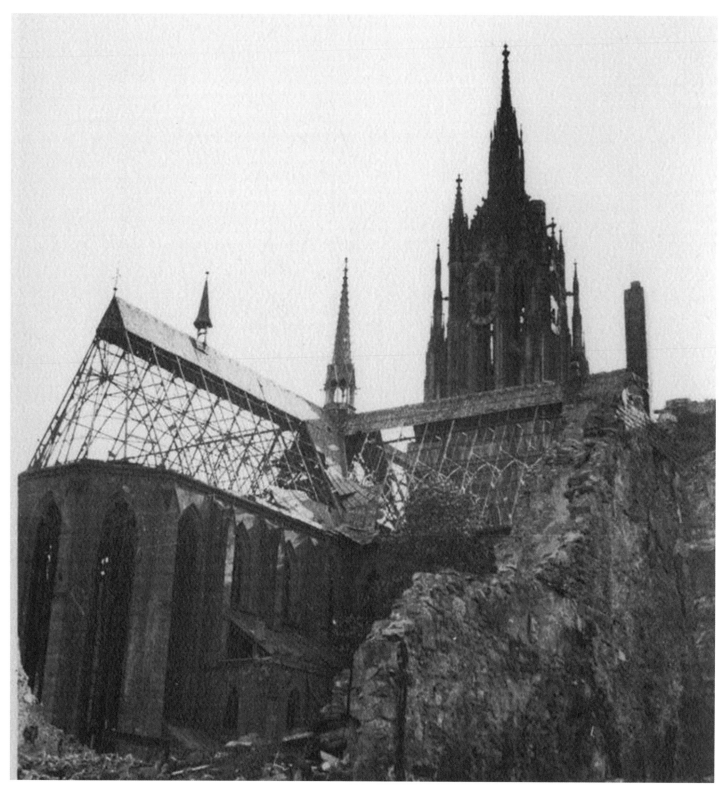

Cathedral ruin.

Part II.

THE PEACE:
A TOPICAL STORY OF MILITARY OCCUPATION

10

RULES OF THE OCCUPYING US ARMY

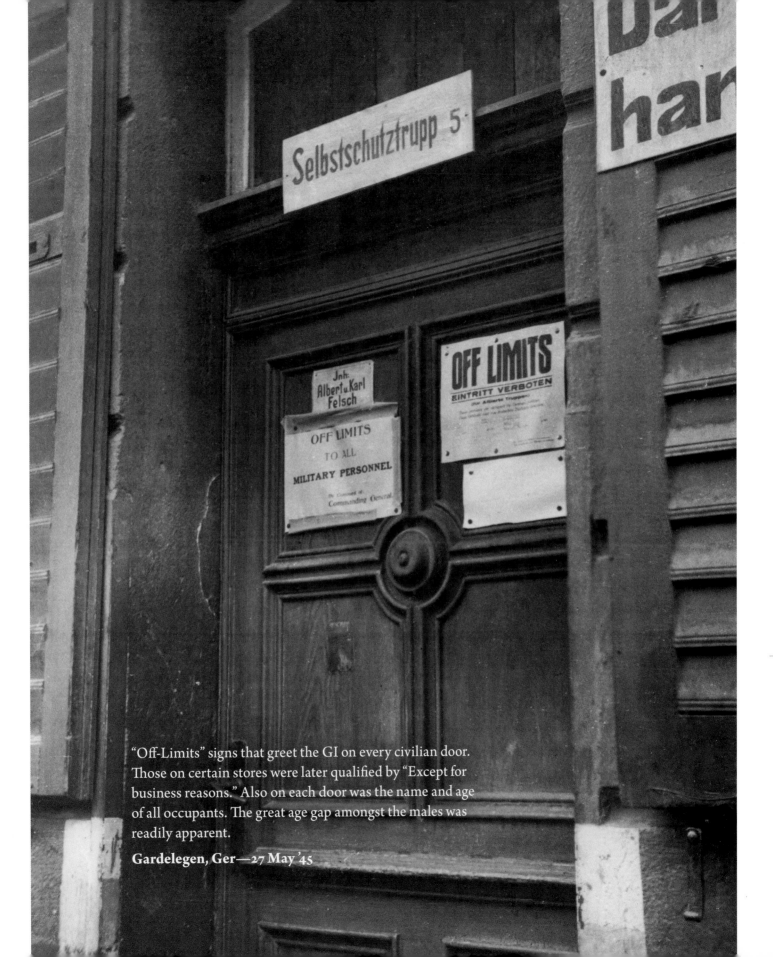

"Off-Limits" signs that greet the GI on every civilian door.
Those on certain stores were later qualified by "Except for
business reasons." Also on each door was the name and age
of all occupants. The great age gap amongst the males was
readily apparent.

Gardelegen, Ger—27 May '45

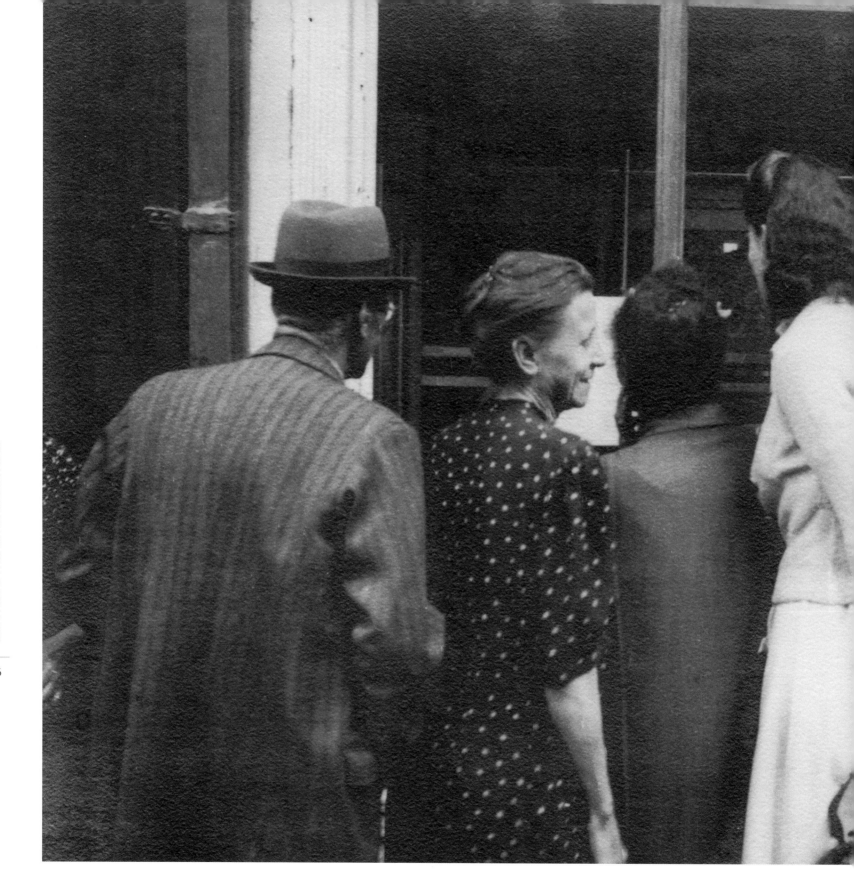

Civilians scan the bulletin board for the latest Military Govt notices.

Wetzlar, Ger—16 May '45

MILITARY GOVERNMENT—GERMANY
SUPREME COMMANDER'S AREA OF CONTROL

PROCLAMATION No. 1

TO THE PEOPLE OF GERMANY:

I, General Dwight D. Eisenhower, Supreme Commander, Allied Expeditionary Force, do hereby proclaim as follows:—

I.

The Allied Forces serving under my command have now entered Germany. We come as conquerors, but not as oppressors. In the area of Germany occupied by the forces under my command, we shall obliterate Nazi-ism and German Militarism. We shall overthrow the Nazi rule, dissolve the Nazi Party and abolish the cruel, oppressive and discriminatory laws and institutions which the Party has created. We shall eradicate that German Militarism which has so often disrupted the peace of the world. Military and Party leaders, the Gestapo and others suspected of crimes and atrocities will be tried and, if guilty, punished as they deserve.

II.

Supreme legislative, judicial and executive authority and powers within the occupied territory are vested in me as Supreme Commander of the Allied Forces and as Military Governor, and the Military Government is established to exercise these powers under my direction. All persons in the occupied territory will obey immediately and without question all the enactments and orders of the Military Government. Military Government Courts will be established for the punishment of offenders. Resistance to the Allied Forces will be ruthlessly stamped out. Other serious offences will be dealt with severely.

III.

All German courts and educational institutions within the occupied territory are suspended. The Volksgerichtshof, the Sondergerichte, the SS Police Courts and other special courts are deprived of authority throughout the occupied territory. Re-opening of the criminal and civil courts and educational institutions will be authorized when conditions permit.

IV.

All officials are charged with the duty of remaining at their posts until further orders, and obeying and enforcing all orders or directions of Military Government or the Allied Authorities addressed to the German Government or the German people. This applies also to officials, employees and workers of all public undertakings and utilities and to all other persons engaged in essential work.

DWIGHT D. EISENHOWER,
General,
Supreme Commander,
Allied Expeditionary Force.

MILITÄRREGIERUNG—DEUTSCHLAND
KONTROLLGEBIET DES OBERSTEN BEFEHLSHABERS

PROKLAMATION Nr. 1

AN DAS DEUTSCHE VOLK:

Ich, General Dwight D. Eisenhower, Oberster Befehlshaber der Alliierten Streitkräfte, gebe hiermit Folgendes bekannt:

The predecessor of all such, Proclamation No. 1. Well-known especially for the sentence, "We come as conquerors, not as oppressors," it is all worth reading.

Gardelegen, Ger—27 May '45

*Some of the following attempts
to copy fine print in the field
are inadequate, but titles
at least give the main intent.*

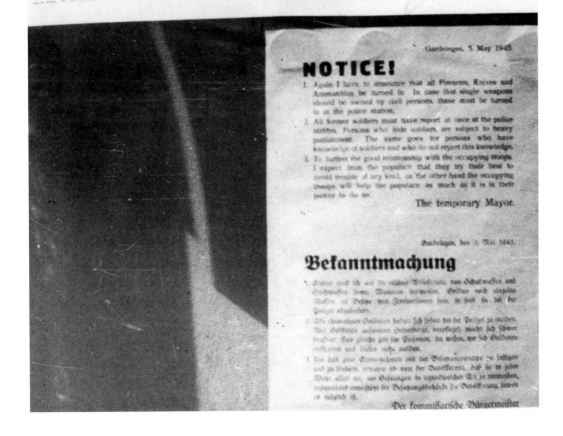

MILITARY GOVERNMENT - GERMANY
SUPREME COMMANDER'S AREA OF CONTROL

NOTICE
CURFEW

Until further notice no person within the occupied territory will be permitted to circulate on the streets or outside his own house without a permit of Military Government between the hours of 2100 and 0500.

Any persons found in the streets without such permit between those hours will be punished by fine or imprisonment.

All persons are further warned that military guards are instructed to shoot any persons seen outside their houses after hours who attempt to hide or escape.

BY ORDER OF MILITARY GOVERNMENT.

MILITAERREGIERUNG - DEUTSCHLAND
KONTROLL-GEBIET DES OBERSTEN BEFEHLSHABERS

BEKANNTMACHUNG
AUSGANGSBESCHRAENKUNG

Bis auf weiteres darf sich niemand im besetzten Gebiete ohne Erlaubnis der Militärregierung von 2100 bis 0500 im Freien oder ausserhalb seiner eigenen Wohnung aufhalten.

Wer in der angegebenen Zeit ohne solche Erlaubnis im Freien angetroffen wird, wird mit Geld- oder Freiheitsstrafe geahndet.

Warnung : Die Militärwachen haben Befehl erhalten auf alle Personen zu schiessen, die während der Ausgangsbeschränkung ausserhalb ihrer Wohnung gesehen werden und die sich zu verbergen oder zu entkommen versuchen.

IM AUFTRAGE DER MILITAERREGIERUNG.

The Curfew Notice is quite legible. Interesting to note how all are printed in both English and German. The little notice below concerns the turning in of all firearms to the police.

Gardelegen, Ger—27 May '45

MG Law suspending the German press and radio. These copies of new laws are posted as notices in conspicuous places throughout each town.

Near Gardelegen, Ger—27 May '45

SUPREME COMMANDER'S AREA OF CONTROL

LAW NO. I
ABROGATION OF NAZI LAW

In order to eliminate from German law and administration within the occupied territory the policies and doctrines of the National Socialist Party, and to restore to the German people the rule of justice and equality before the law, it is hereby ordered :

ARTICLE I

1. The following fundamental Nazi laws enacted since 30 January, 1933, together with all supplementary or subsidiary carrying out laws, decrees or regulations whatsoever are hereby deprived of effect, within the occupied territory :

(a) Law for Protection of National Symbols, of 19 May, 1933, RGBl I 285.

(b) Law against the creation of Political Parties of 14 July, 1933, RGBl I 479.

(c) Law for securing the unity of Party and State of 1 December, 1933, RGBl I 1016.

(d) Law concerning insidious attacks against the State and the Party and for the Protection of Party Uniforms of 20 December, 1934, RGBl I 1269.

(e) Reich Flag Law of 15 September, 1935, RGBl I 1145.

(f) Hitler Youth Law of 1 December, 1936, RGBl I 993.

(g) Law for protection of German Blood and Honor of 15 September, 1935, RGBl I 1146.

(h) Decree of the Fuehrer concerning the Legal Status of the NSDAP of 12 December, 1942, RGBl I 733.

(i) Reich Citizenship Law of 15 September, 1935, RGBl I 1146.

2. Additional Nazi laws will be deprived of effect by Military Government for the purpose stated in the preamble.

ARTICLE II
GENERAL SUSPENDING CLAUSE

3. No German law, however or whenever enacted or enunciated, shall be applied judicially or administratively within the occupied territory in any instance where such application would cause injustice or inequality, either (a) by favouring any person because of his connection with the National Socialist Party, its formations or affiliated or supervised organizations, or (b) by discriminating against any person by reason of his race, nationality, religious beliefs or opposition to the National Socialist Party or its doctrines.

ARTICLE III
GENERAL INTERPRETATION CLAUSES

4. The interpretation and application of German law in accordance with National Socialist doctrines, however or whenever enunciated, are prohibited.

5. Decisions of German courts and official agencies and officials and legal writings supporting, expounding or applying National Socialist objectives or doctrines shall not be referred to or followed as authority for the interpretation or application of German law.

6. German law which became effective after 30 January, 1933, and is permitted to remain in force shall be interpreted and applied in accordance with the plain meaning of the text and without regard to objectives or meanings ascribed in preambles or other pronouncements.

ARTICLE IV
LIMITATIONS ON PUNISHMENT

7. No charge shall be preferred, no sentence imposed or punishment inflicted for an act, unless such act is expressly made punishable by law in force at the time of its commission. Punishment for offences determined by analogy or in accordance with the alleged "sound instincts of the people" or sound Volksempfinden is prohibited.

8. No cruel or excessive punishment shall be inflicted and the death penalty is abolished except for acts punishable by death under law in force prior to 30 January, 1933, or promulgated by or with the consent of Military Government.

9. The detention of any person not charged with a specific offence and the punishment of any person without lawful trial and conviction are prohibited.

10. All punishments imposed prior to the effective date of this law of a character prohibited by law and not yet carried out, shall be modified to conform to this law or annulled.

ARTICLE V
PENALTIES

11. Violation of the provisions of this law shall, upon conviction by a Military Government Court, be punishable by any lawful punishment, including, in the case of Article IV, the death penalty.

ARTICLE VI
EFFECTIVE DATE

12. This Law shall become effective upon the date of its first promulgation.

BY ORDER OF MILITARY GOVERNMENT.

WS 44782 12/44

KONTROLL-...

AUFHEBUNG...

Um die Grunds...
innerhalb des besetzte...
wiederherzustellen und...
verordnet :

1. Die folgenden...
wurden, sowie sämtlic...
-Bestimmungen, verlier...

(a) Gesetz zum...
(b) Gesetz gege...
(c) Gesetz zur...
(d) Gesetz gege...
 uniformen...
(e) Reichsflagg...
(f) Hitlerjugen...
(g) Gesetz zum...
 RGBl I 1146...
(h) Erlass des...
 RGBl I 733...
(i) Reichsbürge...

2. Weitere natio...
Einleitung genannten Zw...

4. Die Auslegung...
gleichgültig wann und w...

5. Entscheidungen...
Ziele oder Lehren erklär...
mehr als Quelle für die A...

6. Deutsches Rech...
und anzuwenden, wie es a...
in Vorsprüchen oder and...

7. Anklage darf nu...
die Tat zur Zeit ihrer...
strafbaren Handlungen un...
ist verboten.

8. Keine grausam...
für alle Verbrechen, die...
werden, abgeschafft, es se...
hat.

9. Die Verhängung...
tung angeklagt sind, und d...
und Verurteilung, sind ver...

10. Alle Strafen, w...
spruche hierzu stehen und...
dieses Gesetzes zu entspre...

11. Jeder Verstoss g...
durch ein Gericht der Mil...
und im Falle des Artikels...

12. Dieses Gesetz tr...

CA Gl 30...

This law begins by voiding nine fundamental Nazi Laws. Then it proceeds to make a general suspension of any Ger. law that causes injustice or inequality by favoring Party members or by discriminating against anyone by reason of race, nationality, religious beliefs, or opposition to the Party or its doctrines.

Gardelegen, Ger—27 May '47

MILITARY GOVERNMENT—GERMANY

SUPREME COMMANDER'S AREA OF CONTROL

LAW No. 51

CURRENCY

ARTICLE I
Allied Military Marks

1. Allied Military Mark Notes of the denominations specified in the Schedule hereto shall be legal tender in the occupied territory of Germany for the payment of any Mark debt.

2. Allied Military Mark Notes will in all respects be equivalent to any other legal tender Mark currency of the same face value.

3. No person shall discriminate between Allied Military Marks and any other legal tender Mark currency of equal face value.

ARTICLE II
Prohibited Transactions

4. Except as authorised by Military Government, no person shall make or enter, or offer to enter, into any arrangement or transaction providing for payment in or delivery of a currency other than Marks.

ARTICLE III
Penalties

5. Any person violating any provision of this Law shall upon conviction by a Military Government Court, be liable to any lawful punishment, other than death, as the Court may determine.

ARTICLE IV
Effective Date

6. This Law shall become effective upon the date of its first promulgation.

BY ORDER OF MILITARY GOVERNMENT

SCHEDULE

Denominations of Allied Military Mark Notes (Marks)	Size (in cm.)	Words and Figures indicating amount and printed in
0.50	4.7 × 7.8	Green
1	4.7 × 7.8	Dark Blue
5	4.7 × 7.8	Reddish Purple
10	4.7 × 11.2	Dark Blue
20	4.7 × 13.6	Red
50	4.7 × 13.6	Dark Blue
100	4.7 × 13.6	Reddish Purple
1,000	4.7 × 13.6	Green

On the face of all notes are printed:

(a) The amount in words thus: Fuenfzig Pfennig, Eine Mark, etc. Also the amount in figures thus: ½ (on the 50Pf. note), 1 (on the 1M. note, etc.

(b) The words "Alliierte Militaerbehoerde" at the top of the note.

(c) The words "In Umlauf gesetzt in Deutschland" "Serie 1944" and the serial number of the note. On the notes for M.20, 50, 100 and 1,000 all of these appear twice.

The basic colour of the field on the face of all the notes is light blue; on the back it is reddish brown.

CA/G 270

MILITÄRREGIERUNG—DEUTSCHLAND

KONTROLL GEBIET DES OBERSTEN BEFEHLSHABERS

GESETZ Nr. 51

WÄHRUNG

ARTIKEL I
Alliierte Militär-Mark

1. Alliierte Militär Marknoten, deren Nennwerte in der nachfolgenden Tabelle angegeben sind, gelten im besetzten Gebiete Deutschlands als gesetzliche Zahlungsmittel für die Bezahlung von Markschulden jeder Art.

2. Alliierte Militär Marknoten werden in allen Beziehungen jedem anderen auf Mark lautenden, gesetzlichen Zahlungsmittel desselben Nennwertes gleichgestellt.

3. Niemand darf Alliierte Militär-Mark und irgendein anderes, auf Mark lautendes, gesetzliches Zahlungsmittel gleichen Nennwertes unterschiedlich behandeln.

ARTIKEL II
Verbotene Rechtsgeschäfte

4. Niemand darf eine Vereinbarung eingehen oder ein Rechtsgeschäft abschliessen, oder den Abschluss einer derartigen Vereinbarung oder eines derartigen Rechtsgeschäfts anbieten, falls darin Zahlung oder Lieferung einer anderen als der Markwährung vorgesehen ist, es sei denn, dass die Militärregierung dies hierzu Genehmigung erteilt hat.

ARTIKEL III
Strafen

5. Jeder irgendeine gegen dieses Gesetz verstösst, wird mit jeder von den Gerichten der Militärregierung nach deren Ermessen verhängten gesetzlich zulässigen Strafe, jedoch nicht der Todesstrafe, geahndet.

ARTIKEL IV
Inkrafttreten

6. Dieses Gesetz tritt am Tage seiner ersten Verkündung in Kraft.

IM AUFTRAGE DER MILITÄRREGIERUNG

TABELLE

Nennwerte der alliierten Militär-Marknoten Mark	Grösse in cm.	Werte und Ziffern, die den Betrag angeben, und die wie folgt aufgedruckt sind
0.50	4.7 × 7.8	Grün
1	4.7 × 7.8	Dunkelblau
5	4.7 × 7.8	Rotlichviolett
10	4.7 × 11.2	Dunkelblau
20	4.7 × 13.6	Rot
50	4.7 × 13.6	Dunkelblau
100	4.7 × 13.6	Rotlichviolett
1,000	4.7 × 13.6	Grün

Auf der Vorderseite aller Banknoten ist gedruckt:

(a) Der Betrag in Worten, z.B.: Fuenfzig Pfennig, Eine Mark, usw. ebenfalls der Betrag in Ziffern, z.B. ½ (auf der 50Pf. Note) 1 auf der 1M. Note, usw.

(b) Die Worte "Alliierte Militaerbehoerde" am oberen Ende der Banknote.

(c) Die Worte "In Umlauf gesetzt in Deutschland Serie 1944" und die Seriennummer der Banknote. Auf den Noten im Nennwerte von M.20, 50, 100 und 1,000 ist diese Aufschrift zweimal ersichtlich.

Die Grundfarbe der Vorderseite ist hellblau, die Grundfarbe der Rückseite ist rotlichbraun.

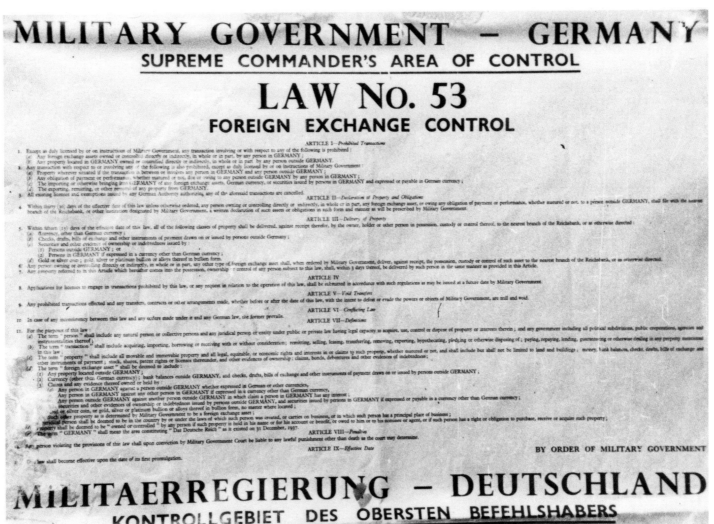

Foreign Exchange Control Law. In general it freezes and requires the turning in to MG all foreign currency and all other foreign exchange assets, receipts being given in return.

Gardelegen, Ger—27 May '45

(*Facing*) MG Law making the Allied Military Mark legal tender for civilians.

Gardelegen, Ger—27 Mar '45

11

WARTIME DESTRUCTION

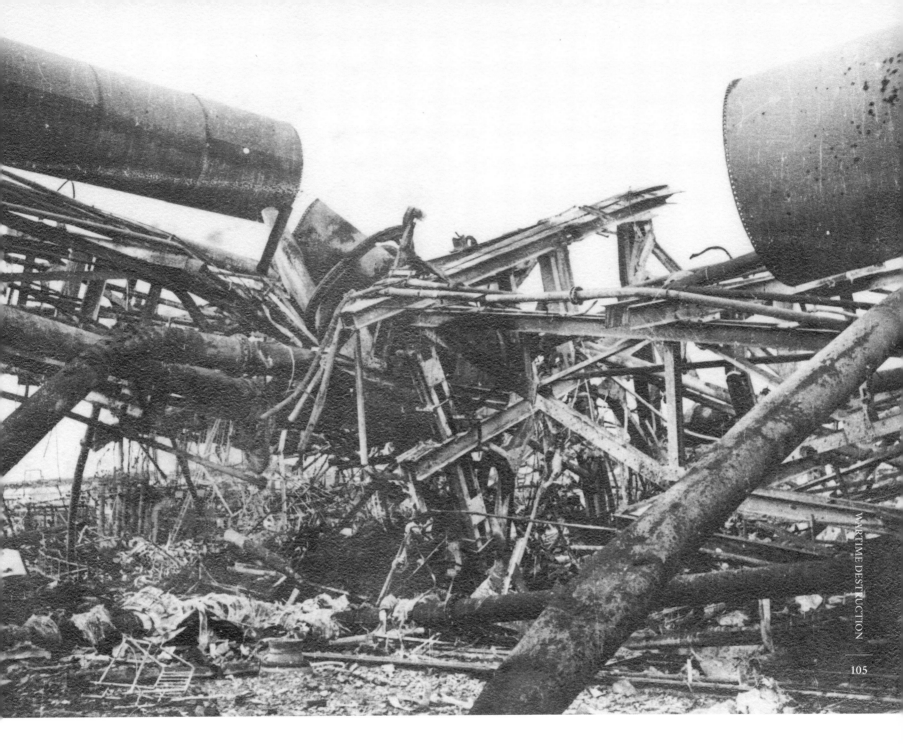

This greatest synthetic oil plant in Germany, the Leuna Werk, was bombed 22 times and was forced to cut its production to $\frac{1}{4}$ its capacity. This and other interesting facts I got from a French slave laborer who worked in the office of the plant and kept track of all the raids. He now is serving the American Military Govt in the city as an interpreter.

Near Merseburg, Ger—6 May '45

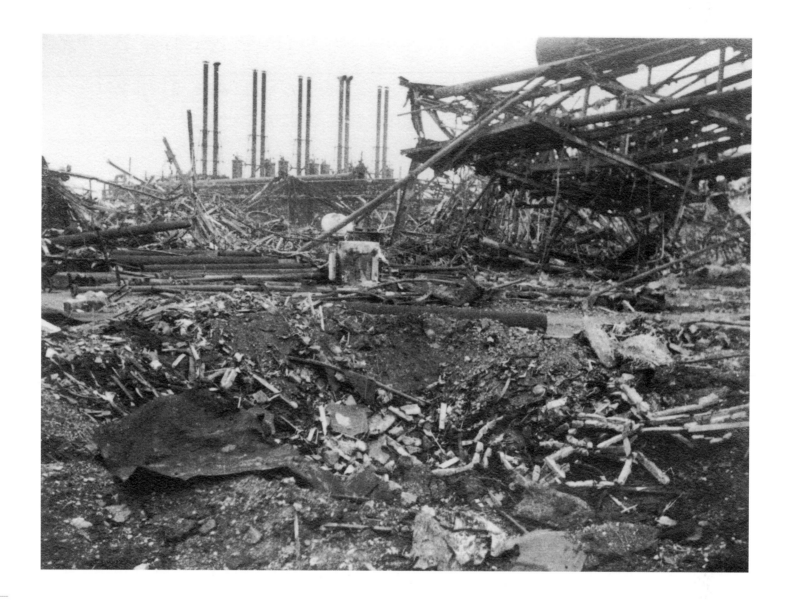

On Nov. 2, 1944, during the 12th raid on this vital Leuna Werk, the B-17 that my friend, Bob Campbell, was piloting was hit by flak, set afire, and forced down.

Near Merseberg, Ger—6 May '45

(*Facing*) Huge statue of Emperor Ludwig, the Bavarian, stands serene in the desolate city center. 171 winding steps bring fools and photographers groping through pitch blackness up to the top of the 125 ft pedestal. See next photo.

Darmstadt, Ger—13 May '45

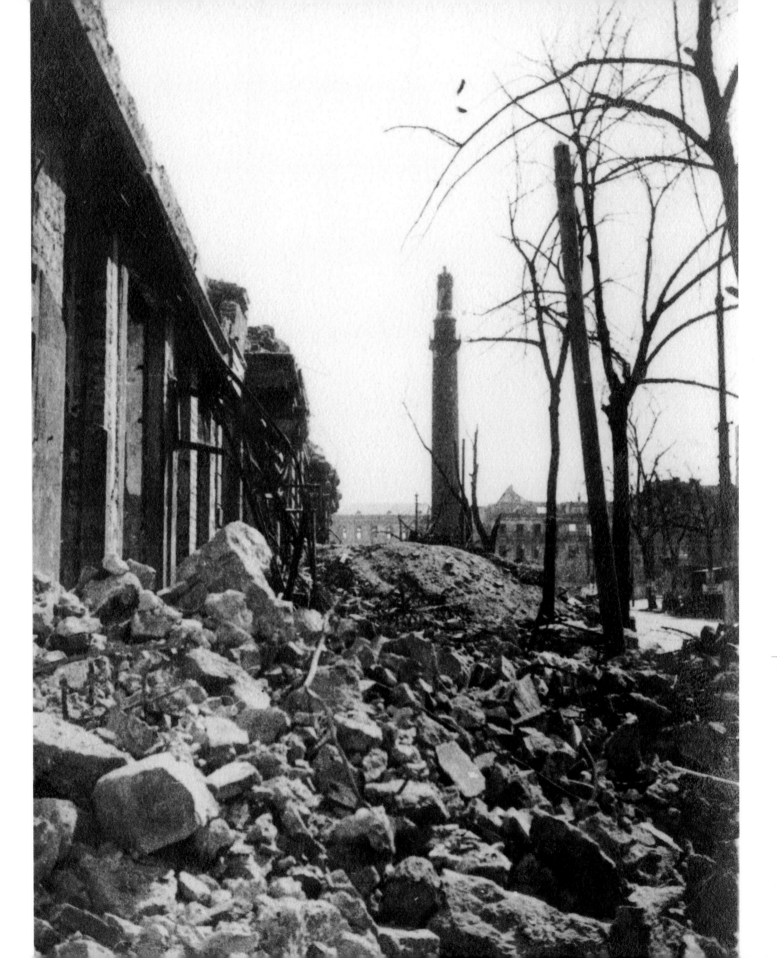

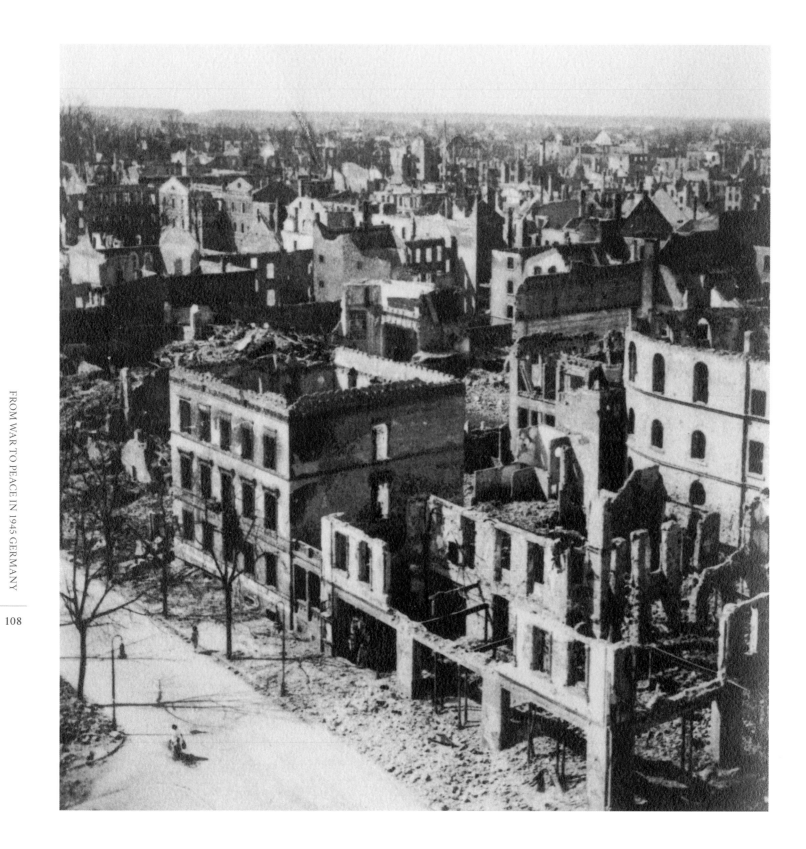

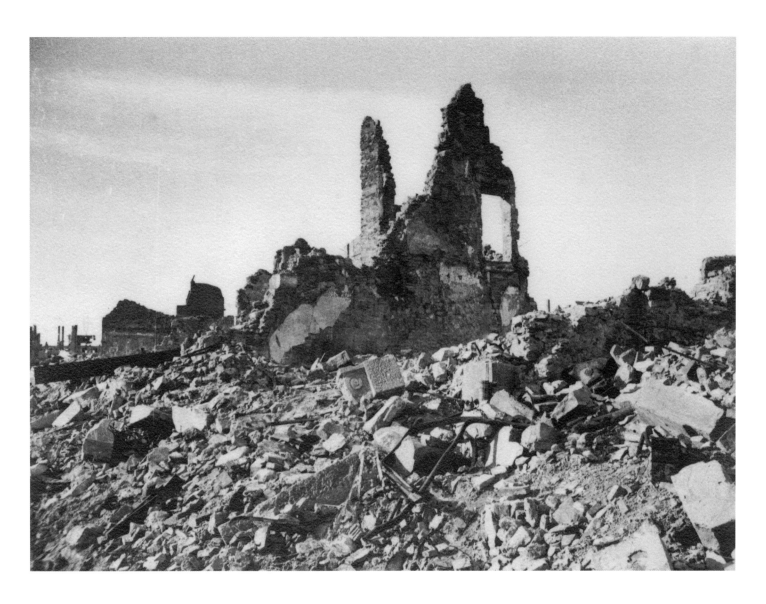

Frankfurt ruins, looking like the crumbling habitation of an ancient civilization.

Frankfurt, Ger—14 May '45

(*Facing*) Burned-out shells that once were the city's important buildings. The Air Force must have had a grudge to settle here. All damage is said to have been caused by a single raid with incendiary bombs. View is from a statue-topped tower.

Darmstadt, Ger—13 May '45

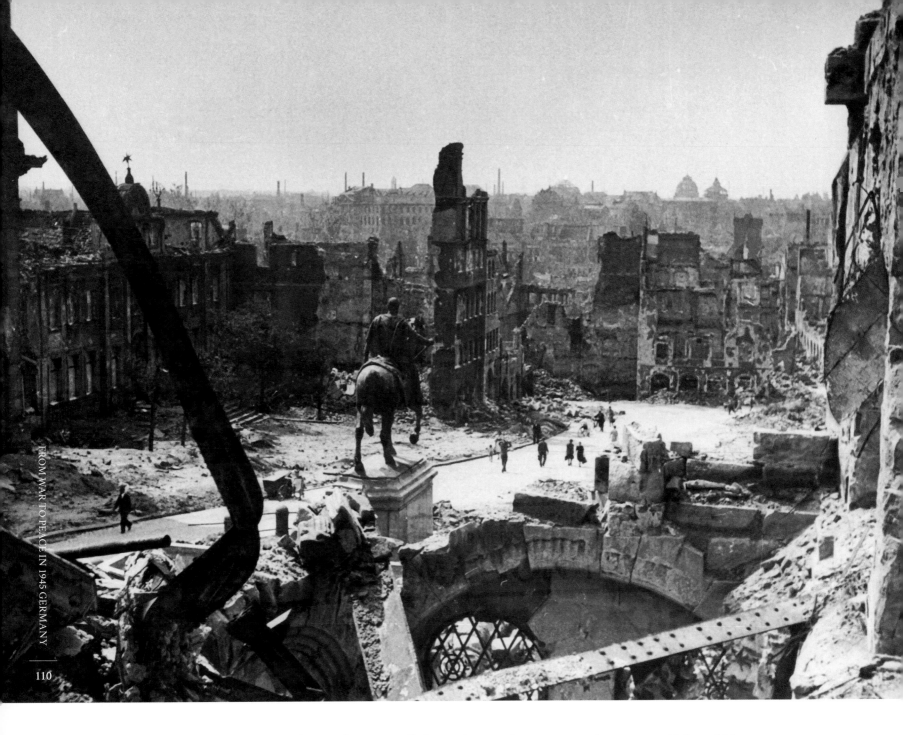

Ruins now lie at the feet of the iron figure of Kaiser Wilhelm. A German living in a nearby room amid the rubble showed me this viewpoint. Looking at it while I took the pic he said that Hitler had gotten what he'd been pleading for—total war.

Nürnberg, Ger—9 July '45

Agfa Isochrome

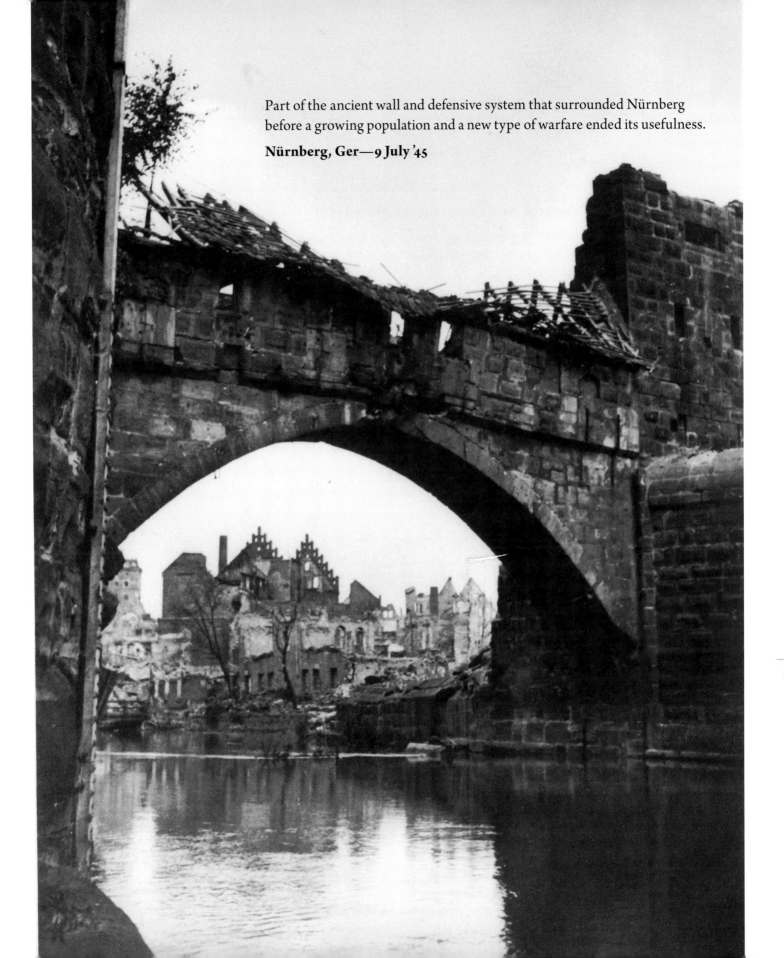

Part of the ancient wall and defensive system that surrounded Nürnberg before a growing population and a new type of warfare ended its usefulness.

Nürnberg, Ger—9 July '45

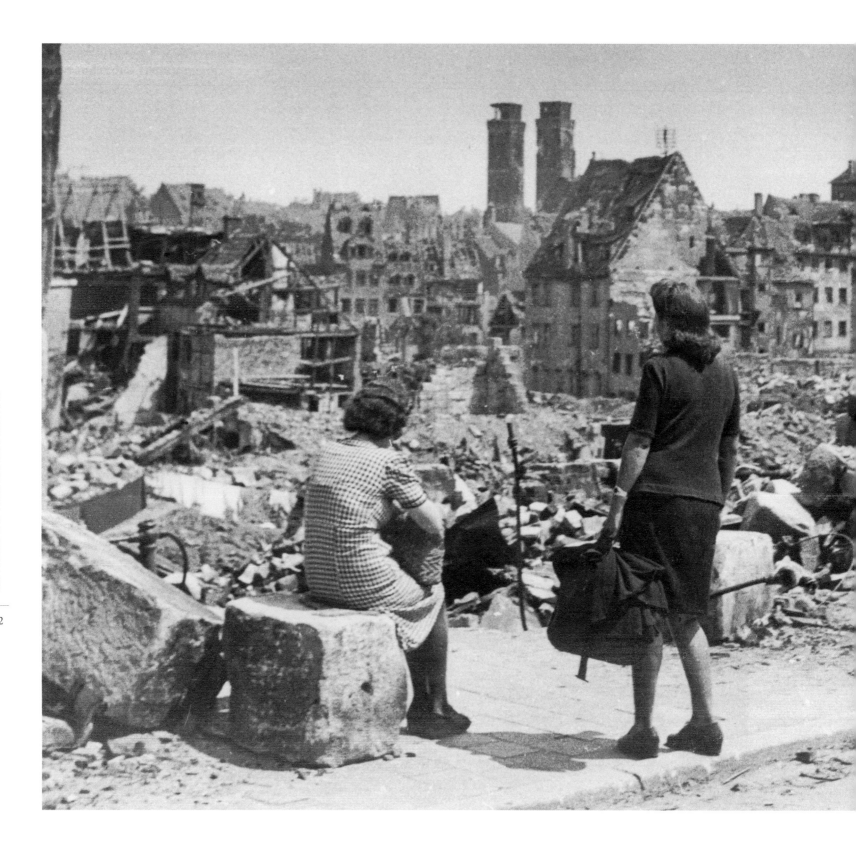

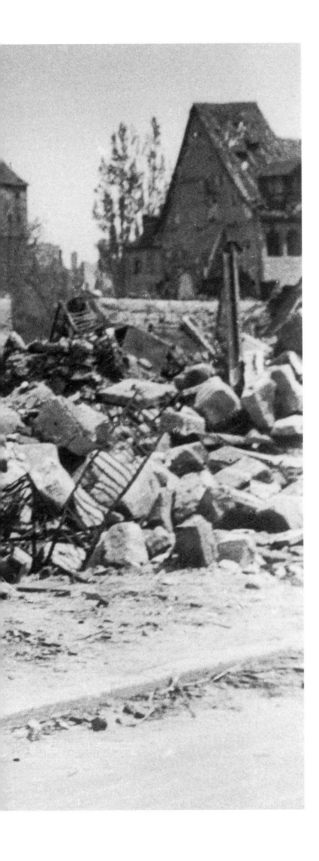

Wonder what's going through the minds of these housewives. Somehow people are living in that jungle of wrecked buildings.

Nürnberg, Ger—9 July '45

12

PEOPLE ON THE MOVE FOLLOWING VICTORY IN EUROPE, MAY 7

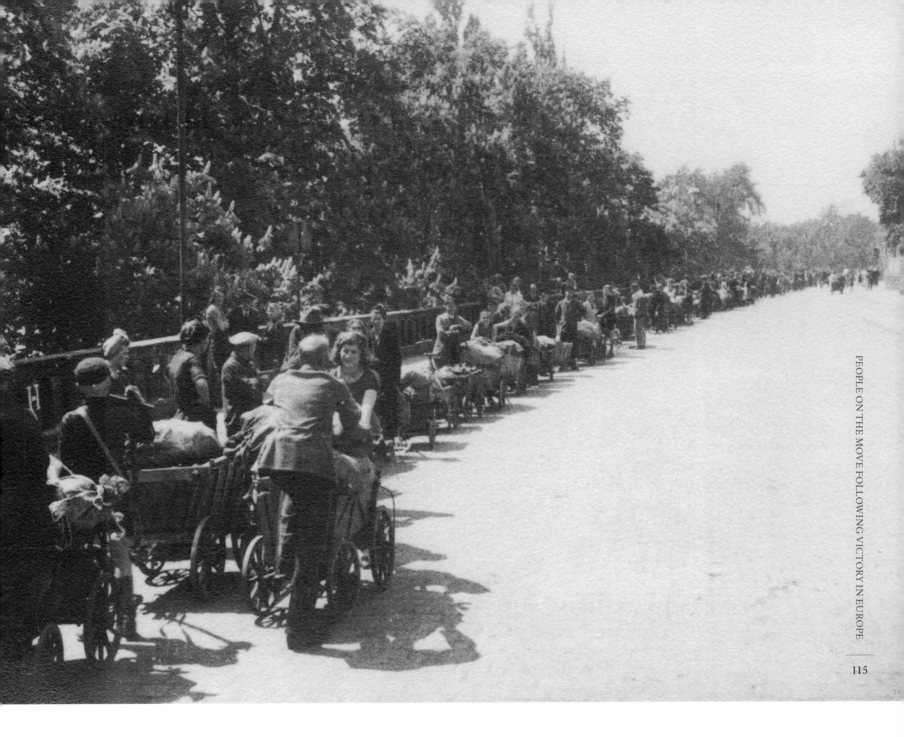

Part of the lineup waiting to cross a narrow bridge. Traffic was one way at a time and very slow. The VE Day news is out, and many of these people are former slave laborers making a break for it.

Weissenfels, Ger—8 May '45

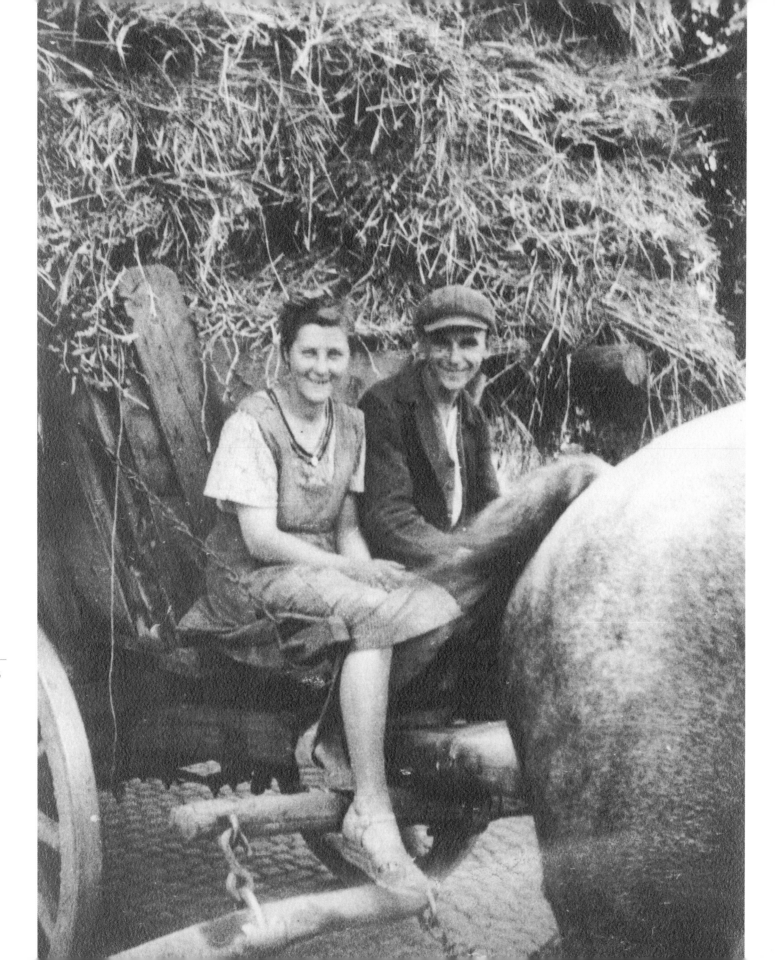

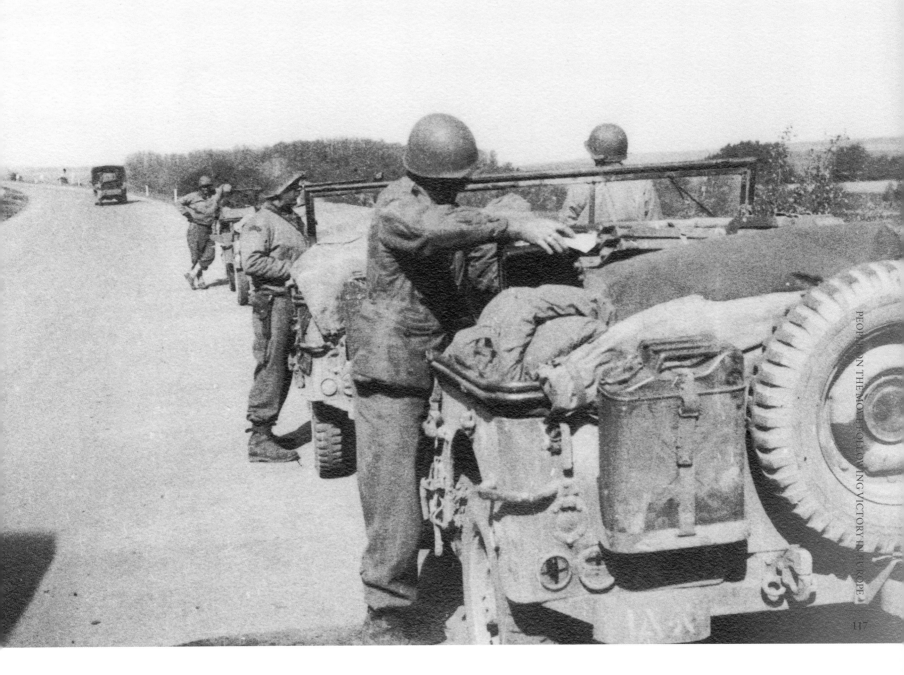

The CIC and Photo Units of 3d Armd. pause for a rest and ration stop on the autobahn to Frankfurt.

Between Sangerhausen and Frankfurt, Ger—12 May '45

(*Facing*) Young German farm folk, looking a bit amused at the prospect of having their pic taken. They are stopped at a checking station at the end of town and an MP is investigating their wagonload behind for stowaways etc.

Sangershausen, Ger—11 May '45

Presumably in VE Day glee, American fighters swarm playfully over Frankfurt.

Near Frankfurt, Ger—12 May '45

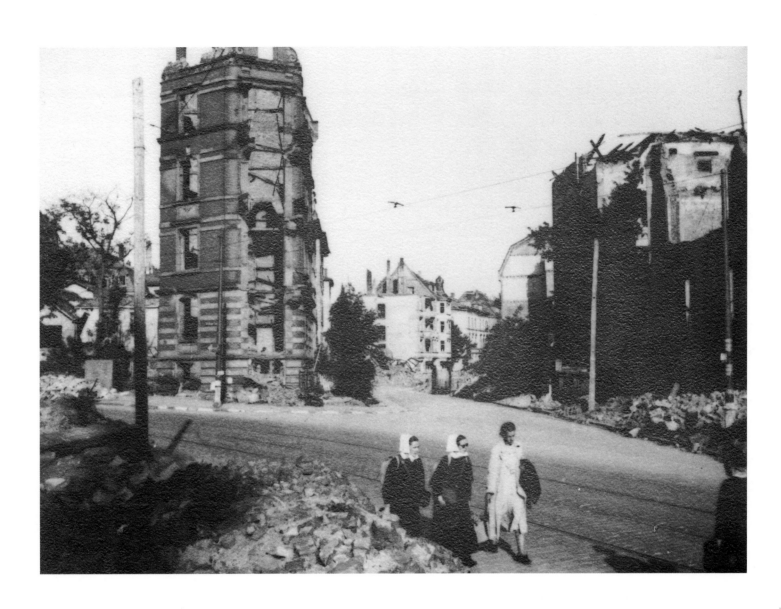

Wreckage in the streets of Frankfurt am Maine. The nuns wearing packs and carrying suitcases appear to be on the move to some more habitable city or place of greater need.

Frankfurt, Ger—14 May '45

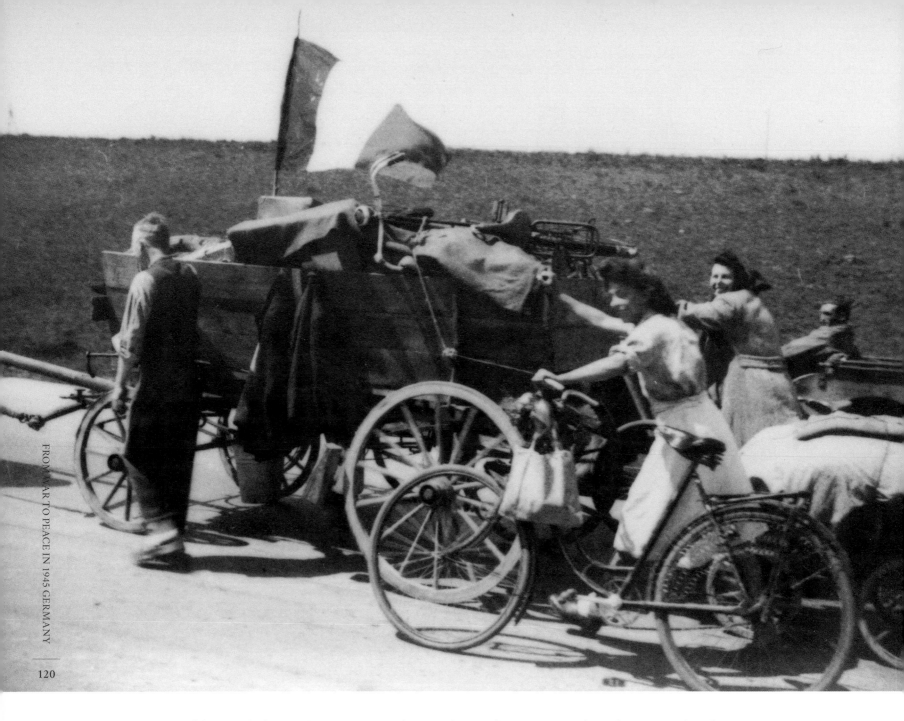

As much a part of the Autobahns as the two concrete lanes is the steady procession of wandering people—for a time averaging 100 per mile. They have become a common sight, but their stories are always interesting.

This is a group of French people making for home under their own steam. By truck and train US authorities are getting such people home, but some like these can't wait to get started.

Near Gotha, Ger—17 June '45

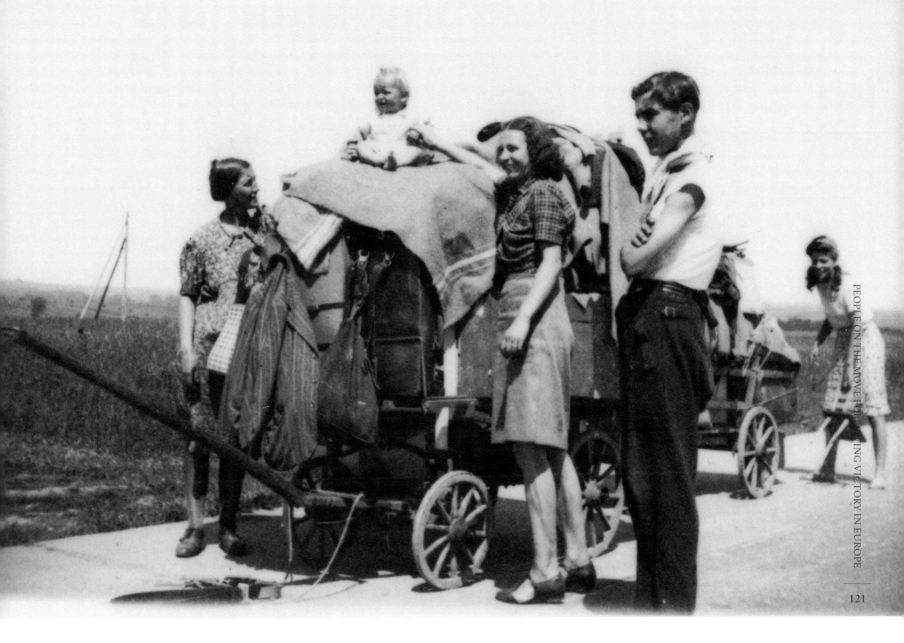

This is a German family, or parts of several. When Cologne was taking a beating last fall they were ordered out. Now, though their home is probably a rubble, they're walking back. Why? Ask the Russians.

Near Gotha, Ger—17 June '45

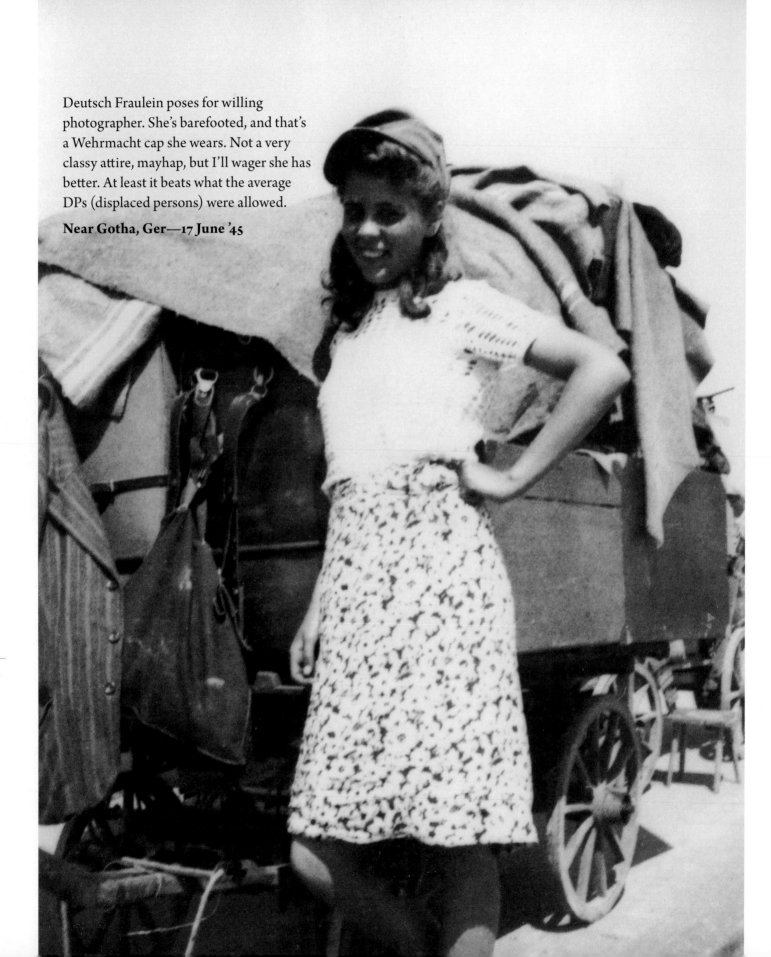

Deutsch Fraulein poses for willing photographer. She's barefooted, and that's a Wehrmacht cap she wears. Not a very classy attire, mayhap, but I'll wager she has better. At least it beats what the average DPs (displaced persons) were allowed.

Near Gotha, Ger—17 June '45

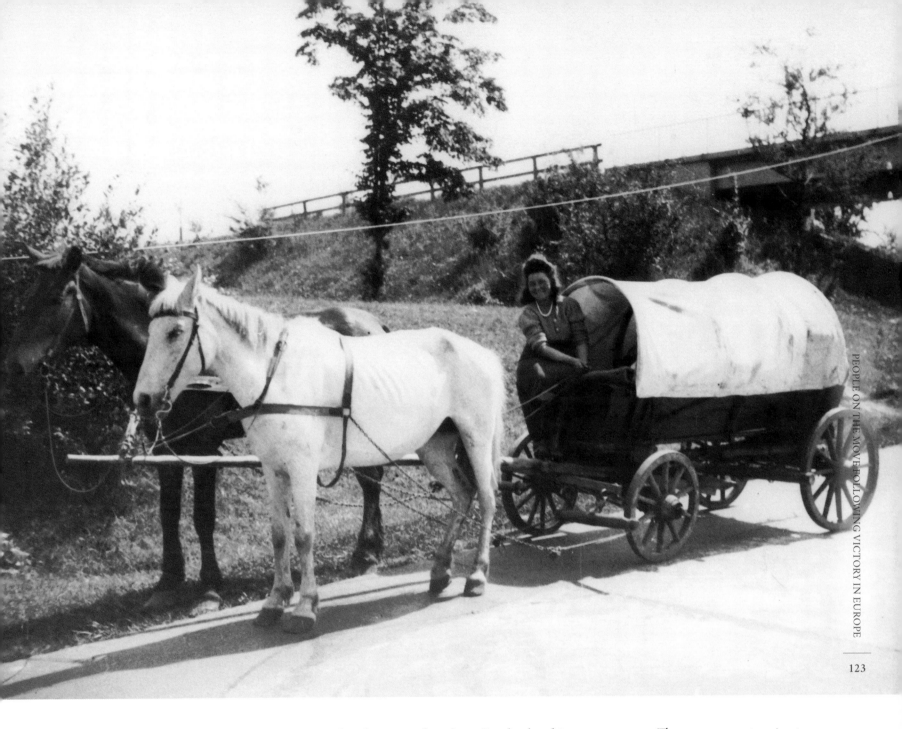

This German Frau and her man were ordered to go and settle in Czechoslovakia two years ago. They are now returning to escape the Russians.

Near Gera, Ger—19 June '45

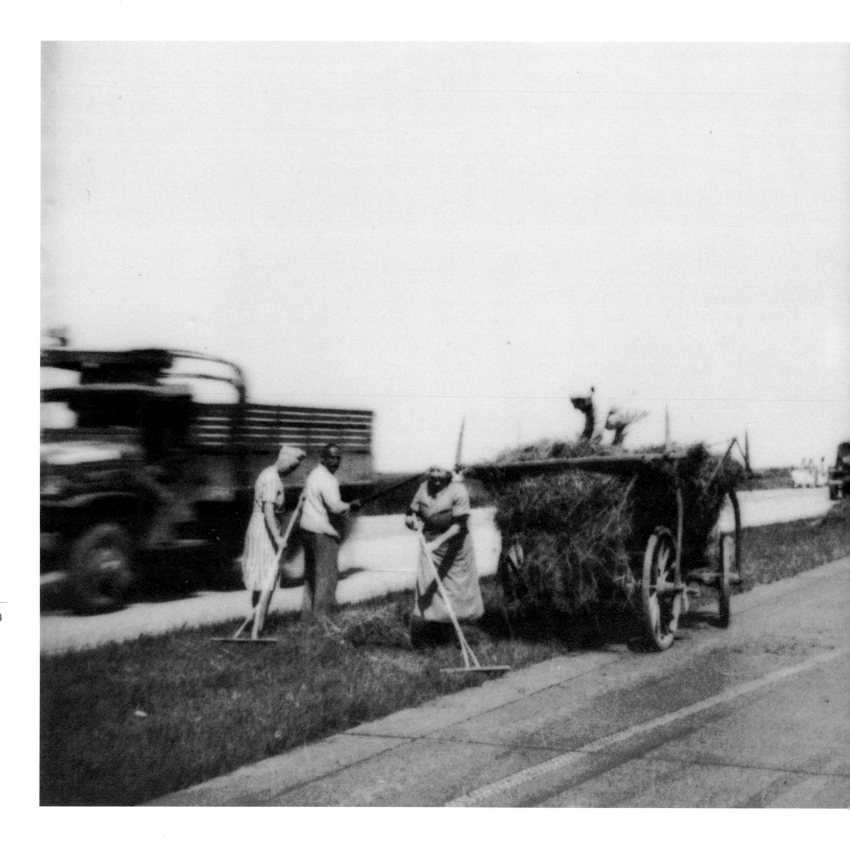

Armies come and go, but the country people carry on as before, though the womenfolk must fill in for men who may never come back. The clash of the old hand methods with new machine methods is everywhere apparent in this country.

Nothing is wasted here. All grass is cut, even to the center strip of the Autobahn. And all this work with scythe and sickle is no roadside beautification project, for it's all raked up and hauled in.

Near Gotha, Ger—17 June '45

13

DISPLACED PERSONS, OR DPS—
A NICE NAME FOR SLAVE LABOR

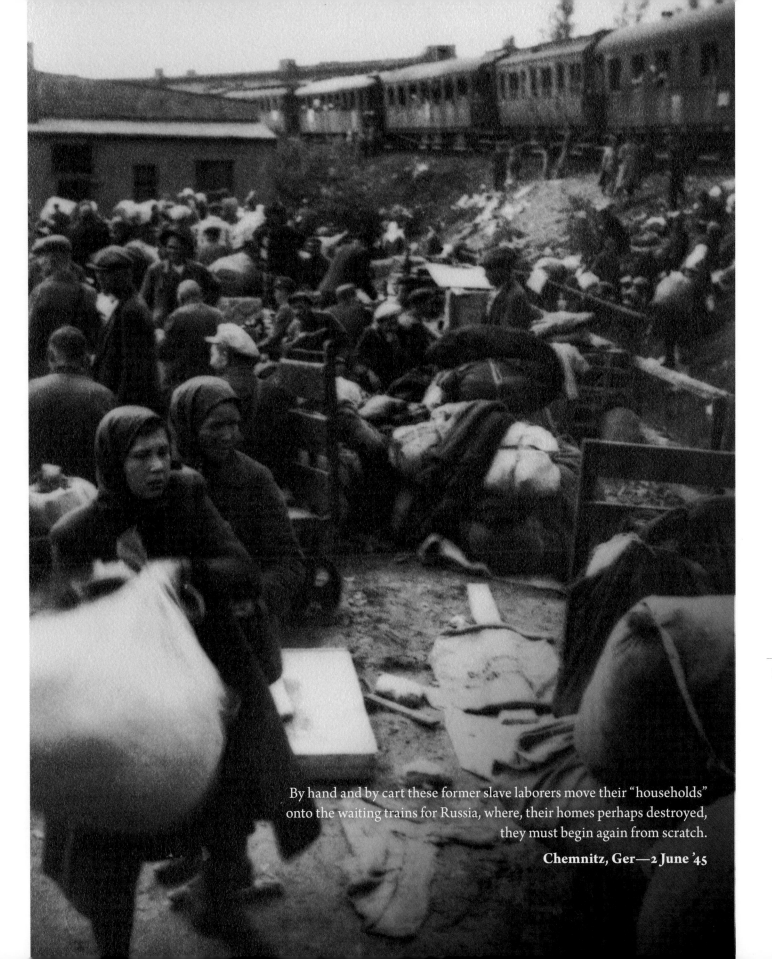

By hand and by cart these former slave laborers move their "households"
onto the waiting trains for Russia, where, their homes perhaps destroyed,
they must begin again from scratch.

Chemnitz, Ger—2 June '45

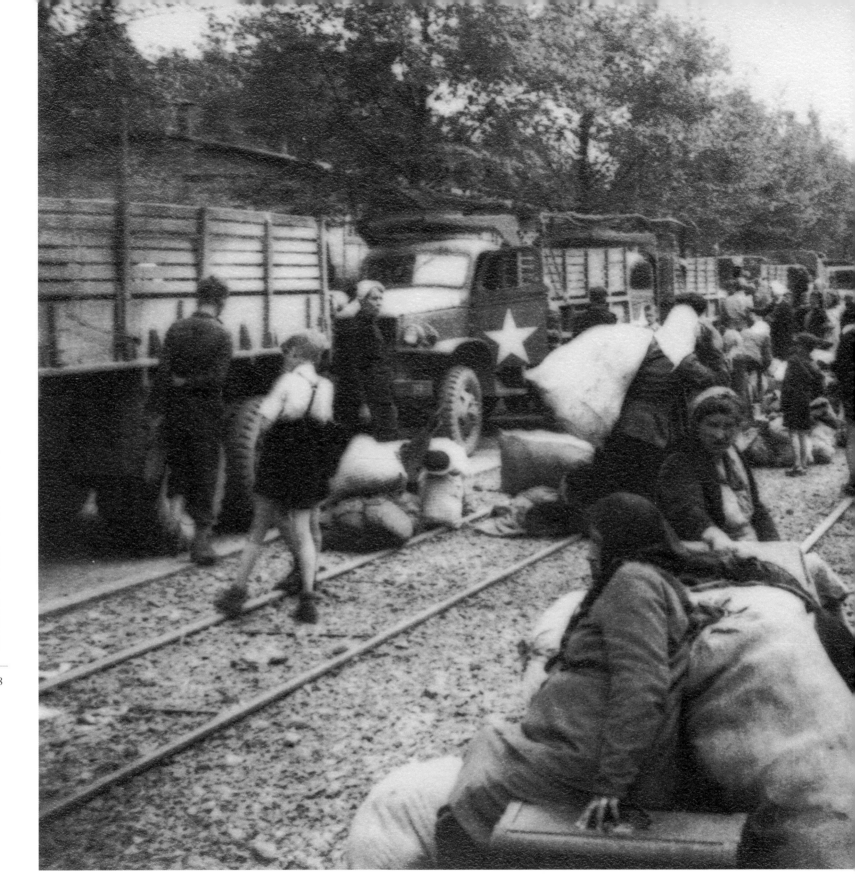

Having just piled off American trucks, these Russian DPs haven't just yet found out how to get their duffels to the train.

Thousands of these people are arriving here daily from all over American-occupied Germany. We had just filmed a story of 1,200 being brought from Ohrdruf, 85 miles distant. Finding ourselves for the first and last time with a little freedom in a Russian-occupied German city, we snooped a bit. The Germans we talked to were glad to see Americans, wondering how long we were going to stay, and complaining about the skimpy ration of food.

Chemnitz, Ger—2 June '45

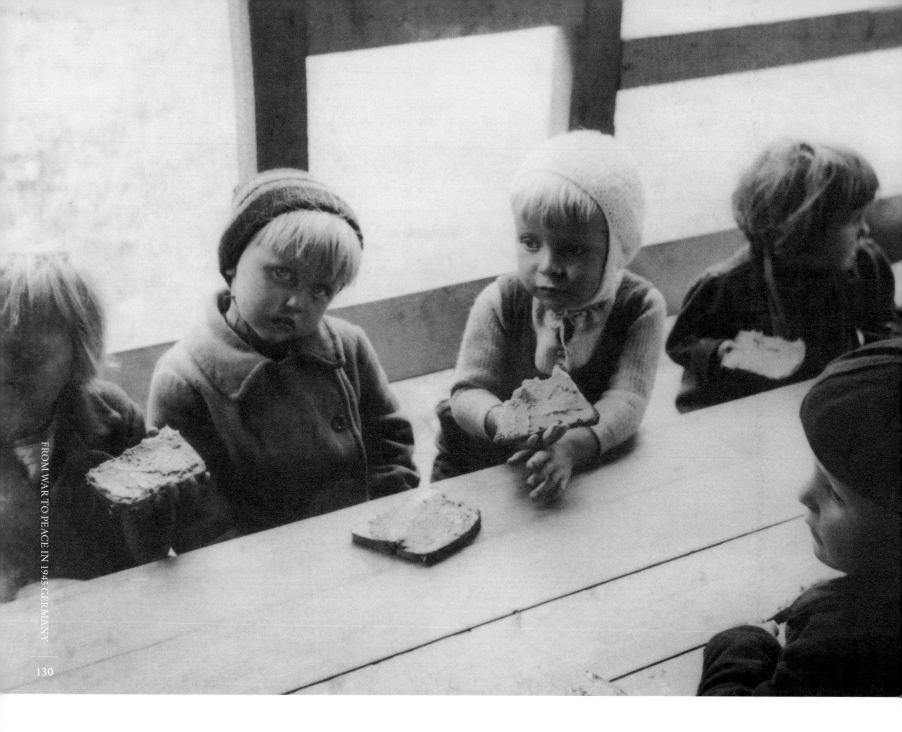

Polish children hungrily munch an afternoon snack of rations that were once in the Red Cross PW Packages.
This is part of the DP Camp's nursery program.

Wetzlar, Ger—14 June '45

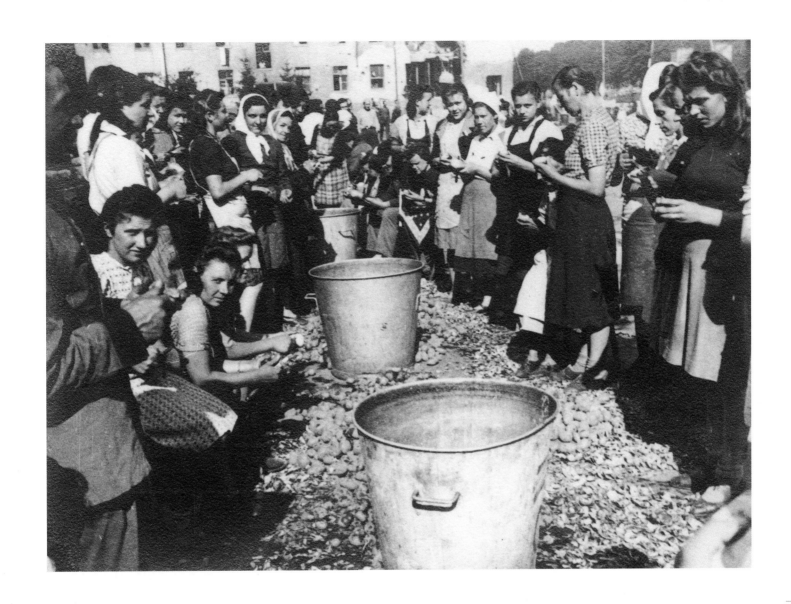

Busy Polish people, thankful that they are no longer slaves to the Nazis, but unwilling to return to their native land for fear of the Russians.

Looks like everybody's on KP today and busy peeling potatoes. Most every meal ends up being a thick soup with heavy, brown bread.

The UNRRA later took over here and made things a bit cleaner & more livable.

Near Wetzlar, Ger—16 May '45

14

GERMAN VILLAGE
AND COUNTRY LIFE

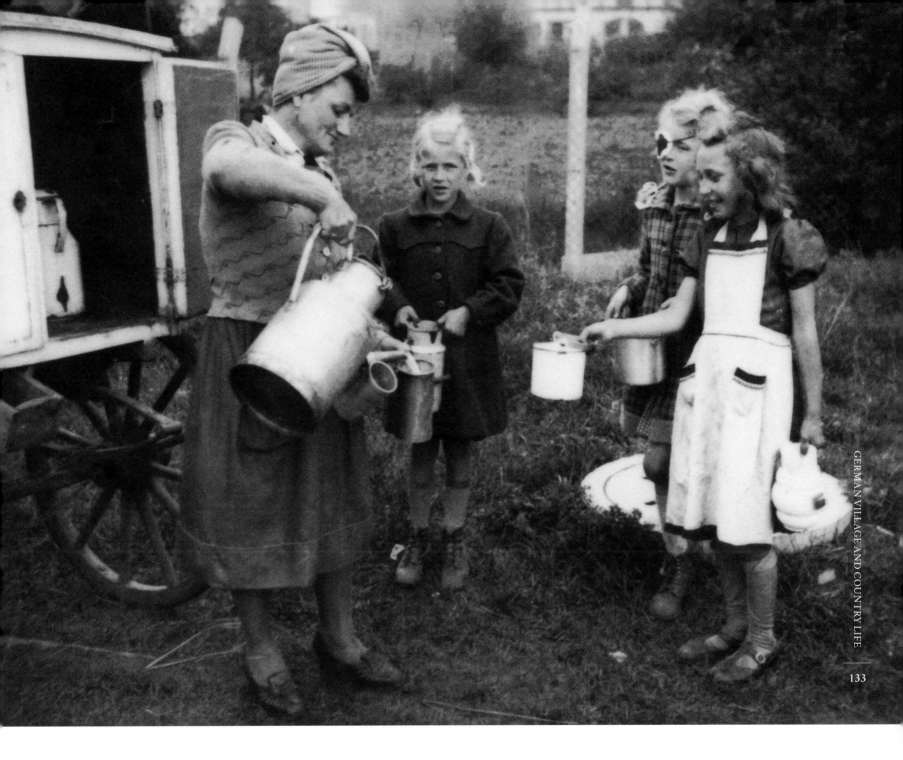

Children wait for their daily measure of milk. The lady has a horse-drawn wagon which she stops at each street corner, ringing a bell to rouse the nearby housewives.

Gardelegen, Ger—23 May '45

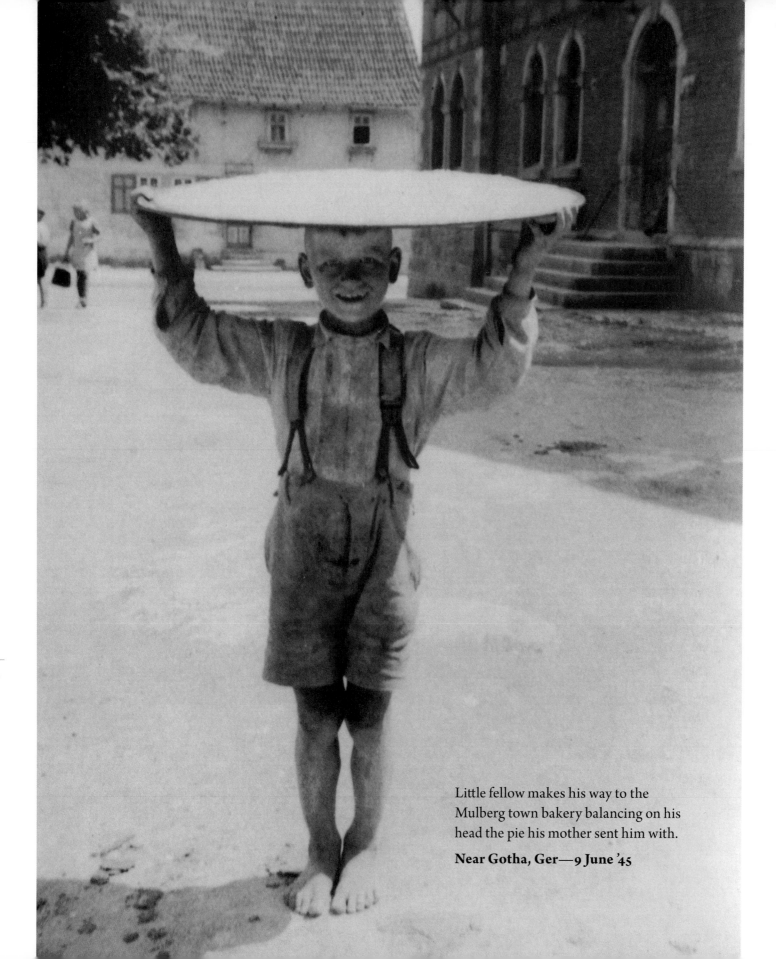

Little fellow makes his way to the
Mulberg town bakery balancing on his
head the pie his mother sent him with.

Near Gotha, Ger—9 June '45

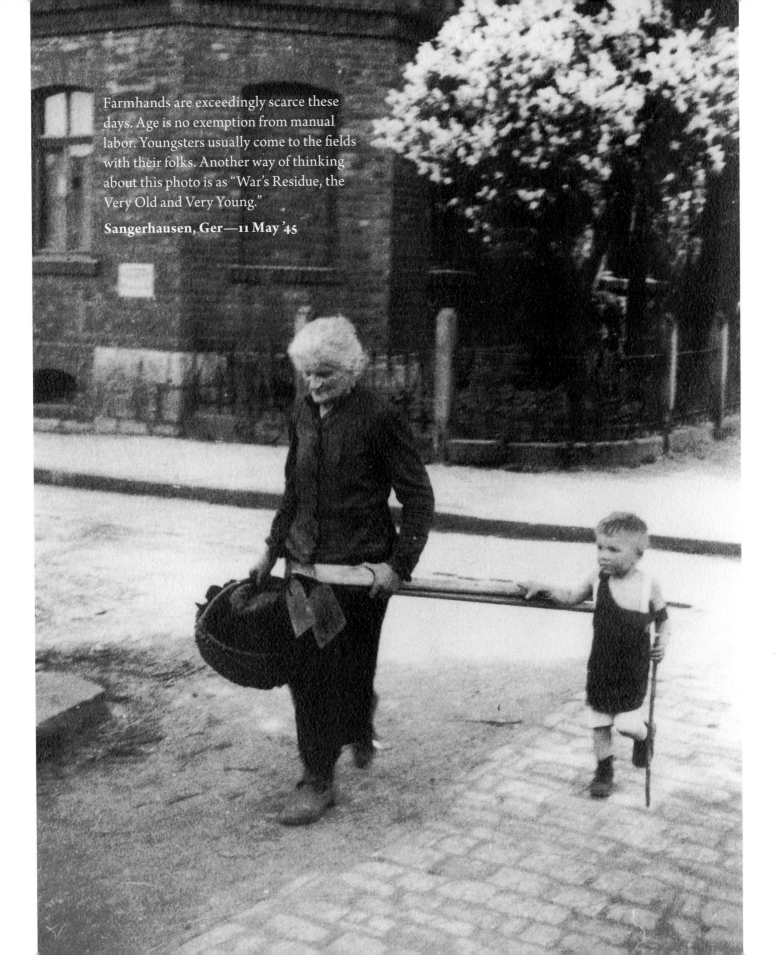

Farmhands are exceedingly scarce these days. Age is no exemption from manual labor. Youngsters usually come to the fields with their folks. Another way of thinking about this photo is as "War's Residue, the Very Old and Very Young."

Sangerhausen, Ger—11 May '45

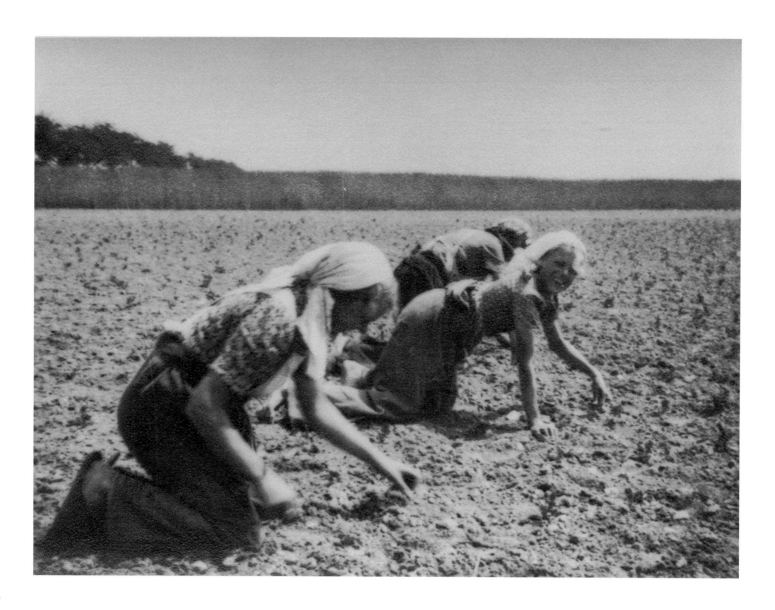

They couldn't help giggling at the two American soldiers who stopped their Peep and walked clear out in the field just to take pictures of them. The youngest is ten, and they work about nine hours a day.

Near Gardelegen, Ger—29 May '45

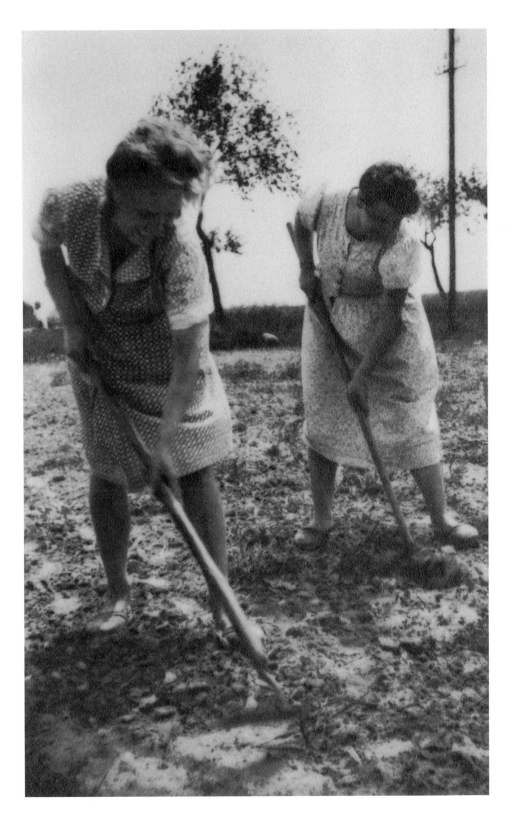

Husky and hard-working, but not eager to be photographed in such a role. The German people are surprisingly alert to the propaganda possibilities of pictures and hence object to posing for any that might show them in an unfavorable light, not so much as individuals, but as representative Germans.

Near Gardelegen, Ger—29 May '45

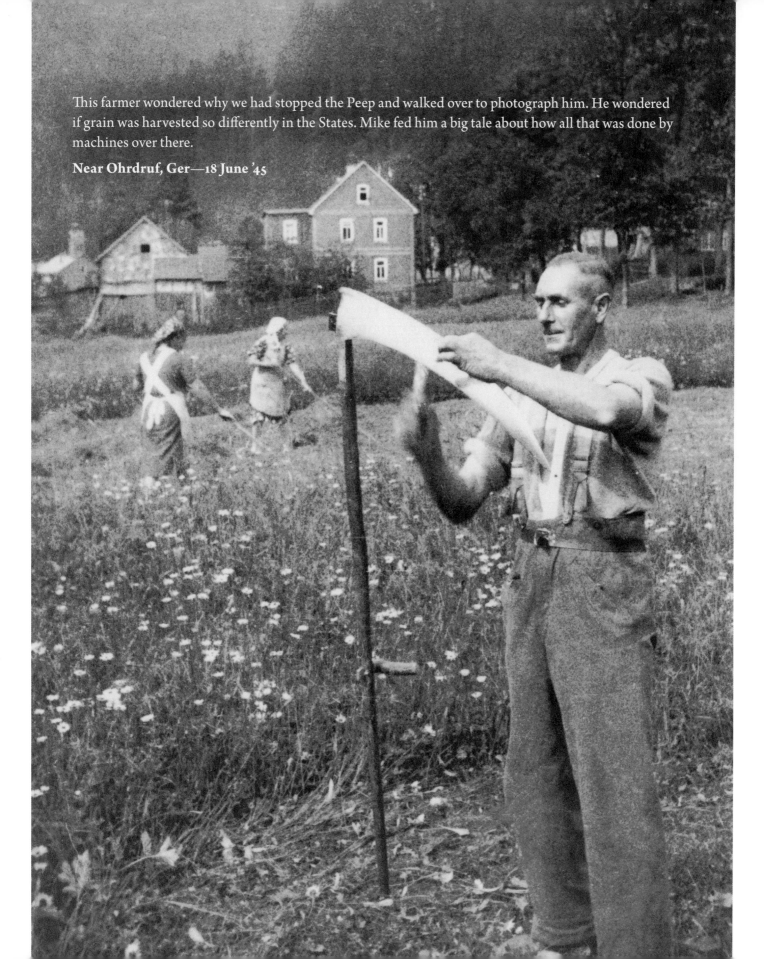

This farmer wondered why we had stopped the Peep and walked over to photograph him. He wondered if grain was harvested so differently in the States. Mike fed him a big tale about how all that was done by machines over there.

Near Ohrdruf, Ger—18 June '45

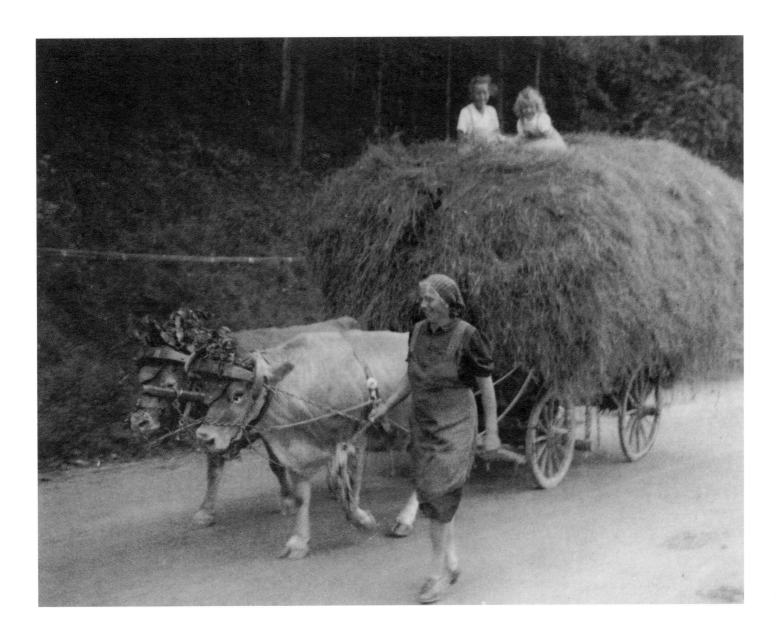

The oxen plod slowly, but at least don't shy from the many American trucks on the roads as horses do. Twining branches and flowers in their horns is a quaint custom.

Near Ohrdruf, Ger—18 June '45

15

REMINDERS OF THE PAST

Outside of the Adolf Hitler Sportsplatz looking rather bare without the great gilt swastika framed in oak leaves that topped its center.

Nürnberg, Ger—8 July '45

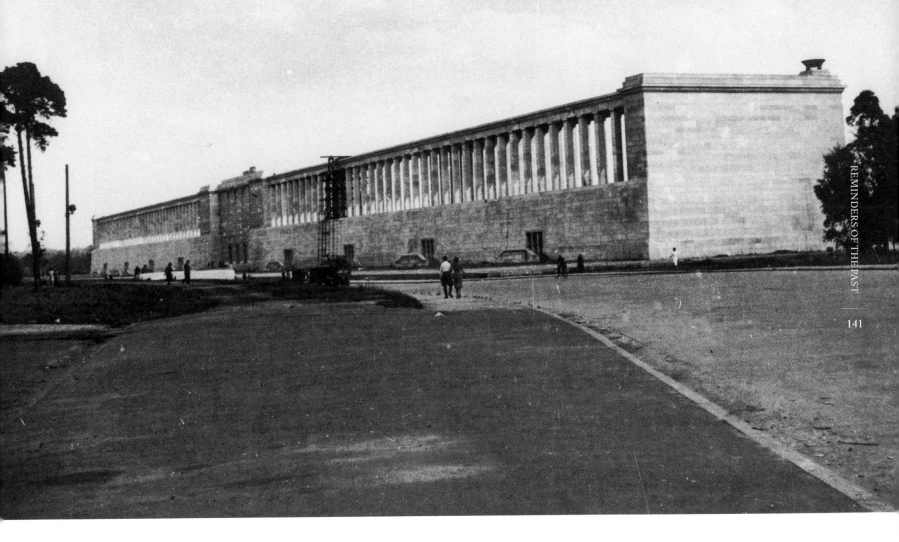

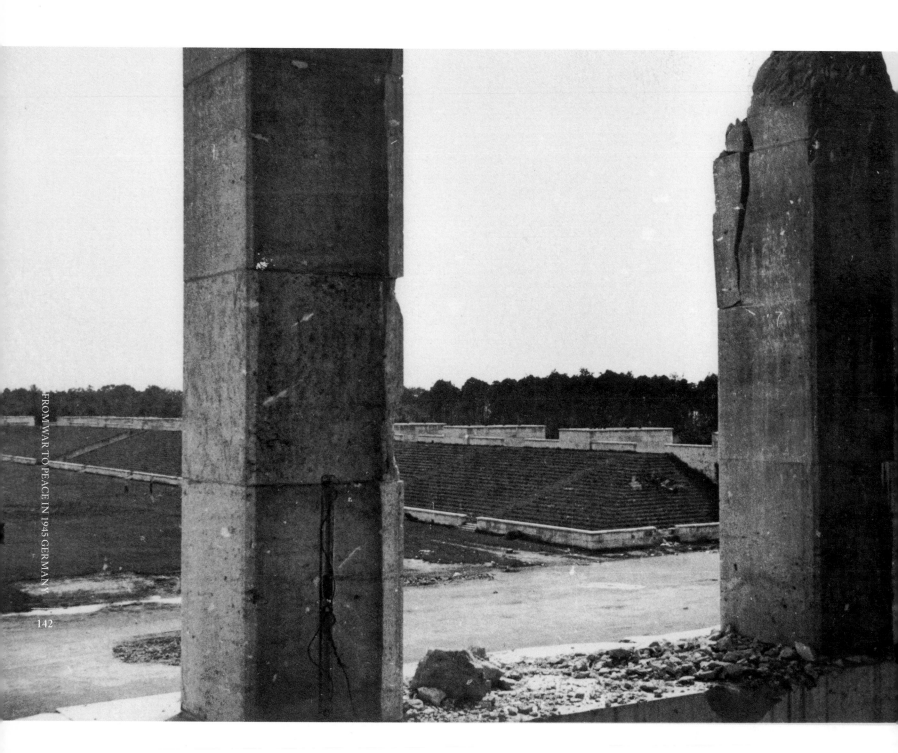

One side of the huge open amphitheater that was one of the foremost prewar Nazi Party meeting places. Now renamed Soldiers Field and used for the GI Olympics and 3d Army baseball finals.

Nürnberg, Ger—8 July '45

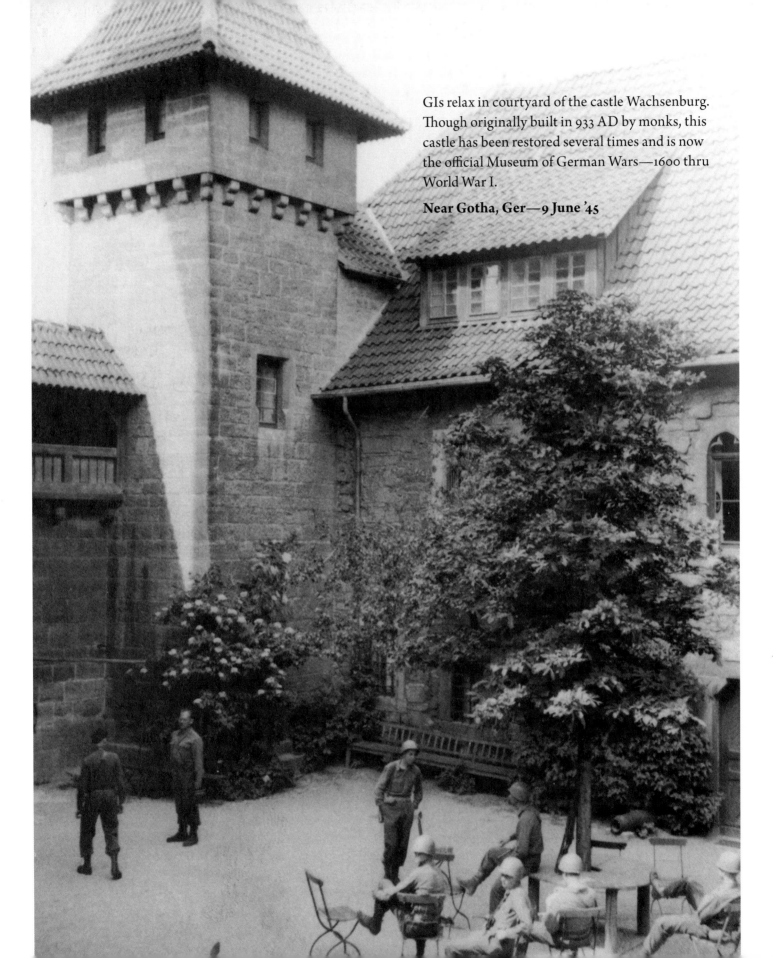

GIs relax in courtyard of the castle Wachsenburg. Though originally built in 933 AD by monks, this castle has been restored several times and is now the official Museum of German Wars—1600 thru World War I.

Near Gotha, Ger—9 June '45

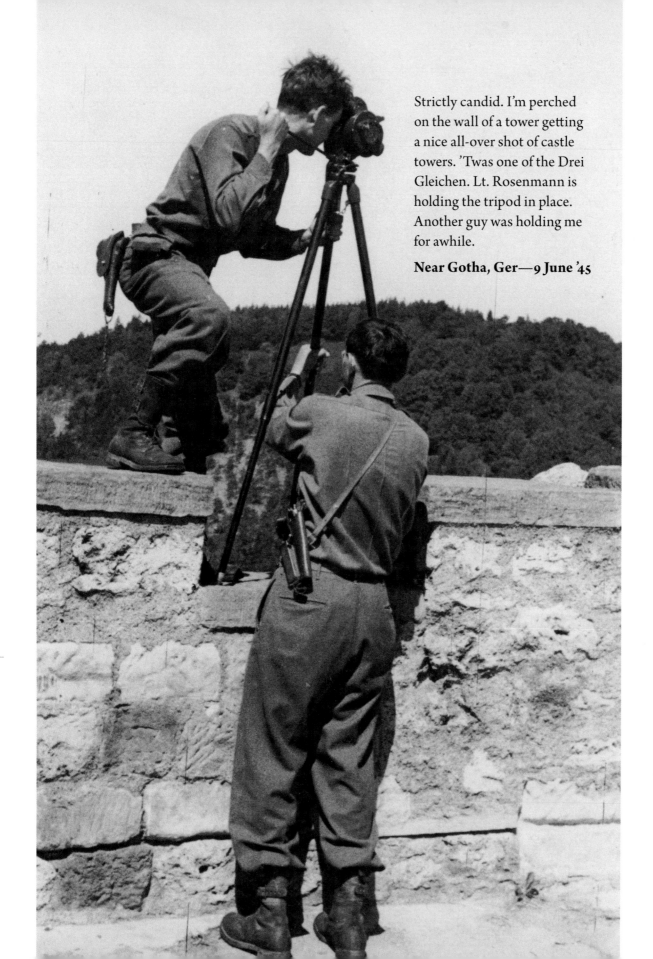

Strictly candid. I'm perched
on the wall of a tower getting
a nice all-over shot of castle
towers. 'Twas one of the Drei
Gleichen. Lt. Rosenmann is
holding the tripod in place.
Another guy was holding me
for awhile.

Near Gotha, Ger—9 June '45

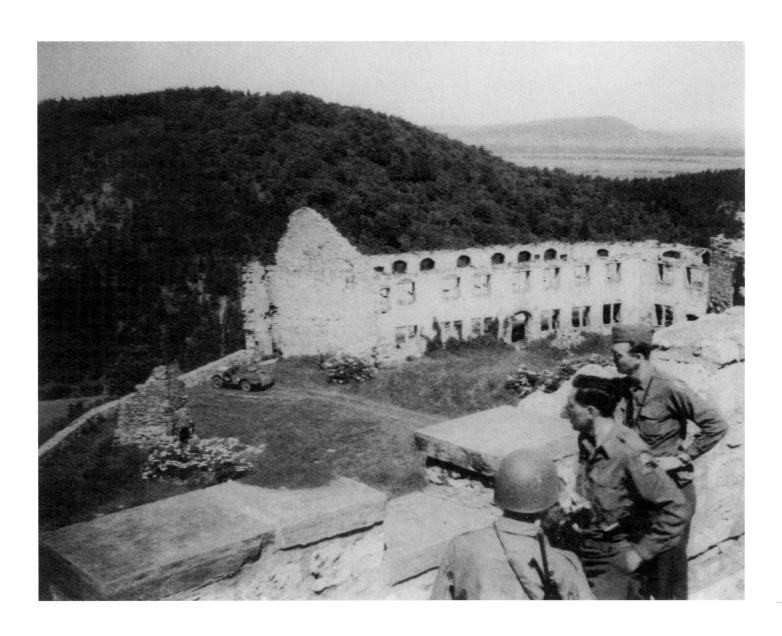

Lt. Rosenmann and me view the ruins of Burg Gleichen from atop one of its towers. This castle was built in the 1000s. The best preserved part is the eerie network of underground passages and dungeons.

Near Gotha, Ger—9 June '45

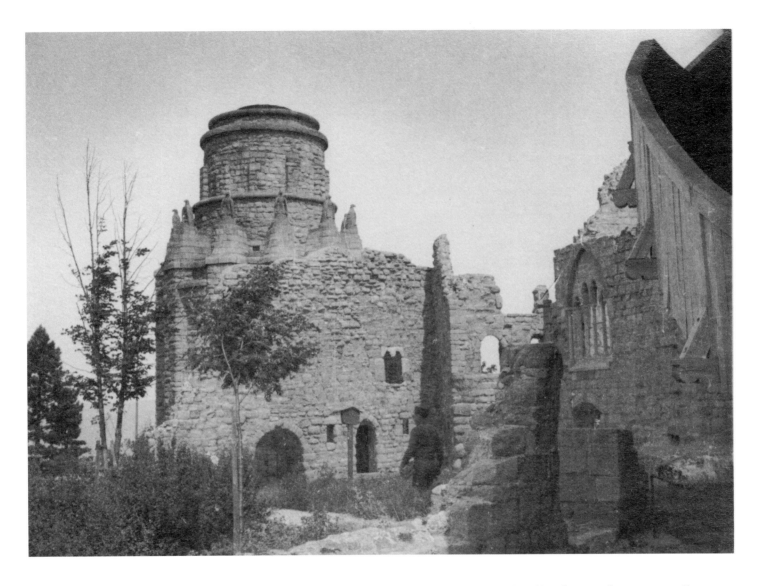

These ruins of the old Castle Rothenburg were restored into a Nazi Shrine of some kind by the SS. There is a small, circular, ceremonial room in the tower base. The bare and virile figure of a man dominates the room's interior, and ceremonial flags flank it. Other rooms were piled high with Nazi literature. Pic shows Lt. Rosie with a couple of books under his arm. I took one small book, "German Children, German Names," which is self explanatory. The chief aim of it seemed to be to avoid Jewish names.

Near Nordhausen, Ger—17 May '45

(*Facing*) The plaque to the honor of Bismarck on the rebuilt part of castle Mulberg. His name is plastered on edifices all over Germany, and their text books are full of it.

Near Gotha, Ger—9 June '45

Frontal view of Valhalla as seen from the first landing below. Built in 1830–1842, it was patterned after the Parthenon in Athens. It had the same 52 Doric columns and 365 steps.

Near Regensburg, Ger—22 July '45

(*Facing*) Inside Valhalla, a superb memorial hall. By following around the wall as the visitors are doing one gets a chronological story of German heroes, each represented by a marble bust. Note the staunch figures above that seem to support the ceiling—that's the Valkyrie of the Gods. It is believed that the souls of German soldiers who died for their country come to rest here.

Near Regensburg, Ger—22 July '45

16

RELATIONS BETWEEN US SOLDIERS AND GERMAN CIVILIANS

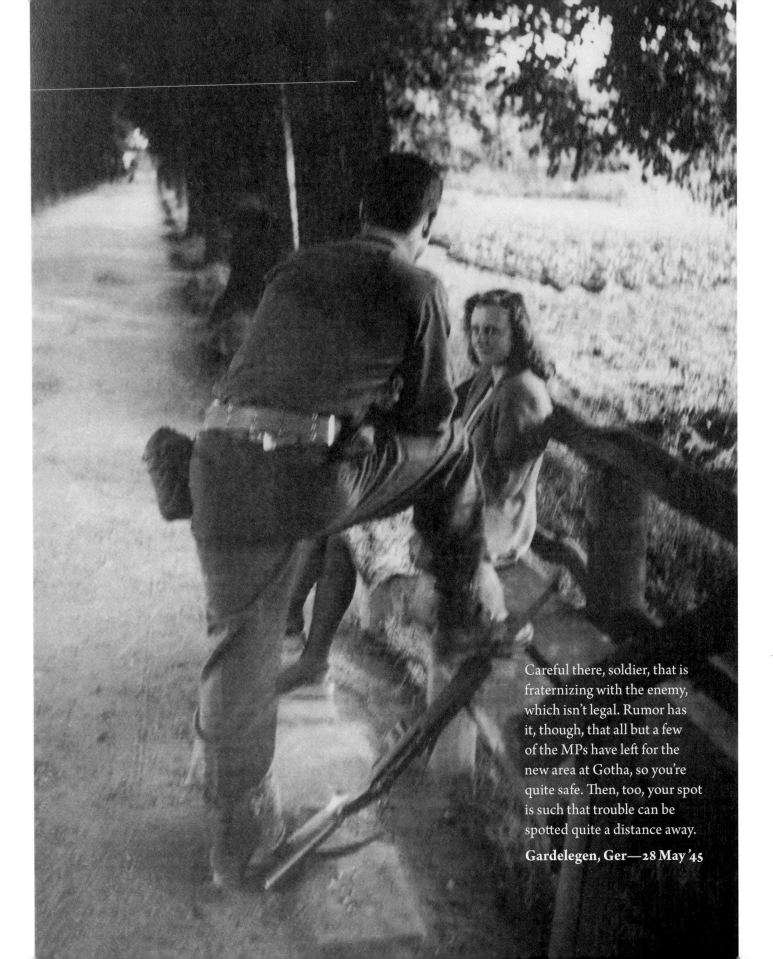

Careful there, soldier, that is fraternizing with the enemy, which isn't legal. Rumor has it, though, that all but a few of the MPs have left for the new area at Gotha, so you're quite safe. Then, too, your spot is such that trouble can be spotted quite a distance away.

Gardelegen, Ger—28 May '45

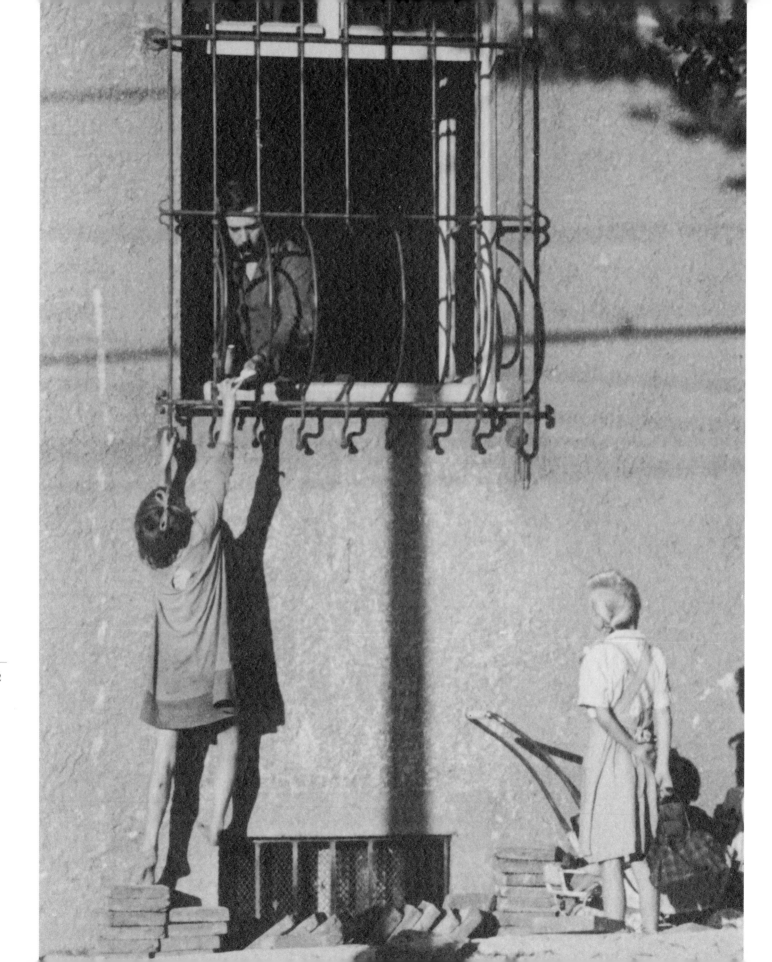

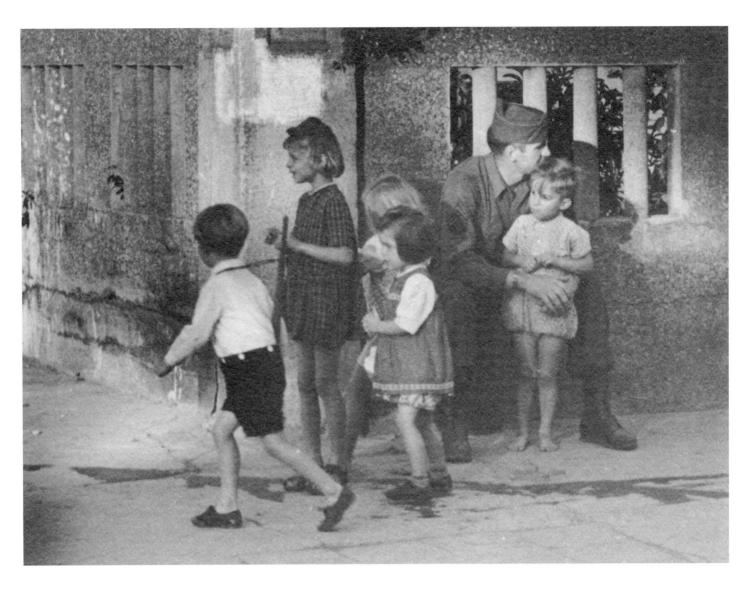

Children everywhere it seems, and many of them. Fellows like them and find most are intelligent and surprisingly healthy.

Regensberg, Ger—mid-Sept '45

(*Facing*) GI hands a morsel of food out to eager child. In many places they haunt mess-gear laundries, carrying a can for food and one for coffee. The fellows soon get used to pouring the leftover coffee from their cups into the container held out and allowing the food in their mess gear to be picked over before dumping into garbage cans.

Regensberg, Ger—mid-Sept '45

GIs leaving German Church after their Service walk between a double line of children waiting to go in for their Sunday School. Carrying a weapon to church was a strange experience.

Gardelegen, Ger—27 May '45

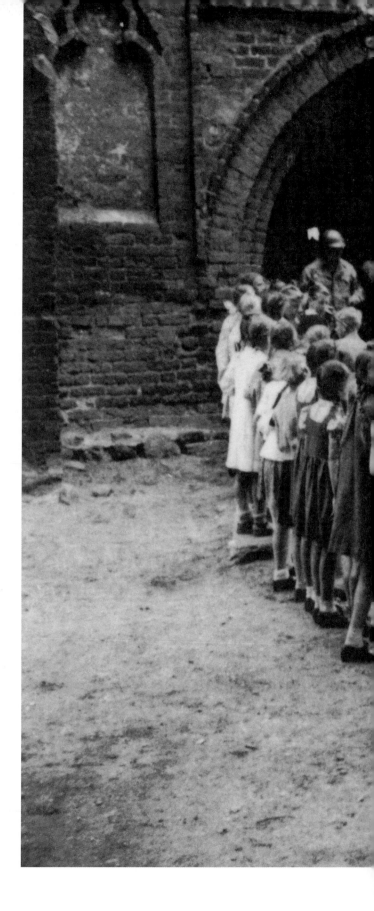

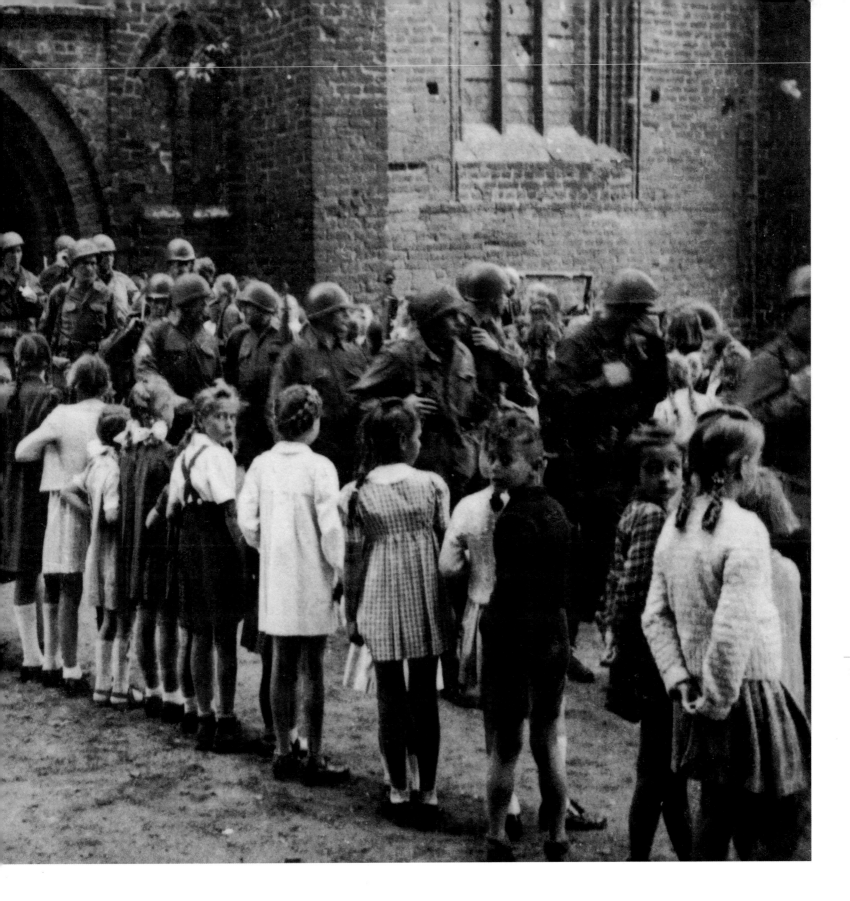

17

WHERE ARE THE GERMAN PWS?

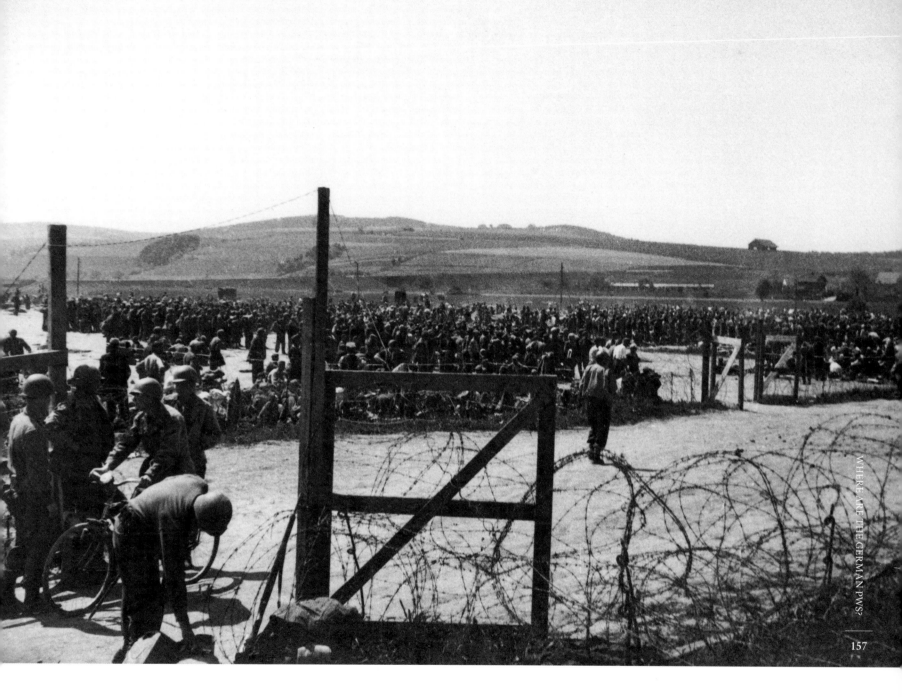

Huge PW enclosure. Some 2,600 are being held here. Their two meals a day come from a supply of regular German Army rations captured in a nearby warehouse.

On Leipzig-Frankfurt Autobahn—16 May '45

GIs make civilian prisoners clear them a ballfield. The Germans and Poles were caught stealing cigarettes and other rations. MG had them locked up till this better use was found for their time.

Neuhaldensleben, Ger—21 May '45

"MG" means Military Government.

German PWs sweep the street in front of the new 102 Inf Div CP. The modern building was a German Finanzamt or Fiscal Office.

Gotha, Ger—2 June '45

18

ENTERTAINMENT AND REST

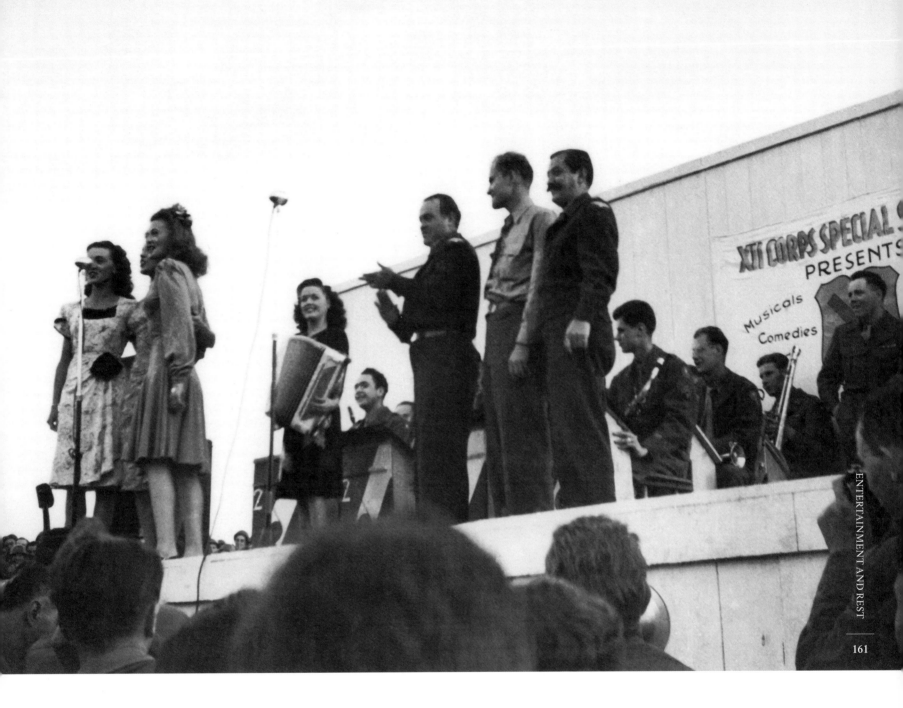

The whole USO troupe out for the finale number. The stage was especially built for this show, the usual showplace being inadequate for the expected crowd.

Regensburg, Ger—5 August '45

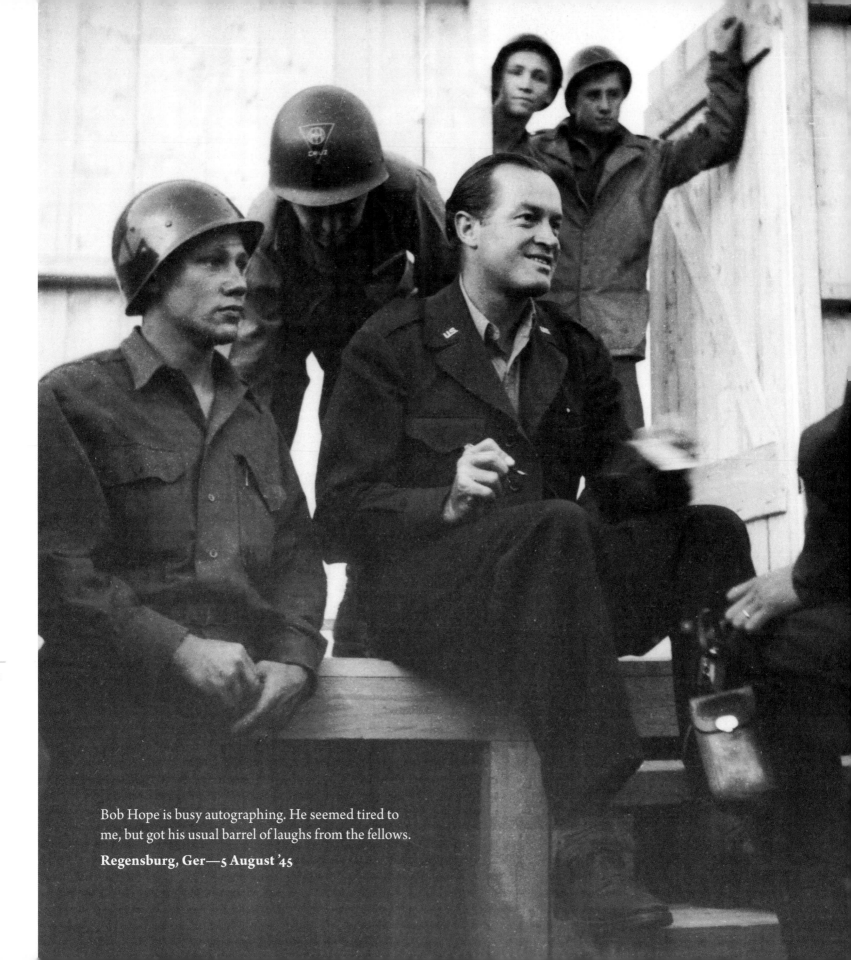

Bob Hope is busy autographing. He seemed tired to me, but got his usual barrel of laughs from the fellows.

Regensburg, Ger—5 August '45

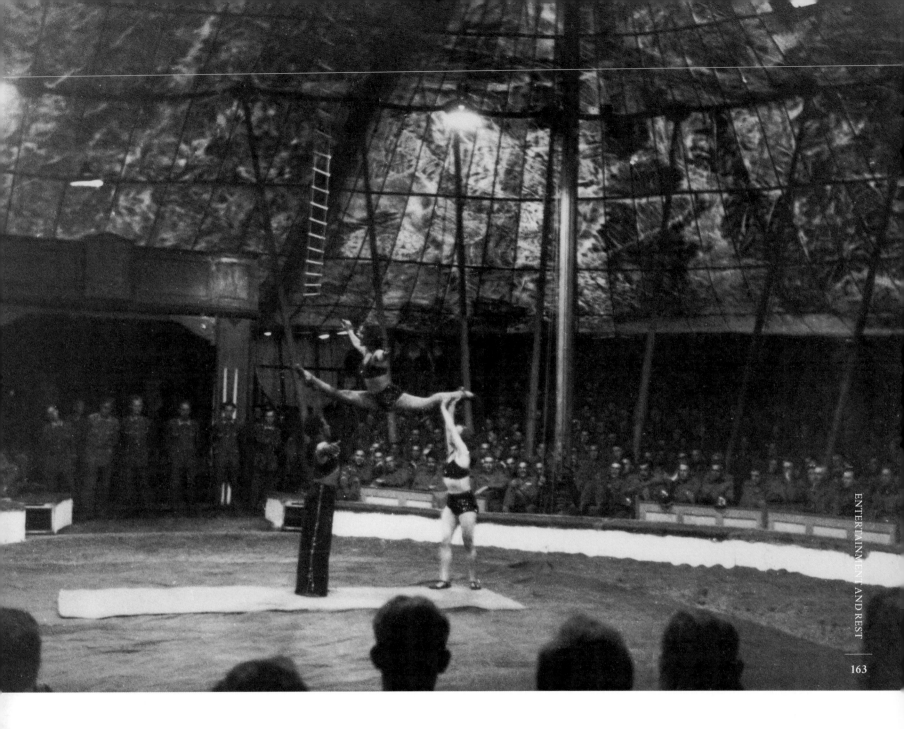

Full house of GIs at the evening circus performance. An afternoon show is given for civilians, but they think it rather third rate because many performers are not German. The fellows, though, keenly enjoyed it all. As with most of the acts this one is a family, the Burketts. It's a contortionist stunt known as the Elastic Act. The father, negro, and mother, white, are shown here holding their heavily tanned daughter split between. The daughter inspired many a GI whistle.

Gotha, Ger—24 June '45

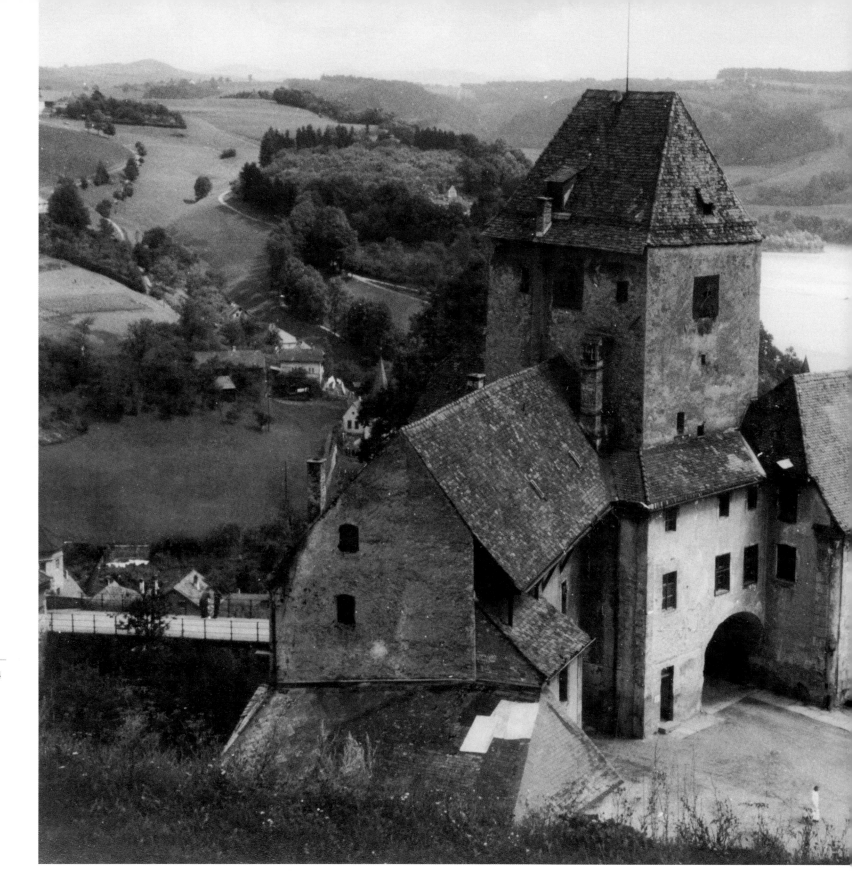

One of the formidably enclosed courtyards in the Oberhaus. The moat and bridge approach to this part appear on the left. Once a Roman fortress, the place recently was a favorite partying spot for Hitler until the US Army took over and converted it into a rest area for GIs. I enjoyed some rest time here.

Near Passau, Ger—16 August '45

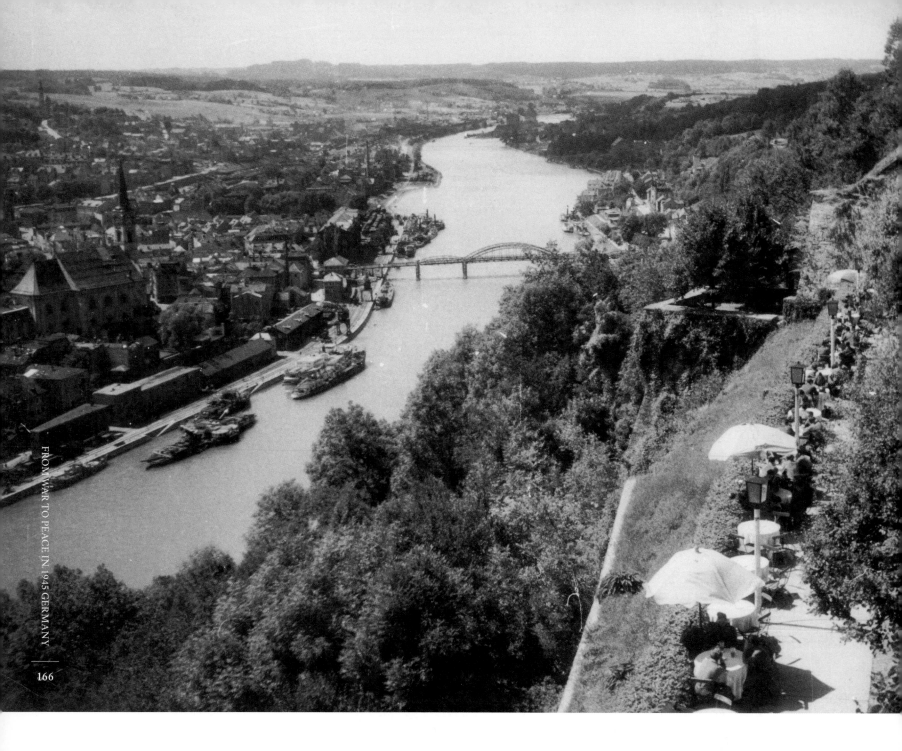

The fringe of the Oberhaus terrace overlooking the river Danube and old city of Passau. GIs on pass to the Oberhaus may bring girl friends to the nightly beer and dance on the terrace.

Near Passau, Ger—16 August '45

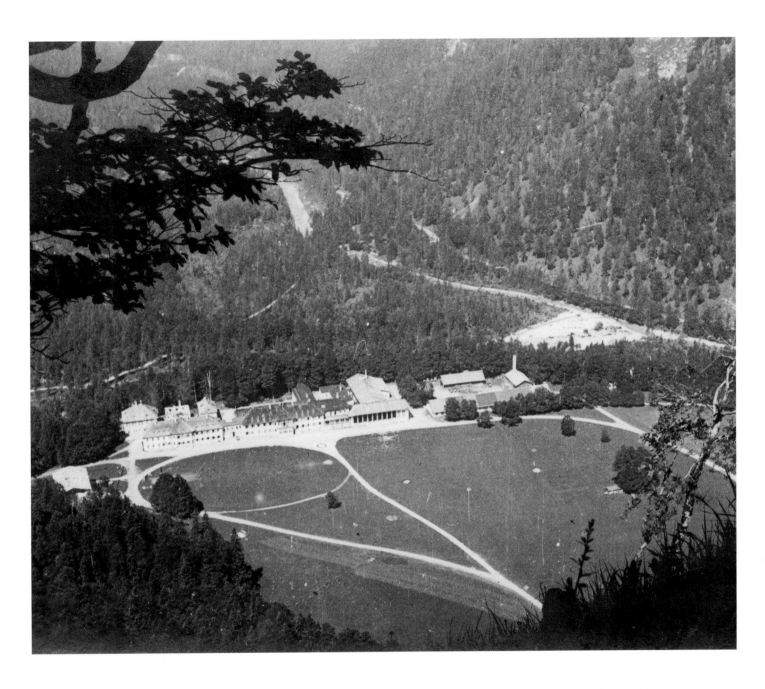

The 166 Sig Photo Co first had this secluded resort, and when they left, my company, the 165th, took over. For the outdoor men it was great, but the city guys were bored sick. A whole contingent of PWs were quartered nearby and did everything from GI-ing the barracks to making prints in the darkroom.

Wildbad Kreuth, Ger—15 July '45

19

GOING HOME

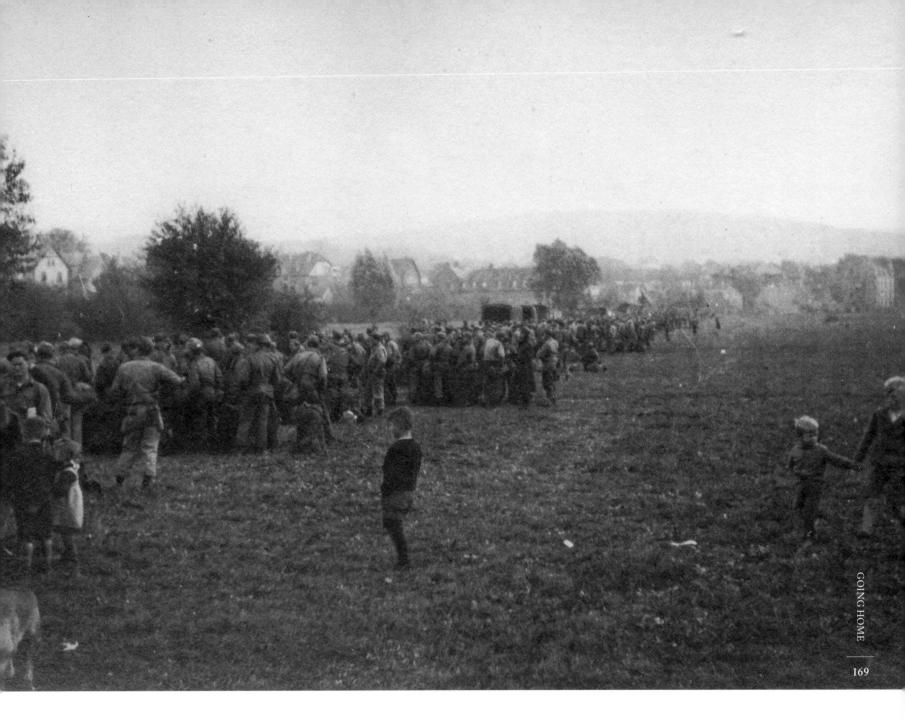

Billeted for a week in an old tobacco factory, we were processed by the old 3rd Repl Depot preparatory to going home. Same outfit, but with greatly changed tactics since the days they were supplying replacements for battle loss.

Final inspection is complete, and now with bulging bags we're waiting by the numbers for trucks.

Marburg, Ger—13 Oct '45

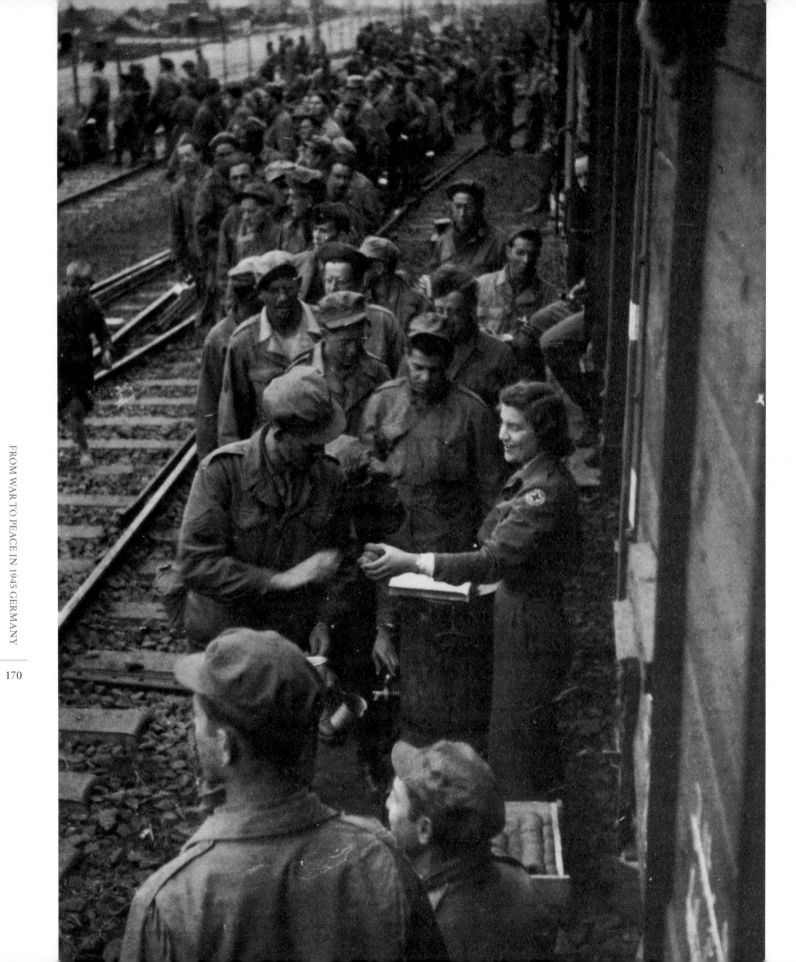

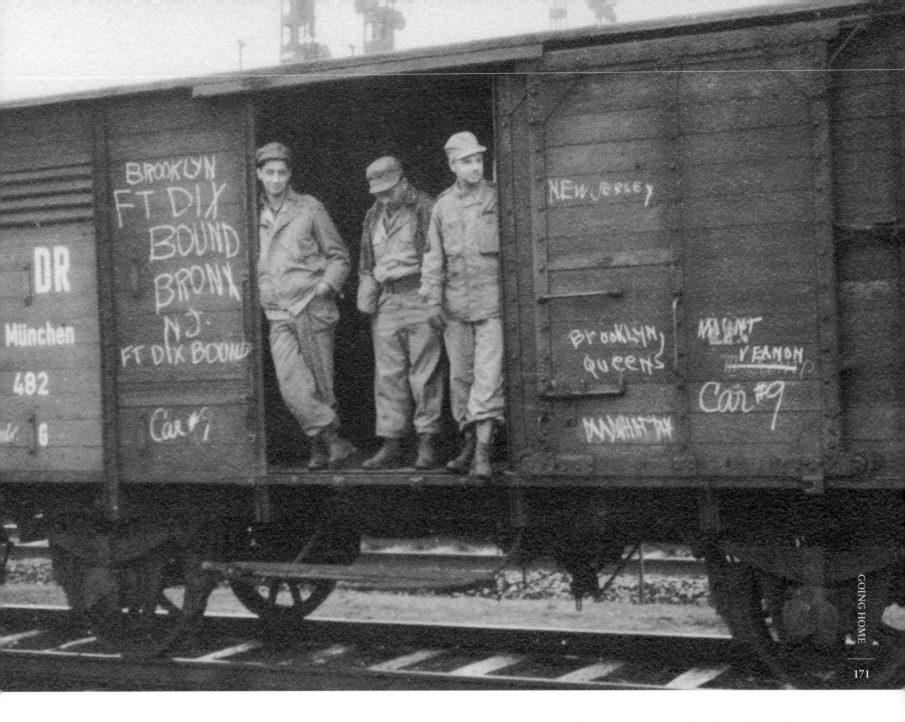

Cattle-class accommodations, Marburg to Antwerp. Not actually the famed "40 (men) and 8 (horses)" of World War I, but no more comfortable for 24 men to ride and sleep in.

Antwerp, Bel.—15 Oct '45

(*Facing*) Handful of doughnuts and canteen cup of hot coffee—the invariable Red Cross handout, but a good sendoff before a rough two nights and a day on a boxcar.

Marburg, Ger—13 Oct '45

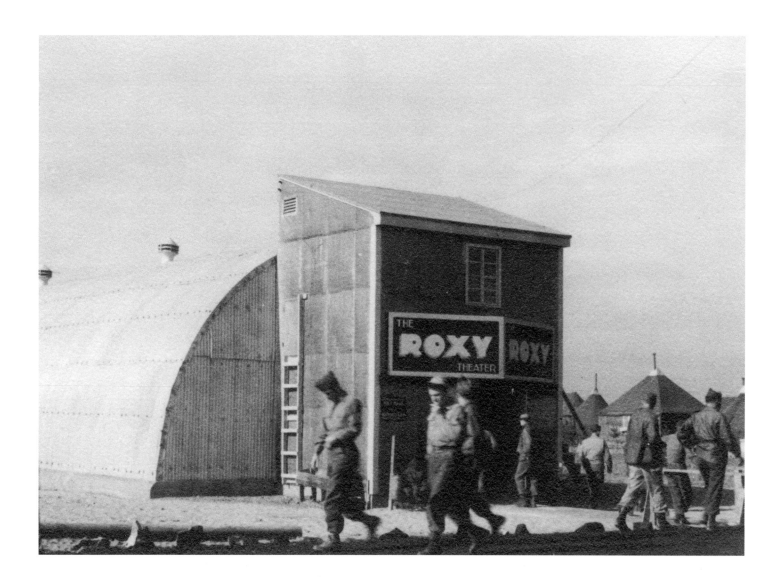

One of the seven theaters at this staging area running continuous showings all afternoon and evening. Nothing but a glorified quonset hut, but right appealing to the GIs because somebody's bothered to name it the Roxy and run shows often enough to eliminate standing in long lines.

Tophat, Bel.—mid-Oct '45

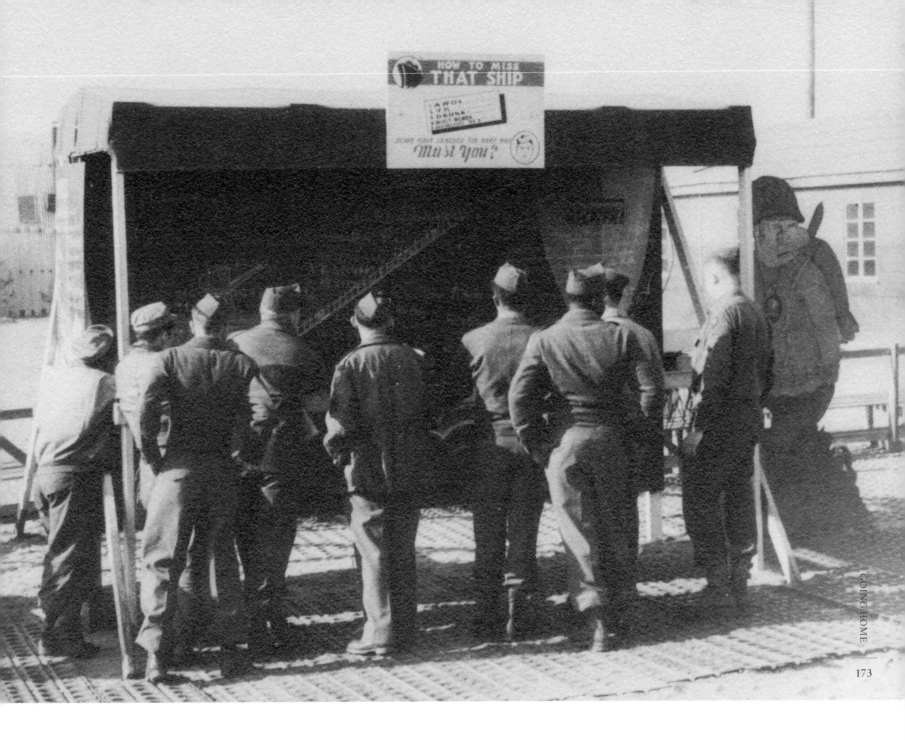

The bulletin board, hub of all rumors, and most frequented spot in camp. Here are posted the names of all ships, their capacities, and the expected date of their arrival. Snafoo stands nearby.

Camp Tophat, Bel.—mid-Oct '45

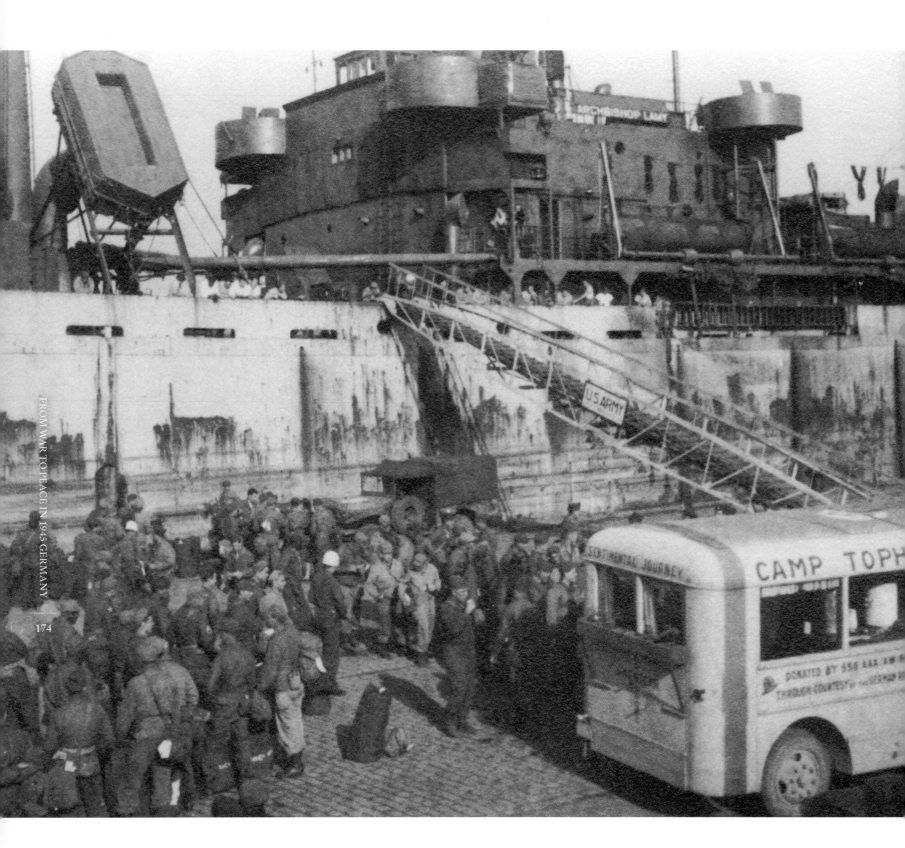

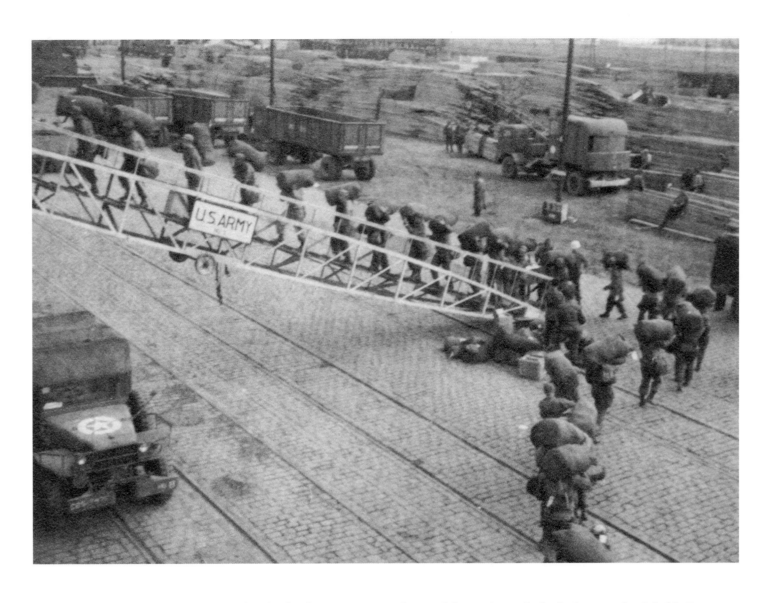

Loaded like coolies we struggle up the plank. That evening we dropped down through the locks into the Scheldt River and then lay at anchor all night.

Antwerp, Bel.—21 Oct '45

(*Facing*) The Red Cross from Tophat out to give us a sendoff. Their chow wagon, being captured enemy equipment, is inscribed "Donated by 555 AAA AW BN through Courtesy of the German Reich."

Antwerp, Bel.—21 Oct '45

Just off Land's End, England, we ran into a storm said to be the worst there in 46 years. The winds rose to gale-force and later to hurricane force. One of the Queens heading in toward England was unable to land and had to ride out the storm.

Atlantic Ocean—23–30 Oct '45

(*Facing*) Scenes like this typified the last eight days of the voyage. Appetites returned and many Joes crawled out on deck. We hadn't been out of our bunks for days. We began to pick up radio programs from the States, and the silly commercials sounded best of all, for the old Armed Forces Network of course never had any.

Atlantic Ocean—31 Oct–7 Nov '45

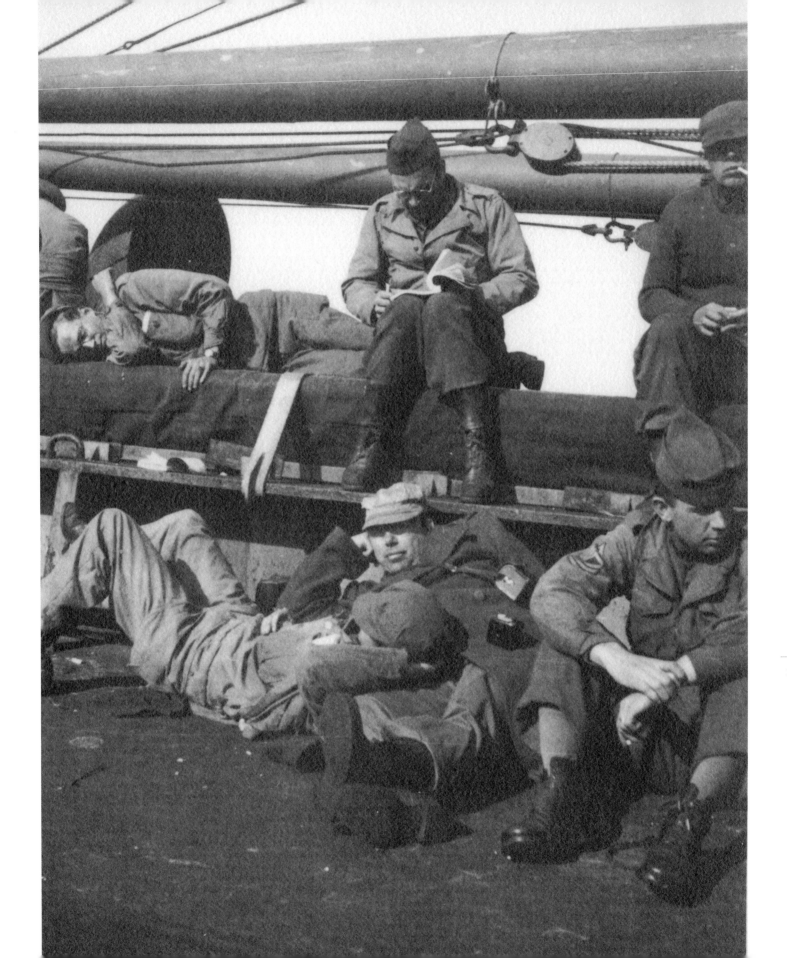

First sight of the USA, and all are crowding the rails to see it, and by later evening we were standing on it.

Boston Harbor—7 Nov '45

AFTERWORD

BRADLEY D. COOK

As the curator of photographs at the Indiana University Archives I actively seek collections dealing with the history of Indiana University. Thus, I quite often speak with Indiana University departments, faculty, staff, alumni, and local citizens about their collections and their willingness to donate such collections to our repository.

My first meeting with Mr. Fleming took place a couple of years ago. I was driving home down Tapp Road here in Bloomington, and as I approached a roundabout at the bottom of a hill I caught sight of a small handmade sign advertising the sale of photographs at the nearby assisted living center. I was intrigued, and although not knowing what to expect I steered toward said center, parked, and made my way to Mr. Fleming's apartment, outside of which I was greeted by more sale advertisements as well as several photographic images displayed on easels.

Although the door was wide open I knocked, and within moments Mr. Fleming appeared, greeted me, and told me to come right in and to take my time looking around. His apartment was very small and yet he had converted most of his living space into a maze of pegboard walls which exhibited many of his best images. He did not even utilize a real bed in his apartment, but rather the pull-out bed from a love seat situated in one cramped corner of his small bedroom. Boxes on tables throughout the apartment allowed one to browse more of his photographs, which were arranged by subject matter.

While I looked at photographs we began talking. When I told him who I was and what my job entailed he began to tell me about his career at Indiana University. To say that I was excited about the images I was viewing and about hearing about his years at our institution would be an understatement. After a while I sat with him and we briefly discussed the possibility of him depositing his original negatives in our repository. After all, his collection spanned parts of seven decades and most of it was shot from the time when he first became a fellow at the Indiana University Audio-Visual Center in 1949 through 2003. Most important to me, however, was the fact that portions of his collection contained images of Indiana University and Bloomington.

It was during our conversation that he retrieved from a nearby shelf an old shoebox, opened it, and began to show me a small collection of photographs he had shot during World War II. The prints had been chronologically arranged into about fifteen small bindings. These photographs were indeed a surprise and without a doubt the hidden gem of his collection.

While he and I sat there looking through this portion of his collection it struck me what truly wonderful photographs these were. I was captivated by the candidness of many of the images,

such as those showing German children trying to obtain food from US mess halls, refugees on the move with what worldly possessions they could carry, German prisoners of war, Bob Hope and Jerry Colonna on stage at a USO show, and a German woman and her young daughter washing clothes in Nuremberg.

The photographs themselves were made even more interesting by the fact that Mr. Fleming had himself typed descriptions, complete with place and date, on the reverse side of each print. Such information always greatly adds to the historical importance of any photograph collection even if such descriptions only add flavor to the overall historical record. As the old adage goes, "A picture is worth a thousand words," and while I do believe this to be true, I would argue that a picture accompanied by basic descriptive information is worth a thousand words tenfold.

What I thought would be a ten-to-twenty-minute detour on my way home turned into a nearly two-hour visit, at which point we both had to say goodbye, but with an understanding that I would give him a few months to think about what he wanted to do with his photograph collection and that I would contact him at that point.

It wasn't until a colleague of mine forwarded an e-mail to me, which Mr. Fleming had sent out to members of his church, that I realized he was near to making a decision on the disposition of his photographs. The e-mail read, in part, "I'm 95 and intend to close my photo gallery & business this year. . . . At the end of each month I may have a 1 or 2 day closeout sale. . . . Any prints left plus my originals may be donated to IU Archives, and I'll have time to relax & read a few books."

Upon reading this I immediately called him and he confirmed with me shortly thereafter that he had decided to donate his collection. What a wonderful opportunity a detour on my way home provided. I again say thank you to Professor Emeritus Malcolm Fleming for donating his entire collection, including his World War II–era photographs, to the Indiana University Archives.

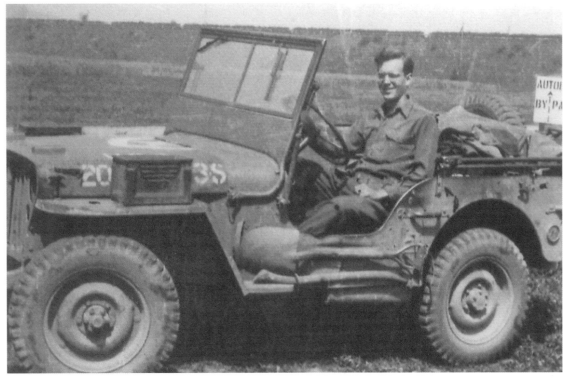

Malcolm and Peep.

MALCOLM L. FLEMING is Professor Emeritus of Education at Indiana University, where he taught photography and courses on learning from pictures and words. He has been a photographer for about eighty years and served as an official army photographer in the US Army Signal Corps from 1944 to 1945.

JAMES H. MADISON is the Thomas and Kathryn Miller Professor Emeritus of History at Indiana University, and the author of *Hoosiers: A New History of Indiana* (IUP, 2014) and *Slinging Doughnuts for the Boys: An American Woman in World War II* (IUP, 2007).

BRADLEY D. COOK is Curator of Photographs at the Office of University Archives and Records Management, Indiana University Bloomington.

EDITOR: Sarah Jacobi

BOOK AND COVER DESIGNER: Jennifer L. Witzke

PROJECT MANAGER/EDITOR: Nancy Lightfoot

MARKETING AND SALES DIRECTOR: Dave Hulsey

EDITORIAL AND PRODUCTION DIRECTOR: Bernadette Zoss

PRODUCTION INTERN: Katelyn Griner

PRINTER: Four Colour Imports